M000312987

A Visual Celebration of
Giant Pandas

This book was published by
Editions Didier Millet Pte Ltd
121 Telok Ayer Street, #03-01
Singapore 068590
www.edmbooks.com

Printed by
Tien Wah Press, Singapore
Printed in Singapore

First published in 2012

Copyright © Fanny Lai and Bjorn Olesen
www.bjornolesen.com

This Forestry Stewardship Council™ logo
offers a guarantee that the products used
to make this book come from responsible sources.
All rights reserved. No part of this publication may be
reproduced or transmitted in any form or by any means,
electronic or mechanical, including photocopying, recording
or any information storage and retrieval system, without
the prior written permission of the copyright owners.

ISBN: 978-981-4385-38-1 (Singapore and Malaysia)
 978-981-4385-36-7 (rest of the world)

©Photo: Bjorn Olesen, 2012

A Visual Celebration of
Giant Pandas

Fanny Lai and Bjorn Olesen

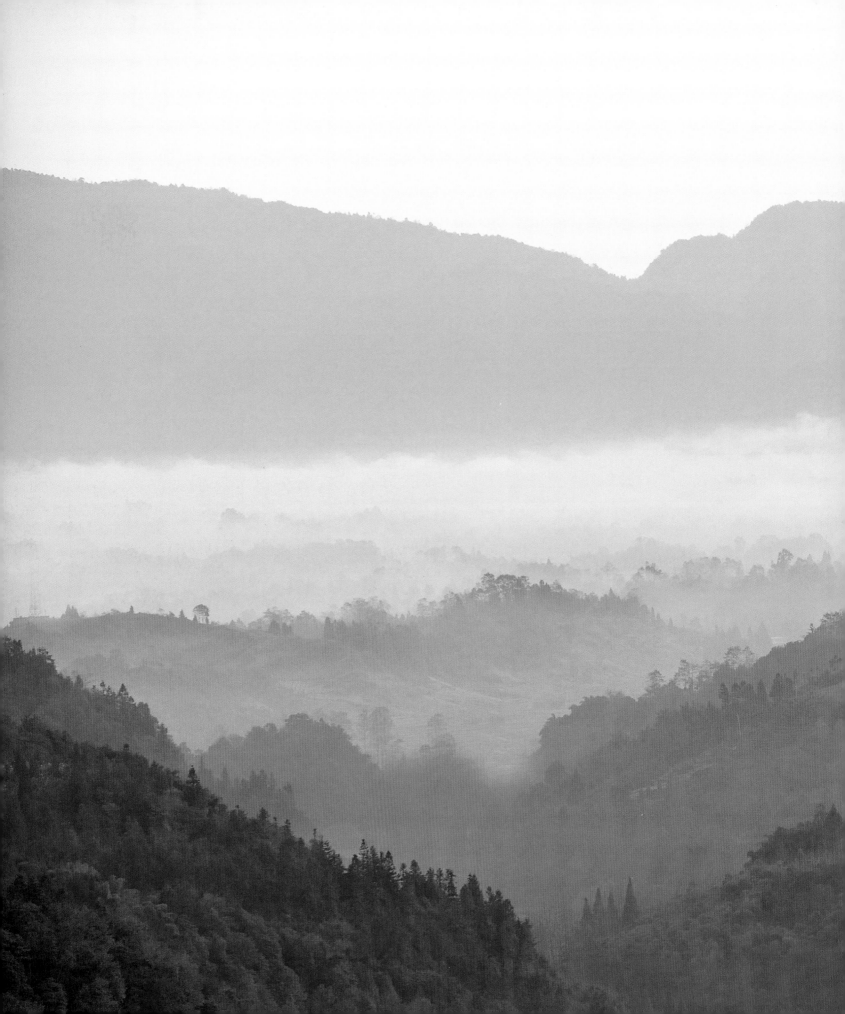

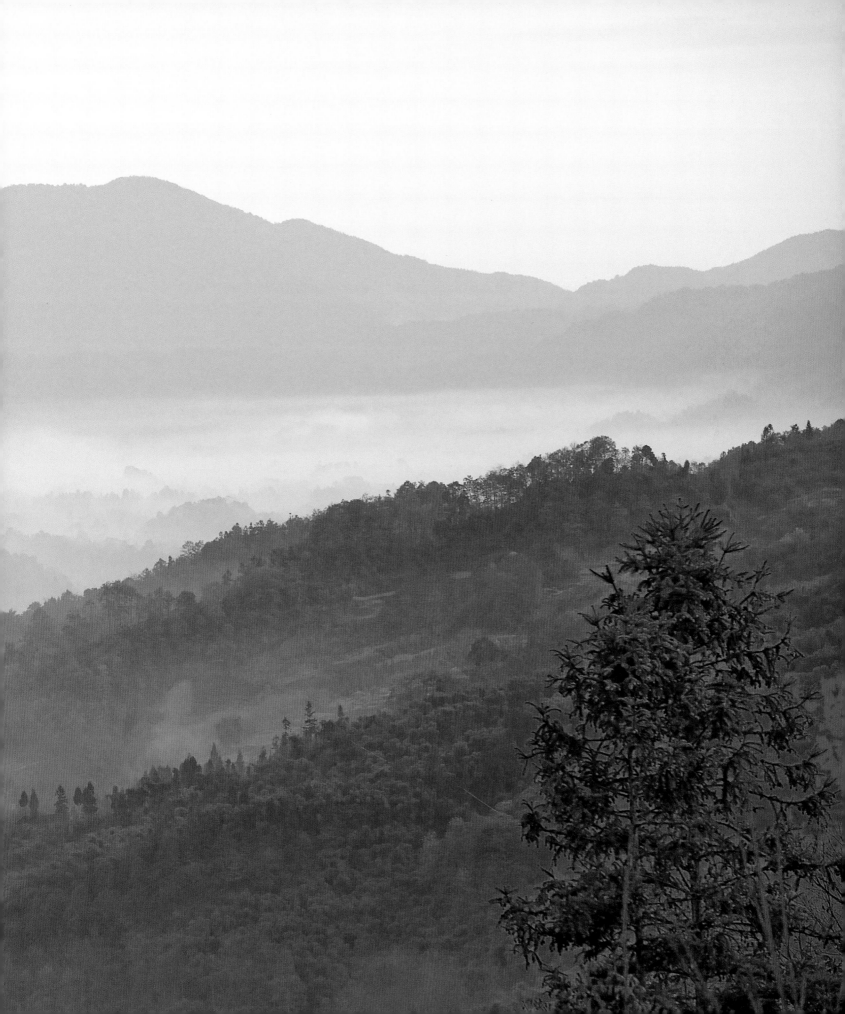

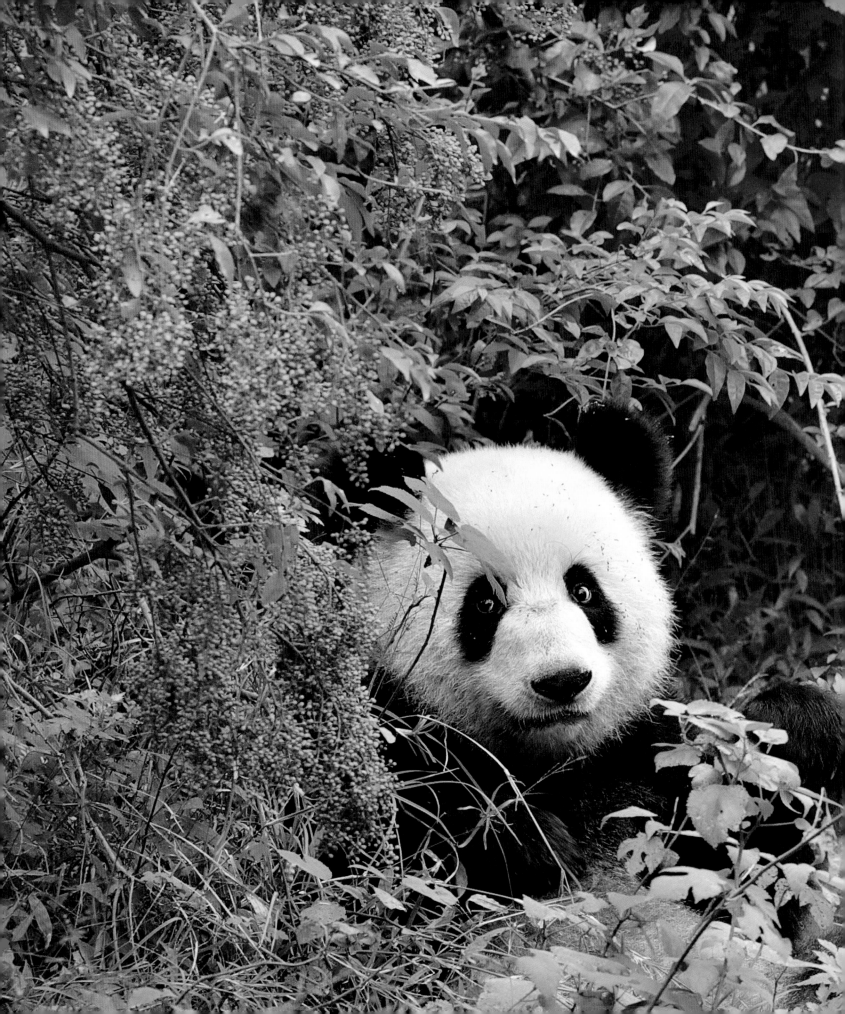

Contents

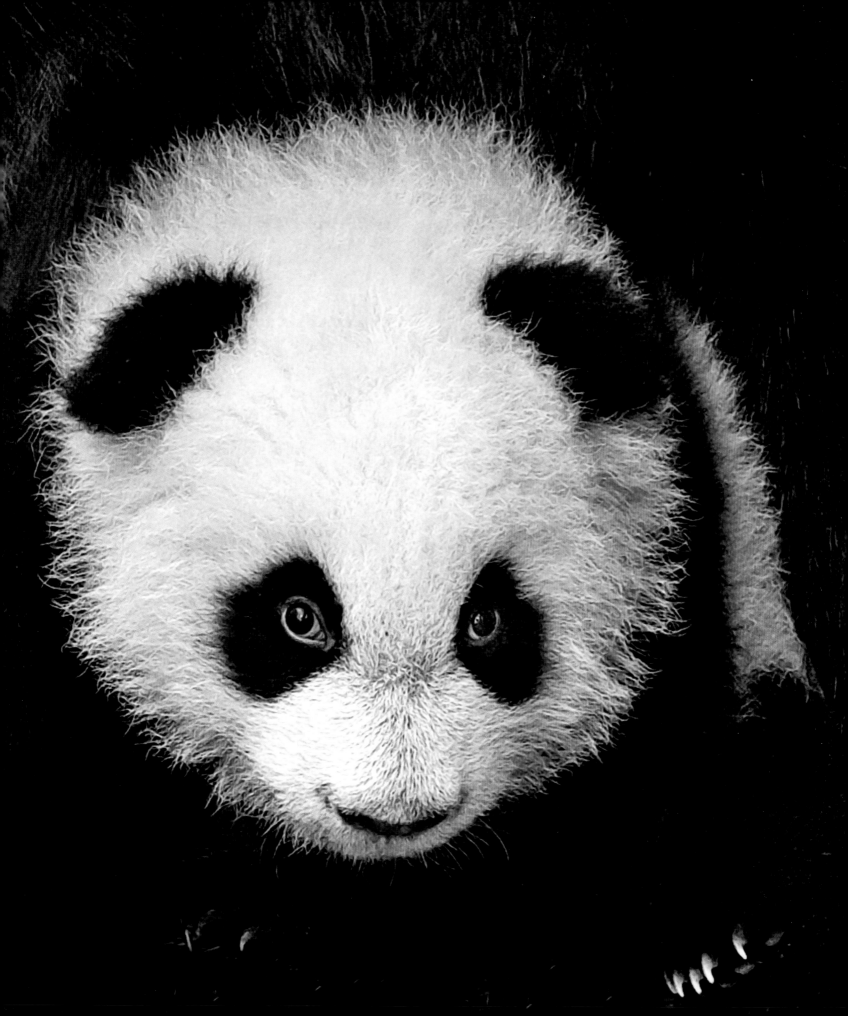

Foreword

The giant panda is perhaps the most powerful symbol in the world when it comes to species conservation. In China, it is a national treasure, and for WWF, the panda has a special significance as the organization's symbol since its formation in 1961.

The region where pandas live, in the Yangtze Basin, and its magnificent forests are home to a stunning array of wildlife such as dwarf blue sheep and beautiful multi-coloured pheasants, as well as a number of other endangered species, including the golden monkey, takin and crested ibis. They also play a crucial role, in the bamboo forests where they roam, by spreading seeds and facilitating greater growth of the vegetation.

The panda's habitat is also home to millions of people. By making this area more sustainable, WWF is also helping to increase the quality of life of local populations. There are also huge economic benefits to local communities through ecotourism and other activities.

Habitat loss and fragmentation are the most pressing threats to the giant panda. The major factors contributing to these threats include conversion of forests to agricultural areas, medicinal herb collection, bamboo harvesting, poaching, and large-scale development activities such as road construction, hydropower development, and mining. The illegal wildlife trade and the natural phenomenon of bamboo die-back are also threats.

Because of China's dense and growing human population, many panda populations are isolated in narrow belts of bamboo no more than 1.2km wide - and panda habitat is continuing to disappear as settlers push higher up the mountain slopes.

Although the situation of the Panda is still very delicate, there is good news. The conservation solutions to save the panda are working. After years of decline, panda numbers are thought to be increasing. In 2004, a survey counted 1,600 pandas - 40% more than were thought to exist in the 1980s. Panda habitat is increasing with the development of new reserves and green corridors. Some threats to panda survival such as poaching and illegal logging have been significantly reduced. Community development projects to help people sustainably coexist with pandas have been very positive. These are the results of joint efforts between WWF, goverments, local communities and individuals worldwide who have contributed towards panda conservation work.

We welcome every effort towards panda conservation, including independent efforts such as this book on giant pandas. Collectively, by raising awareness and mobilizing more people, we hope to not only save the pandas but also help to preserve the rich biodiversity - plants, landscapes, and other animals - that need to be there in order for these magnificent creatures to survive.

Liu Xiaohai
Upper Yangtze Programme Leader
WWF China

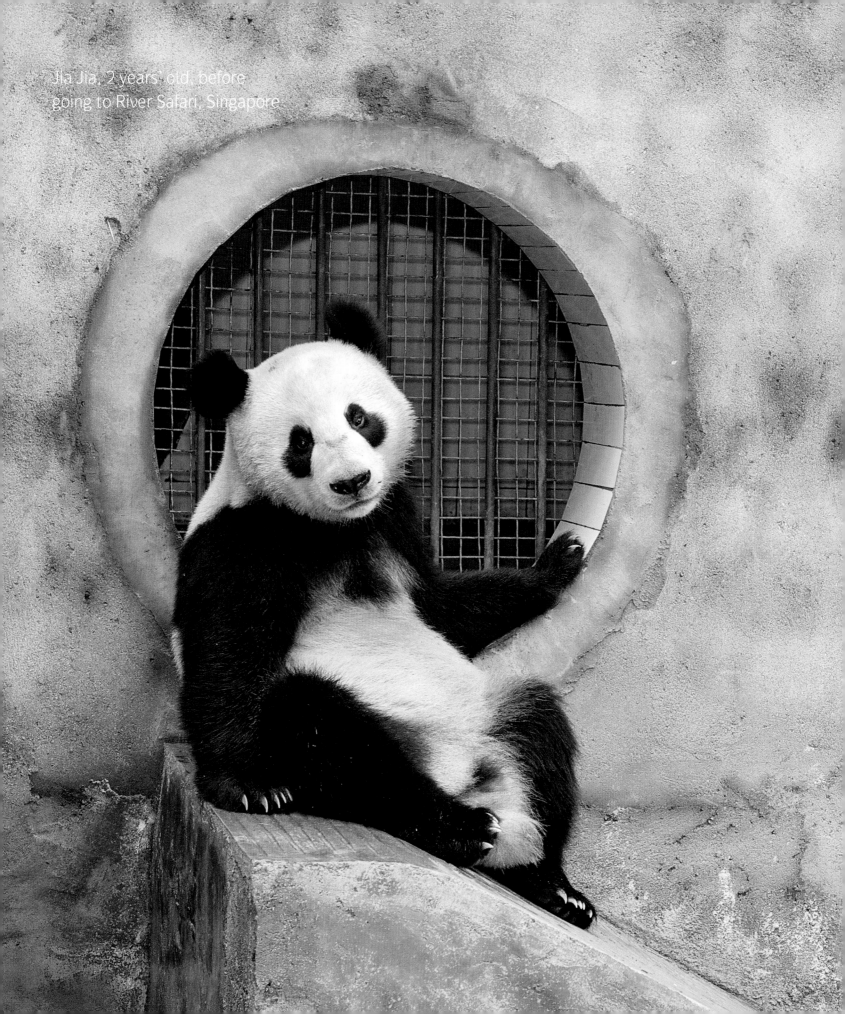

Jia Jia, 2 years' old, before
going to River Safari, Singapore

Introduction

Our fascination with giant pandas started back in 1988 during a visit to San Diego Zoo in California. The zoo broke all its records in serving 3.8 million visitors that year with the arrival of the pandas and the marketing hype surrounding these black and white idols.

We were like typical tourists queuing up patiently to satisfy our curiosity, and we spent more time waiting and reading the interpretation of pandas than having a real close-up observation of these endearing animals.

But having seen the two docile animals, we were fascinated with why the pandas could command such unmatched attention in diplomacy, conservation, and public interest.

It was not until 20 years later that we had a chance to encounter the pandas in Central China, researching the conservation challenges, and understanding the importance of preserving endangered species and their habitat in China.

Giant pandas are the most prominent and dominant conservation ambassadors on our planet. It is our hope that through these pages, we can share the general knowledge and understanding about pandas and their fragile habitat.

The world has thousands of species that are equally, if not more, endangered and we hope that this visual celebration of pandas will serve as a catalyst to spur additional successful conservation programmes to save native endangered wildlife. As our own small contribution, all our proceeds from the sales of this book will be donated to conservation causes.

A book about pandas would be incomplete without devoting space for the red panda and the other endangered animals in the panda habitat.

Apart from a handful of photos, the images for this book have been chosen from more than 10,000 photos taken during countless trips in different seasons in Sichuan province from 2008 to 2011.

It is our sincere wish that this visual celebration of giant pandas will bring delight and joy to you as well as shed some light on the mystery and aura of the silent and enigmatic black and white bears that have captivated us since we first set eyes on them.

Fanny & Bjorn

HISTORY

Map of China's Panda Habitat

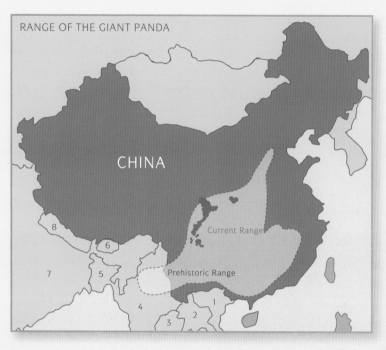

RANGE OF THE GIANT PANDA

CHINA

Current Range

Prehistoric Range

8
6
7
5
4
3 2 1

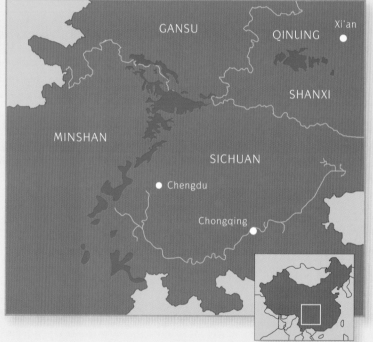

GANSU

QINLING

Xi'an

SHANXI

MINSHAN

SICHUAN

Chengdu

Chongqing

1 Vietnam

2 Laos

3 Thailand

4 Myanmar

5 Bangladesh

6 Bhutan

7 India

8 Nepal

Discovery and Culture

The indigenous Chinese knew of the existence of Giant pandas since early civilization. They were widely distributed all over China, and have had many regional names and references that were entirely different from the bears' model Chinese name – Da Xiong Mao 大熊猫.

Some of its ancient names are Pixiu 貔貅, Shi Tie Shou 食铁兽, Mo 貘, Mo 貊, White Bear 白熊, Bamboo Bear 竹熊 and Bear with Pattern 花熊.

Pixiu 貔貅 is a legendary brave animal. In Chinese history, it was recorded that four thousand years ago a tribe led by Huang Di 黄帝 deployed trained tigers, leopards, bears and Pixiu (giant pandas) to defeat his rivals. About three thousand years ago during the Zi Zhang 西周 period, Pixiu's hides were presented to the emperor together with tiger and leopard hides as royal gifts and as a symbol of victory.

Strangely however, the popular giant pandas are not frequently encountered in the long and colourful history of China.

Shi Tie Shou 食铁兽 was mentioned two thousand seven hundred years ago in Shan Hai Jing 山海经. It is a Chinese classic book rich in mythology, depicting the most ancient geography. Like a medieval wikipedia, it describes myth, magic, religion, ancient history, medicine, folk stories and many other aspects. In this classic text the giant pandas was described as bear-like animals with black and white fur, found in Sichuan. It also mentioned that they ate iron and bronze, hence the name Shi Tie Shou, which literally means an animal that eats metal.

More than two thousand years ago, the emperor of the Han dynasty kept nearly 40 exotic animals in his capital in Xi'an 西安 (known as Chan'an 长安 at the time) for his viewing and hunting pleasure. The Mo 貘 (giant panda) was one of his favourite animals.

In traditional Chinese medicine, established five hundred years ago, it was mentioned that panda hides were used as bedding to keep warm and would also keep away evil spirits. It stated that drinking the bear's urine mixed with water would dissolve any metal that had been wrongly ingested.

Strangely however, the popular giant pandas are not frequently encountered in the long and colourful history of China, in the same way that many other wild animals like tigers, leopards, deers, tortoises and wolves. It was only in the 1960s that the Giant Panda was declared a 'national treasure' in China.

Besides mystical animals such as the dragon or the phoenix, wildlife have been a popular subject illustrated in Chinese religion, cosmology and metaphysics, and also found in zodiac signs, feng shui, folklore, literature, tableware and many other objects. Why had the emperors, intellects and artisans chosen not to portray the giant pandas in their paintings and artworks?

It could be that its black and white colouring was an inauspicious colour associated with death and funerals for the Chinese. Or that its docile and contented character is not inspirational as a mythical hero or God, unlike the ferocious tiger and the aggressive fire-breathing dragon. Perhaps there were insufficient pandas for ancient Chinese to discover its 'medical' properties like the bear paws, tiger penises or rhino horns. Or simply that the intellects in the past did not spend enough time inside the forest of Western China to explore the wonders of the unknown.

The Giant Panda's rise to international super-stardom started only in 1869 when a French Catholic missionary, Armand David (1826-1900), sent the first skin of a young panda from the western part of Sichuan back to the Natural History Museum in Paris, and revealed the giant panda's existence to the 'western' world.

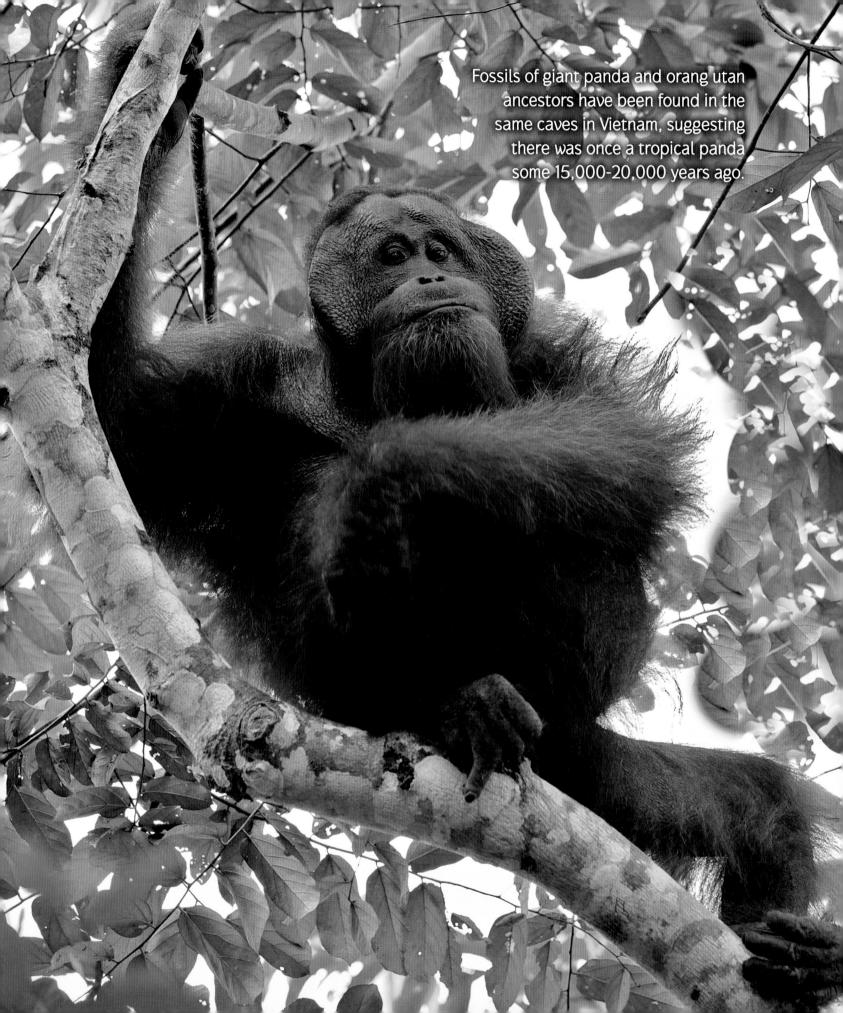

Fossils of giant panda and orang utan
ancestors have been found in the
same caves in Vietnam, suggesting
there was once a tropical panda
some 15,000-20,000 years ago.

The Panda and the Priest

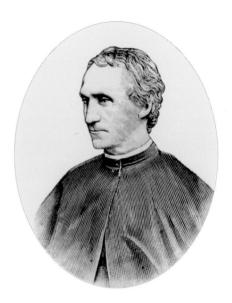

Père Jean-Pierre Armand David (1826-1900)

Père Jean Pierre Armand David (1826-1900)

Père Armand David was a French priest who travelled extensively in China to convert the populace to Catholicism, but found a greater calling and passion for nature. He arrived in China in 1862, but only during the second half of 1884 was he released from his Christian teaching work to become a full time explorer in the interior of the vast Chinese empire. Financially, he was supported by the Paris Natural History Museum and the Academy of Sciences in Paris.

David was a truly superb naturalist, with extensive knowledge of ornithology, zoology, and botany. At the same time he respected the culture of the local people no matter how foreign they may have seemed to him. It was this, and his gentle manner, that allowed him to travel to regions in China where foreigners in many cases had not been before.

His early collections of animal and plant specimens were overwhelming both in number and quality, but it was his careful documentation that made his contribution to the Paris Natural History Museum and Academy of Sciences so valuable.

His name will forever be linked with the giant panda, but scientists recognise him for the numerous other species that he brought to scientific attention during his travels in China, including the Chinese giant salamander, the golden monkey and the Père David Deer now extinct in the wild.

He travelled more than 7,000 miles, much of it on foot ,and it is estimated that he found more than 1,570 plants including 250 species new to the western world.

Ironically, Père Armand David eventually left China without ever seeing a living giant panda, and when he died at the old age of 74 in 1900 in Paris, there were still no foreigners who had seen a live panda.

The Giant Panda Race

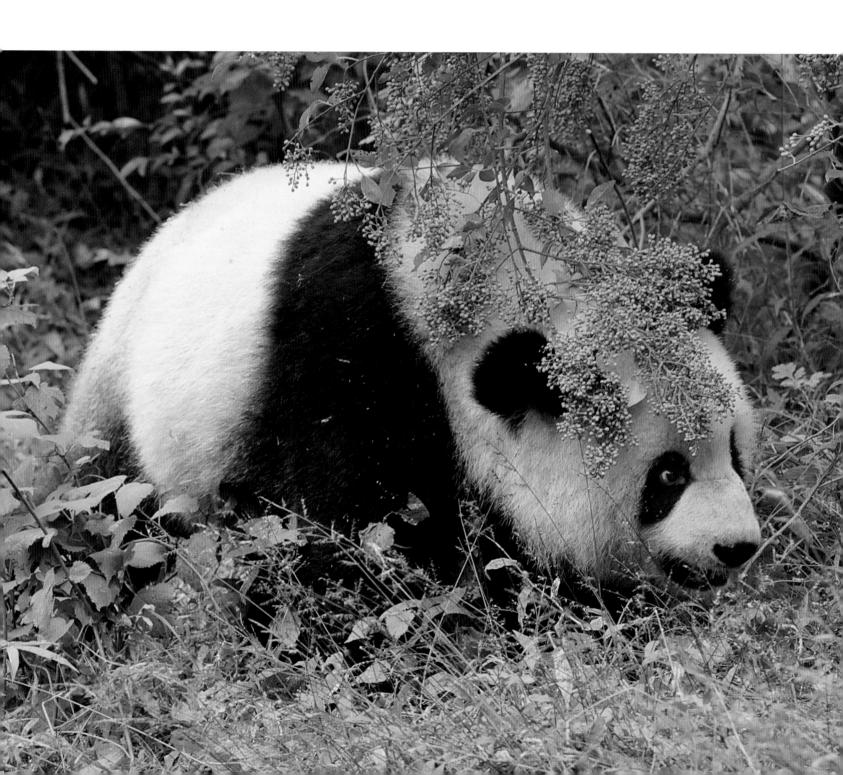

Despite numerous foreign expeditions into Western China and Tibet, it was not until 1916 that the first westerners saw a live panda, and another 14 years before the US President Theodore Roosevelt's sons, Kermit and Theodore Jr., had the dubious honour to be the first Westerners to kill a giant panda on an expedition funded by the Field Museum of Natural History in Chicago.

The next phase of fascination with the giant pandas occurred in the 1930s when the race to bring back a live panda began. The Brookfield Zoo in Chicago was the first American zoo to exhibit a giant panda. It was called Su Lin, caught as a cub in the wild and brought in by Ruth Harkness, described in the book *The Lady and the Panda*. More than 50,000 visitors came on the first day to see Su Lin, and the world's love affair with the charismatic black-and-white bear had just begun.

According to the *Smithsonian Book of Giant Pandas*, a total of 14 giant pandas arrived alive in western zoos between 1937 and 1946, but no one knows how many died en-route. None lived very long by modern standards, and there were no successful breeding efforts. The formation of the People's Republic of China in 1949 ended the export of giant pandas until a few animals went to Europe between 1957 and 1959. No more pandas were released to the 'West' until Richard Nixon, the US President, visited China in 1972, when the Chinese Government presented Ling Ling and Hsing Hsing to him to commemorate the historic visit. The pair was later housed in the National Zoo in Washington, DC.

In the 1980s, many zoos tried to get giant pandas for display, but China stopped giving them out and instead started a scheme with short-term exhibition loans. Soon the situation got out of hand, as these 'travelling' pandas were precluded from breeding, and one could seriously question how much these loans contributed to panda conservation.

In the 1990s, only a few panda loans were made, as a moratorium on the 'rent-a-panda-scheme' went into effect in 1993. This was to allow a re-evaluation of the conservation efforts and to make sure that all loans complied with the Convention on International Trade in Endangered Species (CITES) and the Endangered Species Act. It was a policy recommended by the World Wildlife Fund (WWF) that all loans must not be detrimental to the pandas in the wild, must enhance the conservation of wild pandas, and must not be primarily for commercial purposes, a position that made lots of sense, and was difficult to argue against.

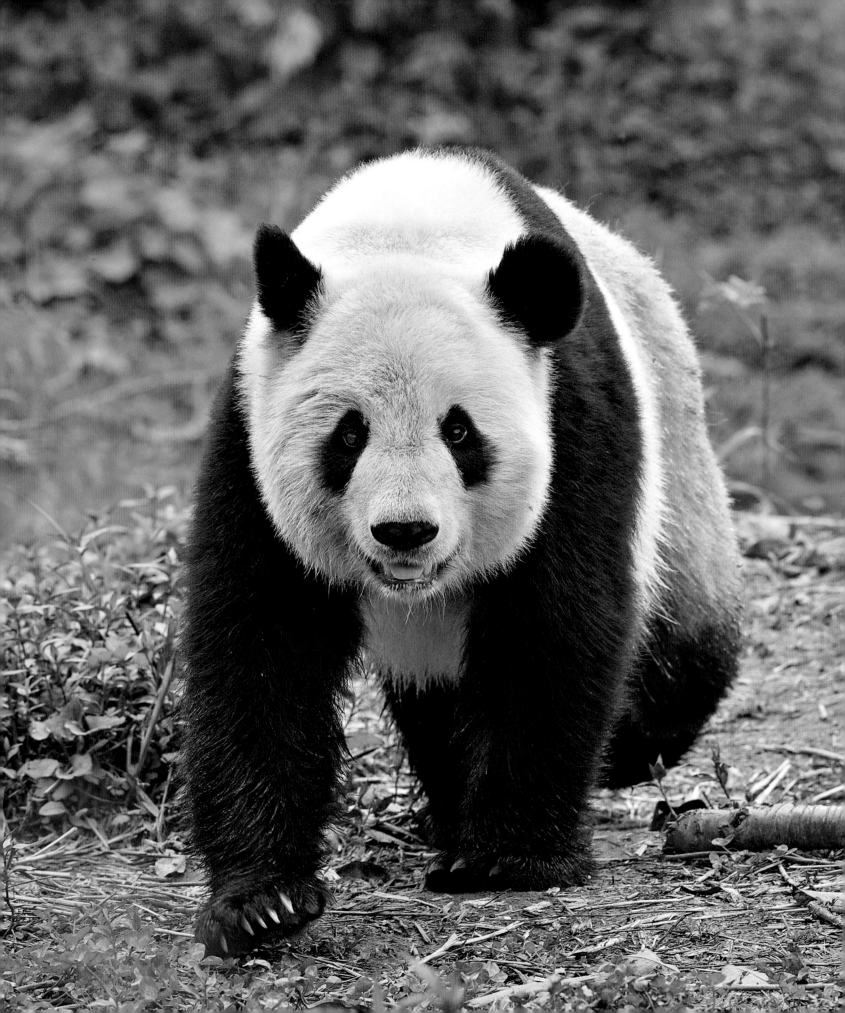

The 'Pandaplomacy' Story

Gift-giving is layered with nuances and meaning in Chinese culture. Not only is the choice of gift important in Chinese tradition, its value has to be commensurate with the occasion and status of the recipient. If the gift is too lavish, it will come across as bribery and inappropriate. One also has to consider its symbolic meaning, timing and occasion of presentation, the rank of the presenter to enhance the value of the gift, and further, the recipient must be of an equivalent rank to reciprocate a sense of respect.

Chinese leaders have a long history in presenting giant pandas to other countries to strengthen diplomatic relationships.

In recent decades, when China has decided to present the giant panda as a diplomatic gift, it will mandate the recipients to a donation of ten million US dollars for the loan of a pair of pandas for ten years of research. The donation is to assist giant panda in-situ conservation and research projects in China.

Most of the countries have followed the request, while a few have succeeded in getting the animals with marginally reduced contributions.

Below are some of the important dates:

BC *Pandas were kept in the emperor's garden in Chang'an during Western Han Dynasty*

685 *Empress Wu Zetian 武则天 (625 – 705) dispatched a pair of pandas to the Japanese emperor during the Zhou Dynasty.*

1869 W *French Catholic missionary Père Armand David sent the first panda specimen of skin and bones back to the Paris Natural History Museum.*

1916 *German zoologist Hugo Weigold, the first westerner known to have seen a living giant panda, purchased a cub in 1916.*

1929 *USA President Theodore Roosevelt's sons Kermit and Theodore Jr. had the dubious honour to be the first foreigners to kill a giant panda.*

1937 *Brookfield Zoo, Chicago was the first USA zoo to exhibit a giant panda. Su Lin 苏琳 mistaken as female, attracted 53,000 visitors on the busiest day. Unfortunately, he only lived for one year. Brookfield Zoo received two more pandas: Mei Mei 梅梅 (1938 – 1942) and Mei Lan 美兰 (1939 – 1953).*

1938 *Bronx Zoo in New York, USA, displayed their first giant panda, Pandora 潘多拉 (1938 – 1941). The zoo subsequently displayed five more pandas until 1987, including Pan Dee 潘弟 and Pan Dah 潘達, a gift from Madame Chiang Kaishek.*

1938 *6 giant pandas were captured in the wild in Sichuan Province and shipped from Shanghai to the United Kingdom. Five pandas arrived in London on December 24, 1938. One panda died from internal lesions during transportation and another one named Grandma 奶奶 died in the quarantine station of London Zoo. The remaining four were named Tang 唐 (1938 – 1940), Sung 宋 (1938 – 1939) Ming 明 (1938 – 1944) and Happy 乐乐 (1938 – 1939). The zoo continued to acquire 7 more pandas in the next five decades until 1993.*

1939 *'Happy' 乐乐 went on tour in Germany from Berlin Zoo, Hannover Zoo, Munich Zoo, Leipzig Zoo to Cologne Zoo and Paris Zoo in France for quick display visits of one or two weeks. It was eventually sold to St. Louis Zoo in USA and died there 7 years later.*

1957 Moscow Zoo, USSR received its first giant panda, Ping Ping 平平 (1957 – 1961), a male from Beijing Zoo as a goodwill gift. They continued to display four more pandas until 2001.

1958 Austrian animal dealer Heini Demmer exchanged three giraffes, two rhinos, as well as hippos and zebras with the Beijing Zoo for the panda Chi Chi 姬姬. She toured to Frankfurt Zoo, Copenhagen Zoo, Tierpark Berlin and was eventually sold to the London Zoo. She went on a mating trip with An An in Moscow Zoo from March 11 until October 17, 1966, but without success and died on July 22, 1972 at London Zoo.

1961 The World Wildlife Fund (WWF) was created with the giant panda as their logo, now the world's most famous nature conservation logo.

1965 Pyongyang Central Zoo, North Korea received a pair of pandas from China: Dan Dan 丹丹 and San Xing 三星. In total, China has sent five pandas to North Korea.

1971 Ueno Zoo, Tokyo, Japan's Premier Kakuei Tanaka received a goodwill gift from the Chinese government, Lan Lan 兰兰 and Kang Kang 康康. In total Ueno Zoo has kept 9 giant pandas.

1972 National Zoo in USA received Ling Ling 玲玲 and Hsing Hsing 兴兴 as a diplomatic goodwill gift from the Chinese Government to the US President, Richard Nixon.

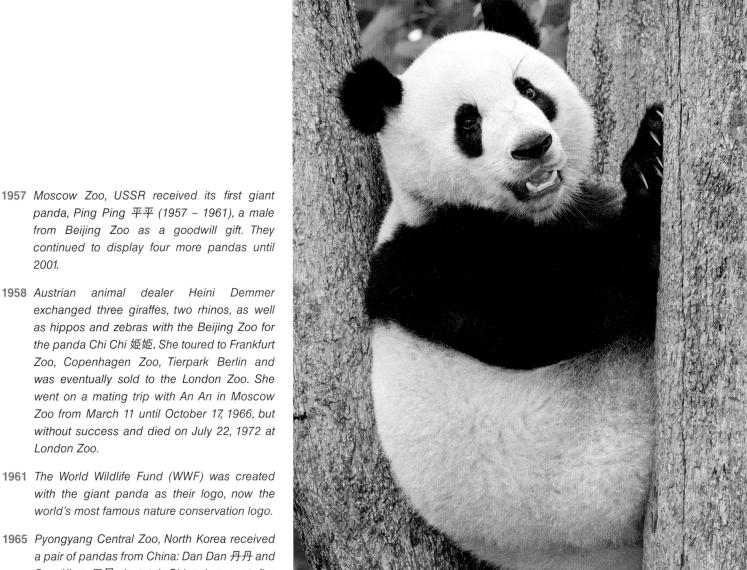

Giant pandas were kept in the emperor's garden in Chang'an during the Western Han Dynasty more than two thousand years ago

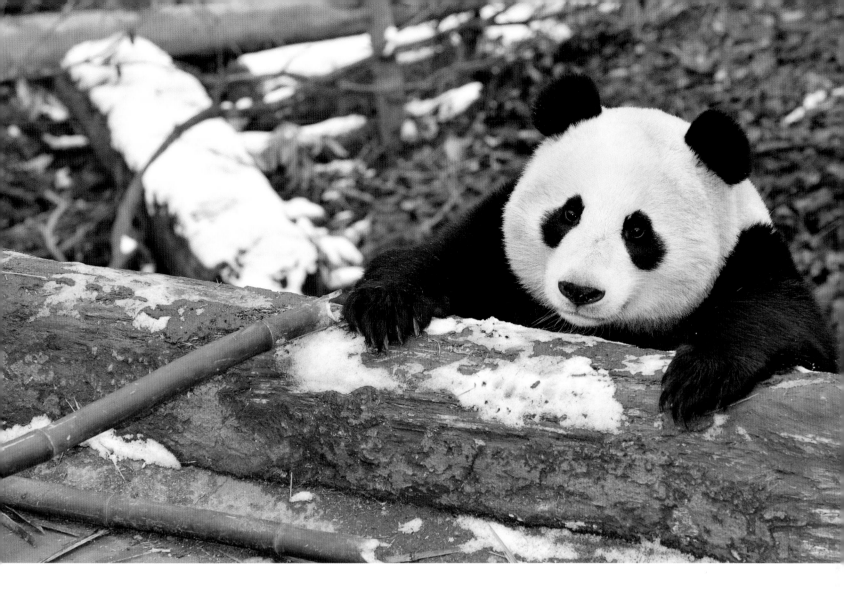

1973 *The French President George Pompidou received a goodwill gift from the Chinese Government: Yen Yen 燕燕 & Li Li 黎黎 . The latter died in 1974, but Yen Yen became the biggest star in Zoo de Vincennes until his death in 2000. A mistake was made when this panda 'pair' was chosen, as they were both males.*

1975 *Chapultepec Zoo in Mexico received a pair of giant pandas, Pe Pe 贝贝 and Ying Ying 迎迎 donated by the Chinese government.*

1978 *The King of Spain, Juan Carlos received Shao Shao 紹紹 and Chang Chang 強强 from China.*

1980 *Berlin Zoo, Germany received Bao Bao 宝宝 (male) and Tjen Tjen 添添 (female) as a gift from the Chinese Premier Hua Guofeng to the German Bundeskanzler Helmut Schmidt. These pandas did not mate. Bao Bao, born in 1978, is the oldest male panda in captivity and the oldest panda outside of China.*

1980's In the 80's, China allowed the touring of giant pandas abroad for a fee under the Shanghai and Wuhan Circus. They toured 13 countries and were kept in 24 different places for an average stay of 6-9 months. They visited Fukuoka Zoo, Ideda Zoo, Hakodate Zoo, Kofu Zoo in Japan; Los Angeles Zoo, San Francisco Zoo, Busch Gardens Tampa Bay, Toledo Zoo, Cincinnati Zoo, and Columbus Zoo in the USA; Toronto Zoo, Calgary Zoo, and Assiniboine Park Zoo in Canada; Parken Zoo in Sweden, Dublin Zoo in Ireland, Safaripark Beekse Bergen in Holland, Zoo van Antwerpen in Belgium, Melbourne Zoo, and Taronga Zoo in Australia; Auckland Zoo in New Zealand; Safariworld in Thailand; roadshows in Indonesia, and Singapore Zoo in Singapore.

1994 Adventure World Wakayama, Japan was the first to get a pair of giant pandas on a long-term breeding loan, when they received Ei Mei 永明 and You Hin 阳浜. Adventure World has an excellent breeding record: Rau Hin 良浜 born in 2000, Yu Hin 雄浜 2001, Ryu Hin 隆浜 and Shu Hin 秋浜 2003 (first surviving twins outside China), Kou Hin 幸浜 2005, Ai Hin 爱浜 & Mei Hin 梅浜 2006, Mei Hin 梅浜 & Ei Hin 永浜 2008, and Kai Hin 海浜 & You Hin 阳浜 2010. Twins were again born in 2012 with only one surviving cub. They have a total of 9 pandas making it the largest population outside of China.

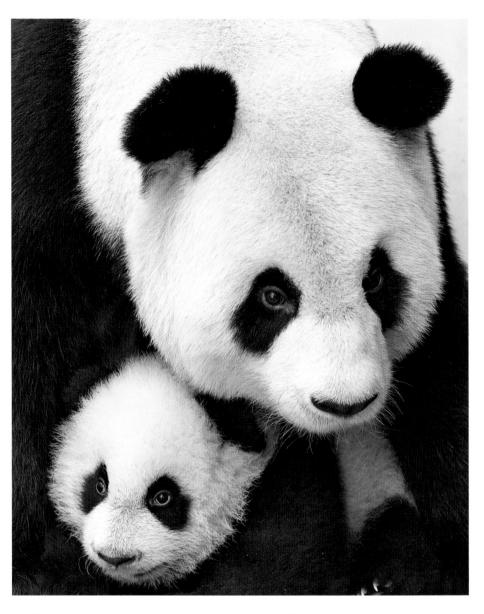

As with humans, the time a cub spends with its mother is one of the most important periods of its life. The mother shows the cub how to avoid danger, look for tasty bamboo - survival skills a young cub needs for life.

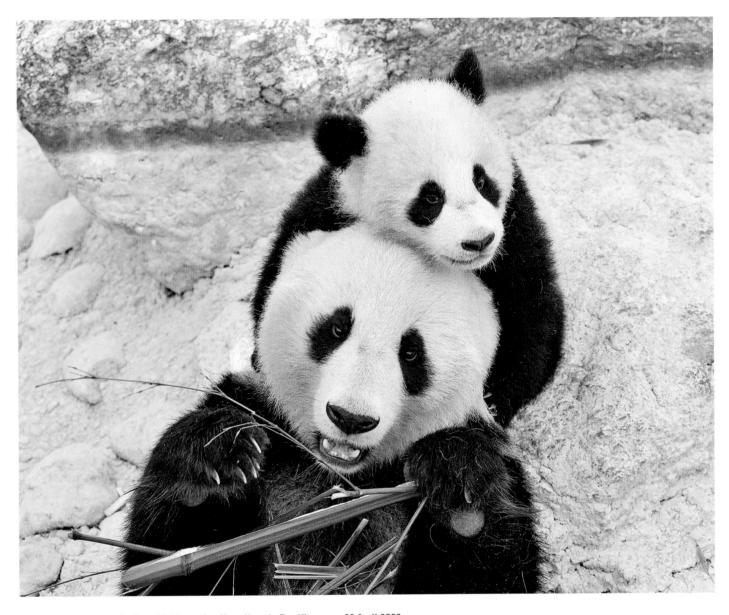

8 months old Fu Long playing with his mother Yang Yang in Zoo Vienna on 28 April 2008.

1996 *San Diego Zoo, USA received Bai Yun 白云 and Shi Shi 石石. Bai Yun is the mother of Hua Mei 华美, Mei Sheng 美生, Su Lin 苏琳, Zhen Zhen 珍珍, and Yun Zi 云子.*

1999 *Zoo Atlanta, USA received their first giant panda pair: Lun Lun 伦伦 and Yang Yang 洋洋, who had their first offspring Mei Lan 美兰 in 2006, and later Xi Lan 喜兰 in 2008, and Po 阿波 in 2010.*

1999 *Ocean Park, Hong Kong received An An 安安 and Jia Jia 佳佳 from the central government of China to mark the 10th anniversary of Hong Kong's return to Chinese sovereignty, two more pandas were given to the park, Le Le 乐乐 and Ying Ying 盈盈.*

2000 *Kobe Oji Zoo, Japan received Tan Tan 旦旦 and Ko Ko 兴兴. In 2010 Ko Ko tragically died while under anaesthetic.*

2000 *National Zoo, USA received Mei Xiang 美香 and Tian Tian 添添, who gave birth to Tai Shan 泰山 in 2005.*

2003 *Chiang Mai Zoo in Thailand received a pair of giant pandas, Chuang Chuang 创创 and Lin Hui 林惠. They gave birth to Lin Ping 林冰 in 2009.*

2003 *Memphis Zoo, USA received Ya Ya 丫丫 and Le Le 乐乐.*

2003 *Zoo Vienna, Austria, the oldest zoo in the world, received Yang Yang 阳阳 and Long Hui 龙徽. They got their first baby Fu Long 福龙 in August 2007 and exactly three years later in 2010 their second baby Fu Hu 福虎 meaning 'lucky tiger' was born. This was the first panda baby in an European Zoo that was not conceived through artificial insemination!*

2007 *Bing Xing 冰星 and Hua Zui Ba 花嘴巴 arrived in Zoo Madrid, Spain. The mother Hua Zui Ba sensationally gave birth to male twins in September 2010. The twins were named Po 宝 and De De 德德.*

2008 *Taipei Zoo, Taiwan received a pair of giant pandas named Tuan Tuan 团团 and Yuan Yuan 圆圆. Tuanyuan means "reunion". It created a strong debate about whether the pandas symbolised the consideration of reunification of the two nations.*

2009 *Adelaide Zoo, Australia finally received pandas Wang Wang 网网 and Funi 福妮, presented by China's President Hu Jintao to Prime Minister John Howard during Australia's Apec meeting in Sydney in 2007.*

2010 *On the 10th anniversary of the founding of the Macau Special Administrative Region (SAR), it received a pair of Giant Pandas from the Central People's Government. They were named Hoi Hoi 开开 and Sam Sam 心心, which means happiness and joy.*

2011 *Ueno Zoo, Japan received Xian Nu 仙女 and Bi Li 比力 from Bifengxia Panda Base. The pair was first shown to the public on April 1st, when 21,886 people visited Ueno Zoo! The pair has been renamed Shin Shin 真真 and Ri Ri 力力 and they became the proud parents of a male cub in July 2012. Unfortunately, the cub died a week after birth.*

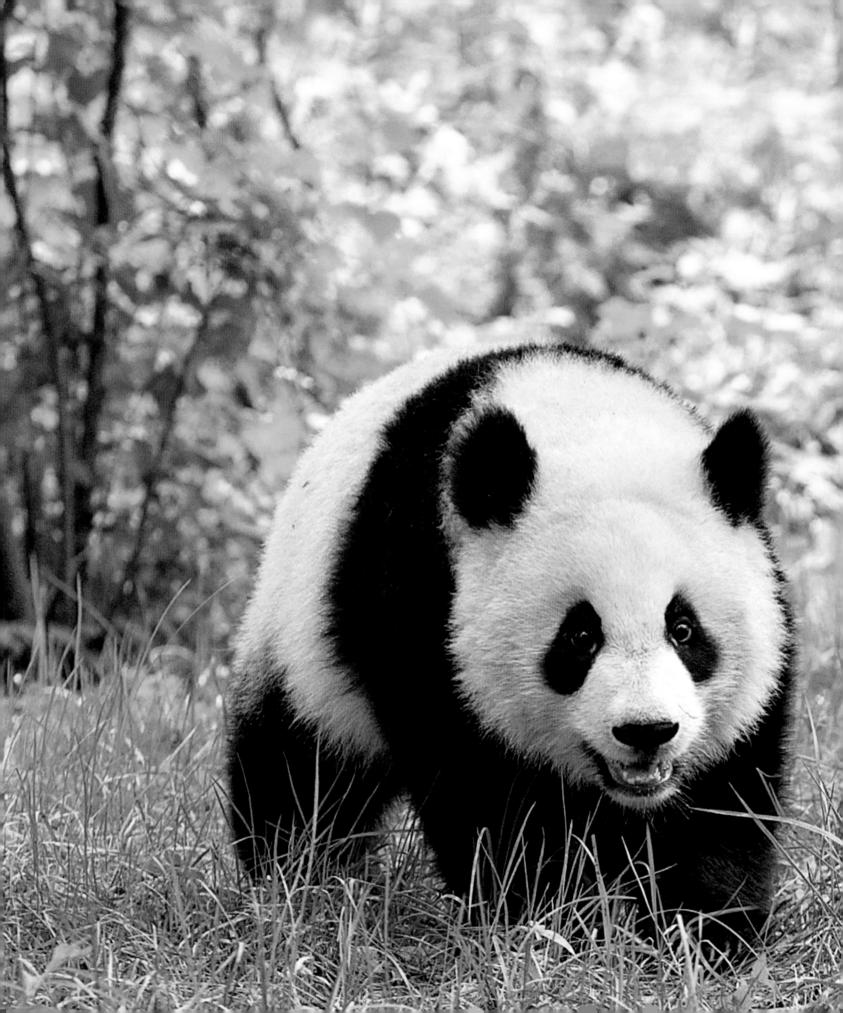

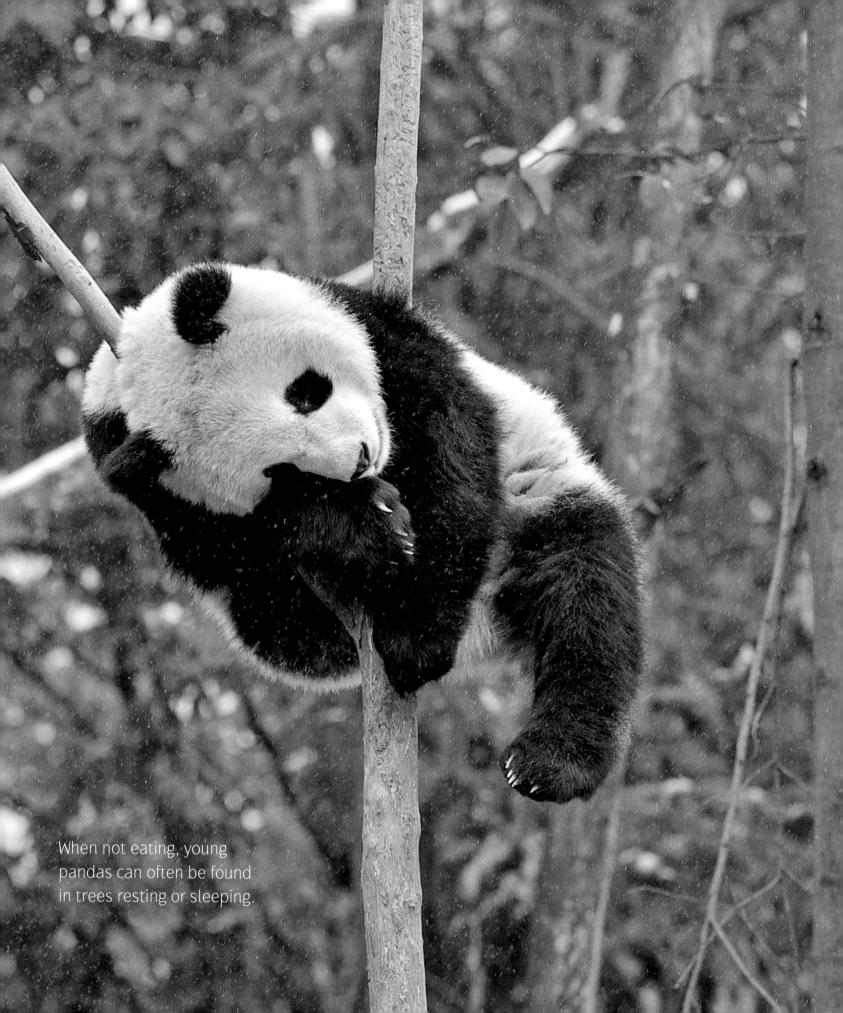

When not eating, young pandas can often be found in trees resting or sleeping.

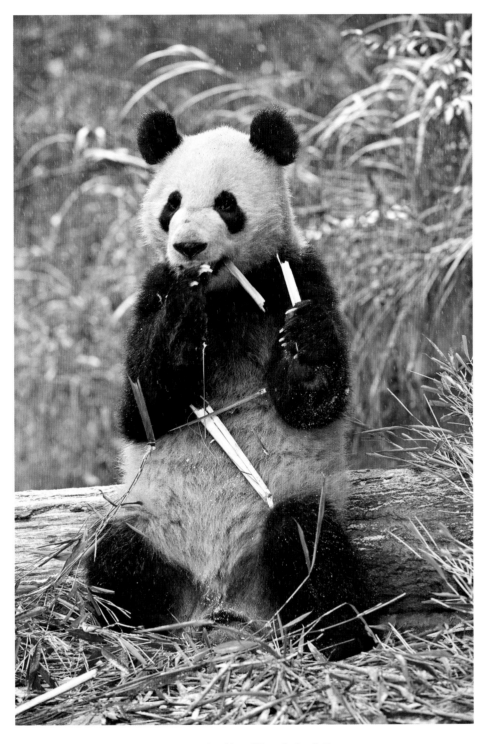

**Kai Kai shown here is 3 years and four months old, at Bifengxia Panda Base.
He is now at River Safari, Singapore.**

2011 *In December, Edinburgh Zoo, UK received Tian Tian 甜甜 and Yang Guang 阳光 under an agreement between Royal Zoological Society of Scotland and Chinese Wildlife Conservation Association. Tian Tian was voted the female face of December 2011 by BBC.*

2011 *The world's oldest panda, Ming Ming 明明, died at age 34 in China's Long Xiang Jiang Safari Park.*

2012 *ZooParc de Beauval, France received Huan Huan 欢欢 and Yuan Zi 圆仔 from Chengdu Panda base.*

2012 *Toronto Zoo in Canada announced that they will receive a pair of giant pandas in Spring 2013 for a minimum period of 5 years, after which time the pandas will relocate to Calgary Zoo.*

2012 *Bao Bao 宝宝, from Zoo Berlin, died on 22nd August at the age of 34. He was the oldest panda in the world outside China, and was one of the main attractions of Zoo Berlin since his arrival there in 1980.*

2012 *In September, River Safari, Singapore received Kai Kai 凯凯 and Jia Jia 嘉嘉 from Bifengxia Panda Base.*

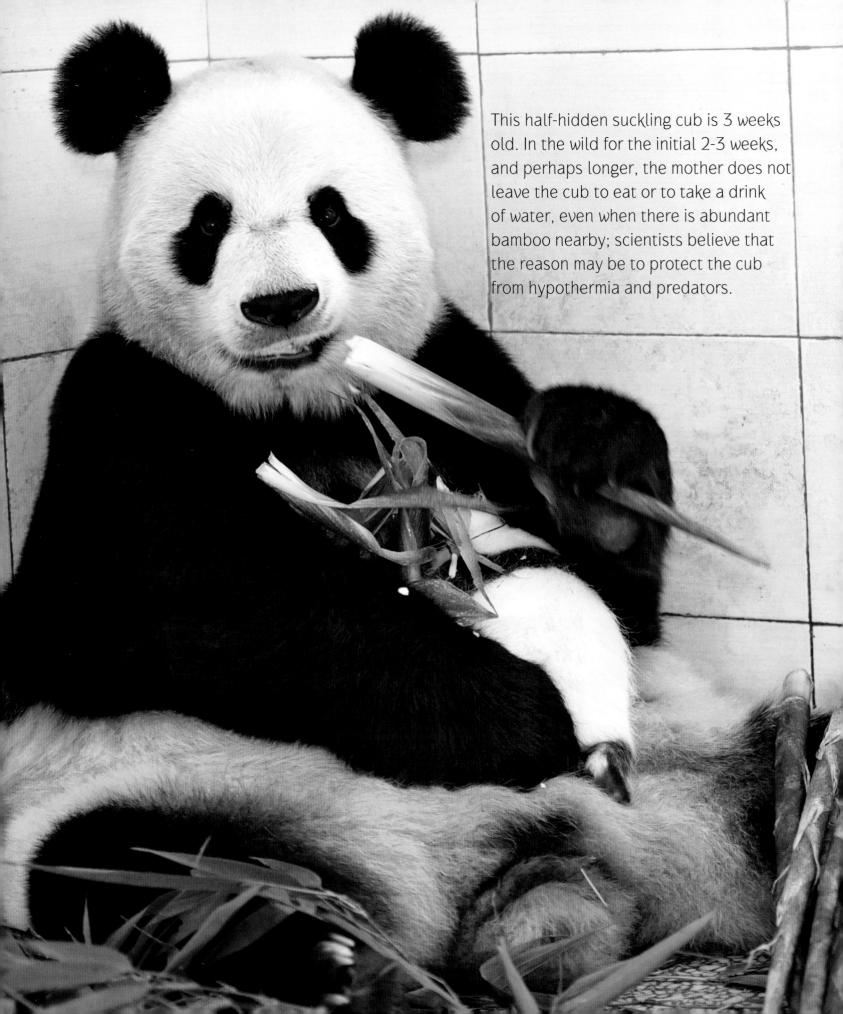

This half-hidden suckling cub is 3 weeks old. In the wild for the initial 2-3 weeks, and perhaps longer, the mother does not leave the cub to eat or to take a drink of water, even when there is abundant bamboo nearby; scientists believe that the reason may be to protect the cub from hypothermia and predators.

Milestones in Zoos

As of early September 2012, there were 47 giant pandas living in 16 zoos outside China: in the United States of America, Mexico, Austria, Spain, Japan, Thailand, Taiwan, Australia, the United Kingdom, France and Singapore. 16 of these 44 pandas have been bred in zoos. For pandas that are on loan from China, all the offspring will belong to China, and the zoos are only allowed to keep the young for a maximum period of two years. The zoo may keep the young for ten years if they donate six million US dollars to China for conservation purposes. Most of the zoos keep their captive-born offspring because of popular demand, often breaking their visitor records in the process.

Through the tracking of all giant pandas living in zoos and breeding centers, scientists have learned invaluable details about the biology of pandas. Zoo managers maintain the International Studbook for Giant Pandas, published yearly by the Chinese Association of Zoological Parks in cooperation with the International Species Inventory System (ISIS).

In the studbook, giant pandas are individually numbered and through their permanently implanted transponders can be accurately tracked.

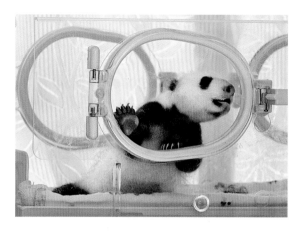

At the age of 15 to 30 days, black patterns begin to show, and at 30 days they start looking like the pandas we know.

For pandas that are on loan from China, all the offspring will belong to China, and the zoos are only allowed to keep the young for a maximum period of two years.

A panda takes time to rest and digest before continuing the labour of eating up to 25 kg of fibrous bamboo in a day.

47 Giant Pandas in 11 countries outside of China

	Names	Date and Place of Birth	Zoos outside of China
1	Xiu Hua	June 25, 1985 in Mexico City, Mexico	Chapultepec Zoo, Mexico since June 25, 1985
2	Shuan Shuan	June 15, 1987 in Mexico City, Mexico	Chapultepec Zoo, Mexico since June 15, 1987
3	Xin Xin	July 1, 1990 in Mexico City, Mexico	Chapultepec Zoo, Mexico since July 1, 1990
4	Ei Mei	September 14, 1992 in Beijing, China	Adventure World, Japan since September 6, 1994
5	Bai Yun	September 7, 1991 in Wolong, China	San Diego Zoo, USA since September 10, 1996
6	Yang Yang	September 9, 1997 in Chengdu, China	Zoo Atlanta, USA since November 5, 1999
7	Lun Lun	August 25, 1997 in Chengdu, China	Zoo Atlanta, USA since November 5, 1999
8	Tan Tan	September 16, 1995 in Wolong, China	Kobe Oji Zoo, Japan since July 16, 2000
9	Rau Hin	September 6, 2000 in Shirahama, Japan	Adventure World, Japan since September 6, 2000
10	Tian Tian	August 27, 1997 in Wolong, China	National Zoo, USA since December 6, 2000
11	Mei Xiang	July 22, 1998 in Wolong, China	National Zoo USA since December 6, 2000
12	Gao Gao	Estimated in 1992 in the wild, China	San Diego Zoo USA since January 15, 2003
13	Yang Yang	August 10, 2000 in Wolong, China	Zoo Vienna, Austria since March 14, 2003
14	Long Hui	September 26, 2000 in Wolong, China	Zoo Vienna, Austria since March 14, 2003
15	Le Le	July 18, 1998 in ChongQing, China	Memphis Zoo, USA since April 7, 2003
16	Ya Ya	August 3, 2000 in Beijing, China	Memphis Zoo USA since April 7, 2003
17	Chuang Chuang	August 6, 2000 in Wolong, China	Chiang Mai Zoo, Thailand since October 12, 2003
18	Lin Hui	September 28, 2001 in Wolong, China	Chiang Mai Zoo, Thailand since October 12, 2003
19,20	Ai Hin & Mei Hin (twins)	December 23, 2006 in Shirahama, Japan	Adventure World since December 23, 2006
21	Bing Xing	September 1, 2000 in Chengdu, China	Zoo Madrid, Spain since September 7, 2007
22	Hua Zuiba	September 16, 2003 in Chengdu, China	Zoo Madrid, Spain since September 7, 2007
23	Xi Lan	August 30, 2008 in Atlanta, USA	Zoo Atlanta, USA since August 30, 2008
24, 25	Mei Hin & Ei Hin (twins)	September 13, 2008 in Shirahama, Japan	Adventure World since September 13, 2008
26	Tuan Tuan	September 1, 2004 in Wolong, China	Taipei Zoo since December 23, 2008
27	Yuan Yuan	August 30, 2004 in Wolong, China	Taipei Zoo since December 23, 2008
28	Lin Ping	May 27, 2009 in Chiang Mai, Thailand	Chiang Mai Zoo, Thailand since May 27, 2009
29	Yun Zi	August 5, 2009 in San Diego, USA	San Diego Zoo, USA since August 5, 2009
30	Wang Wang	August 31, 2005 in Wolong, China	Adelaide Zoo since November 28, 2009
31	Funi	August 23, 2006 in Wolong, China	Adelaide Zoo since November 28, 2009
32,33	Kai Hin & You Hin	August 11, 2010 in Shirahama, Japan	Adventure World since August 11, 2010
34	Fu Hu	August 23, 2010 in Vienna, Austria	Zoo Vienna, Austria since August 23, 2010
35,36	Po & De De	September 7, 2010 in Madrid, Spain	Zoo Madrid, Spain since September 7, 2010
37	Po	November 3, 2010 in Atlanta, USA	Zoo Atlanta, USA since November 3, 2010
38	Ri Ri	August 16, 2005 in Wolong, China	Ueno Zoo since February 21, 2011
39	Shin Shin	July 7, 2005 in Wolong, China.	Ueno Zoo since February 21, 2011
40	Tian Tian	August, 2003 at Bifengxia, Ya-an, China	Edinburgh Zoo since 4 December 2001
41	Yang Guang	August, 2003 at breeding centre in Mongolia, China	Edinburgh Zoo since 4 December 2011
42	Huan Huan	August 10, 2008 at the Chengdu Panda Base	ZooParc de Beauval, France since 15 January, 2012
43	Yuan Zi	September 6, 2008 at the Chengdu Panda Base	ZooParc de Beauval, France since 15 January, 2012
44	New-born cub	July 27, 2012 at the San Diego Zoo	San Diego Zoo USA since July 27, 2012
45	New-born cub	August 10, 2012 at Shirahama, Japan	Adventure World since August 10, 2012
46	Kai Kai	September 14, 2007 at Bifengxia, Ya-an, China	Singapore Zoo since September 6, 2012
47	Jia Jia	September 3, 2008 at Bifengxia, Ya-an, China	Singapore Zoo since September 6, 2012

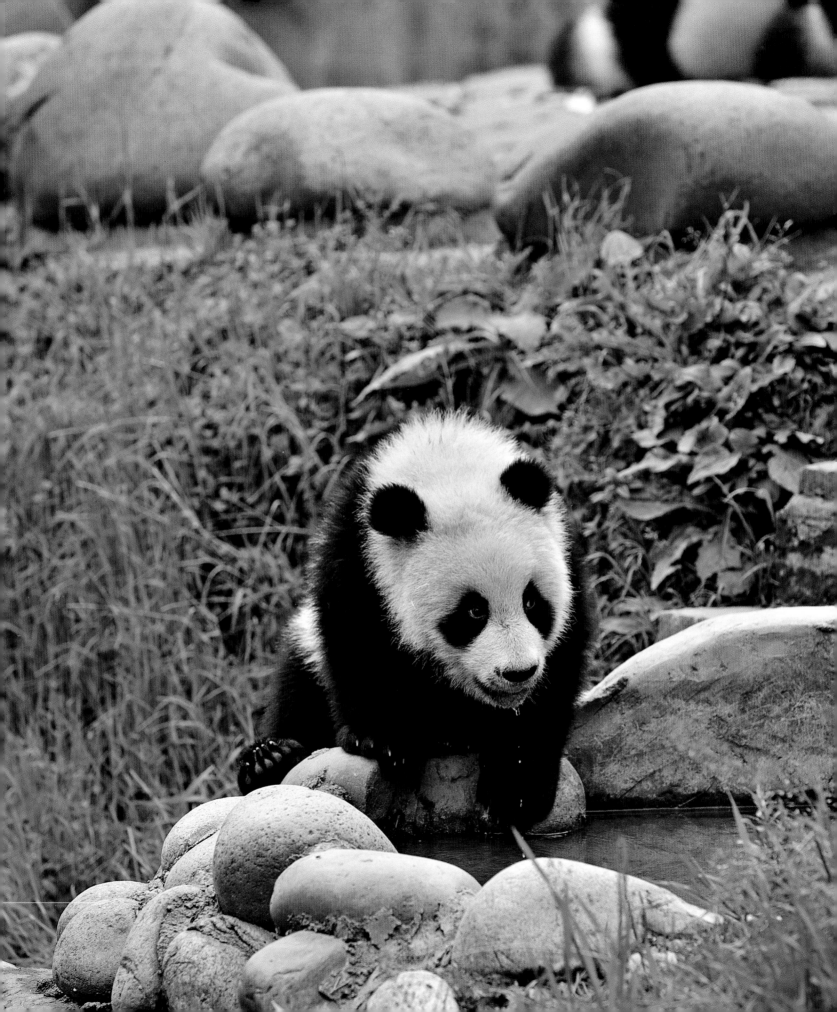

Generally, there is no shortage of water in the pandas' habitat, and normally they need to drink every day. Actually they love water; even at the coldest time in winter they seek flowing water, and they may travel comparatively long distances to lower parts of the mountain to get drinking water. Their preference for water is also reflected in their fondness for bathing and swimming - they are good swimmers, and in the wild they have been observed crossing rapidly flowing torrents. A panda drinks silently, bringing its lips close to the water so it can suck it up.

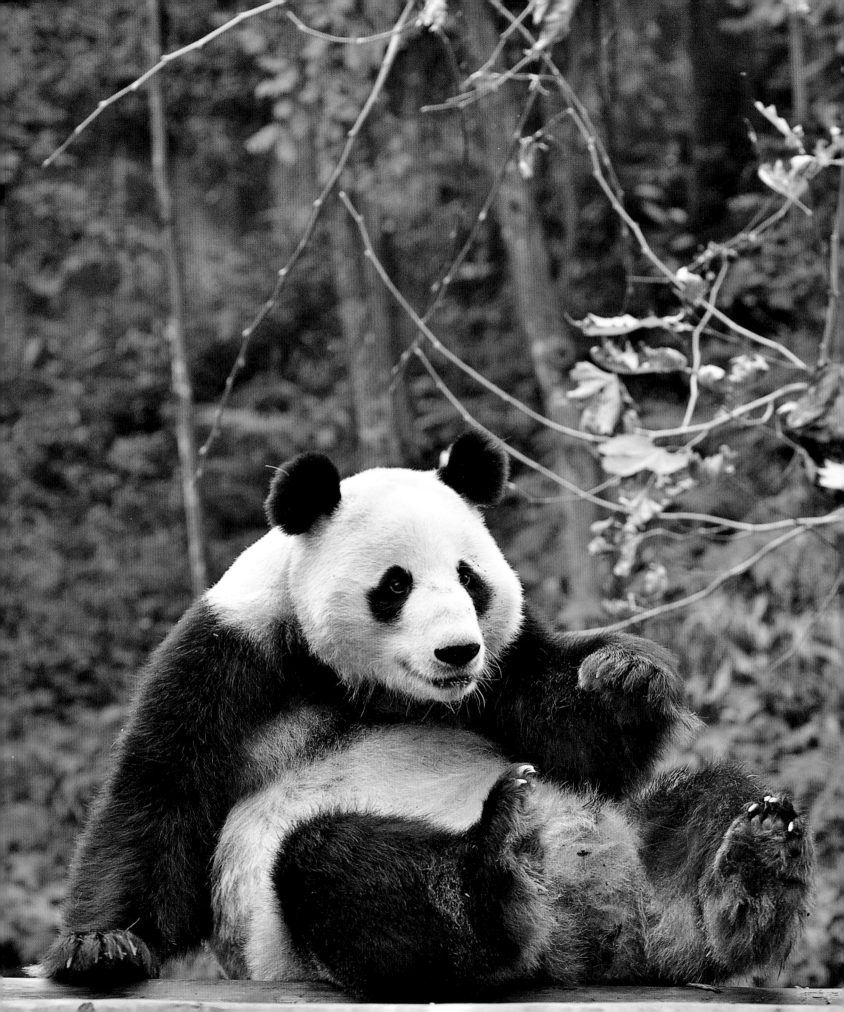

Why is the Panda so Iconic?

One of the key events that elevated the giant pandas to superstar status was back in 1961 when the World Wildlife Fund (WWF) created their giant panda logo, the same year they were founded. Scottish naturalist Gerald Waterson made the preliminary sketches, from which Sir Peter Scott, the world-renowned wildlife conservationist and painter, designed the final WWF giant panda logo. Although the logo has evolved since then, the giant panda's distinctive features remain the integral part of WWF's treasured and unmistakable symbol, which has become one of the most recognised trademarks that has ever been devised.

Soon after, in 1963, a set of Chinese panda stamps by the famous Chinese artist Wu Zuoren appeared.

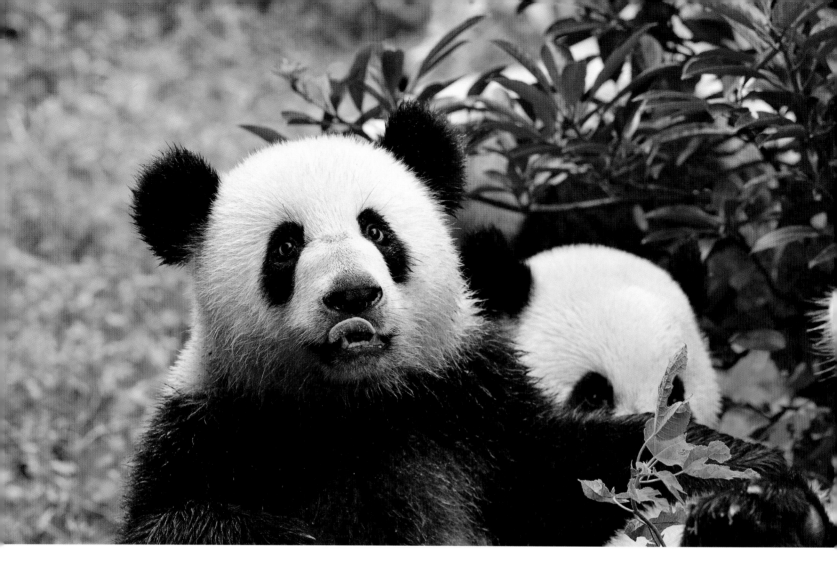

Without doubt the giant pandas are strikingly marked with black ears,
large black eye patches with the nose on a white furred head and neck.

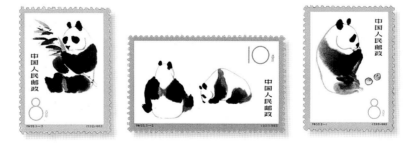

Panda stamps by the famous Chinese artist Wu Zuoren.

There are several reasons for the cult status of the giant panda. Pandas have features that are similar to humans including the flat face, and when sitting upright, they also look like an infant with the appearance of softness, a round outline, and large eyes in a disproportionately large head. The black rings surrounding the panda's eyes have accentuated and enlarged the size of the eyes. They have opposable thumbs to grab objects, which is a unique feature to primates, apes and humans. This roly-poly animal, with stout legs and a short tail, is unique among bears.

In zoos, the more popular animals also tend to be black, white or black and white such as the black panthers, gorillas, penguins, polar bears, white tigers, zebras plus the giant pandas. The striking black and white markings, their apparent clumsiness, and being seemingly harmless to people, are all something that people like.

The famous panda Jing Jing 晶晶, born in the Chengdu Research Base for Giant Panda Breeding, was also one of the chosen mascots for the 2008 Beijing Olympic Games.

Understandably, having commanded such huge conservation donations, giant pandas are treated like royalty in zoos. No other zoo animals enjoy such customised and lavish exhibits, or get as much attention focused on satisfying their every need. "Pandarazzi" cover their every move, just like paparazzi following the most popular celebrities around the world.

At Beijing Zoo the iconic giant panda comes in many colours and sizes!

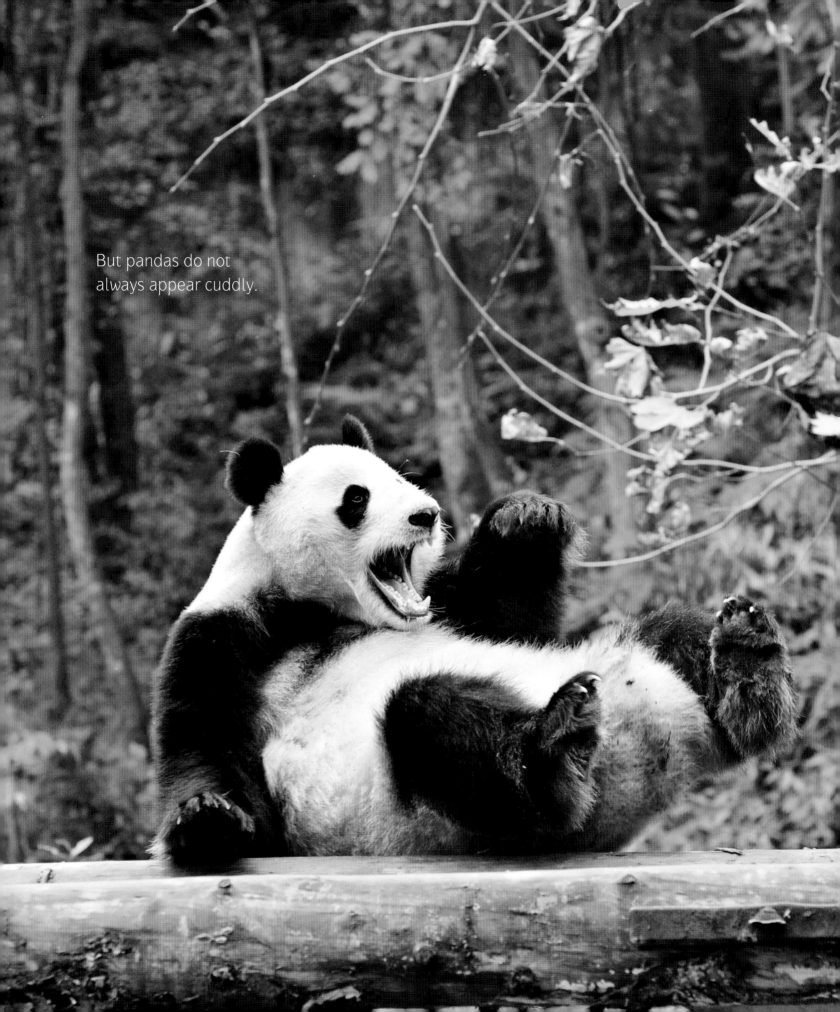

But pandas do not always appear cuddly.

Pandas are a source of continued fascination for all age groups.

Committees are organised to count down and welcome their arrival with detailed plans for public relations, marketing, operations, diplomatic and community events.

In 2008, the blockbuster Oscar-nominated animation film 'Kung Fu Panda' added to the popularity of the iconic black and white bear. The film received favourable reviews from critics and the movie-going public including Chinese audiences. A popular sequel 'Kung Fu Panda 2' was released on 26 May 2011 by DreamWorks Animation. Not surprisingly, 'Kung Fu Panda 3' is set to be released in 2016. It is probably safe to say that the giant panda is the greatest icon of conservation today.

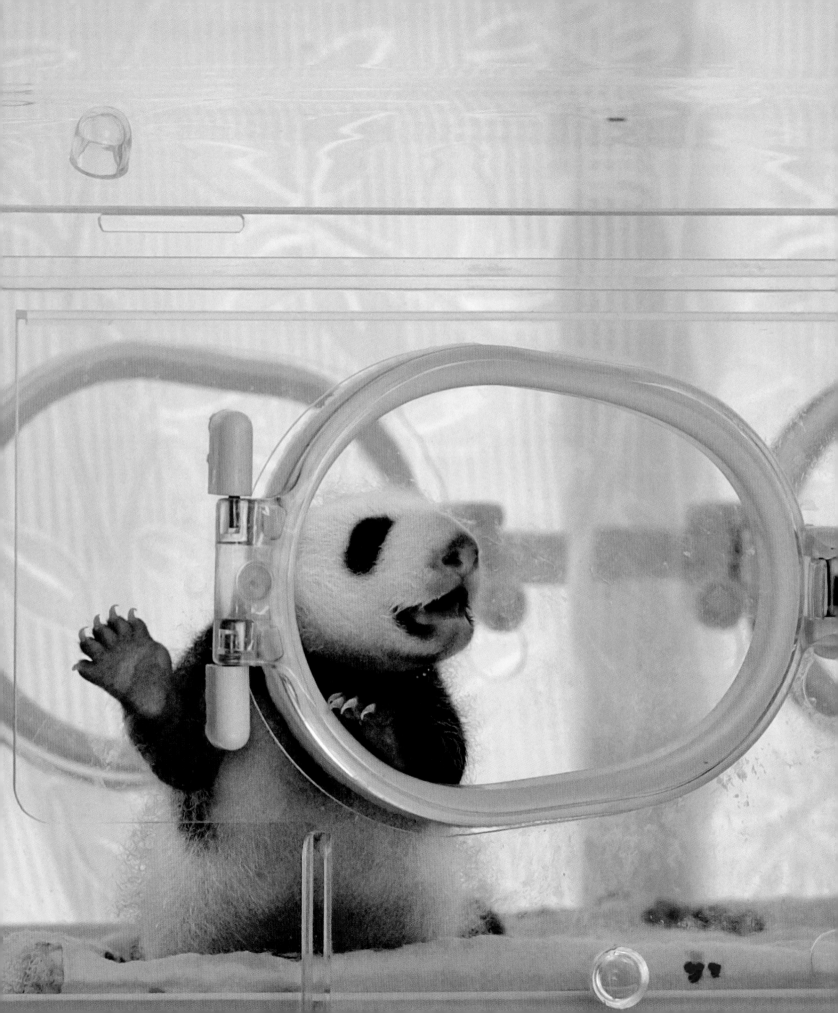

SCIENCE

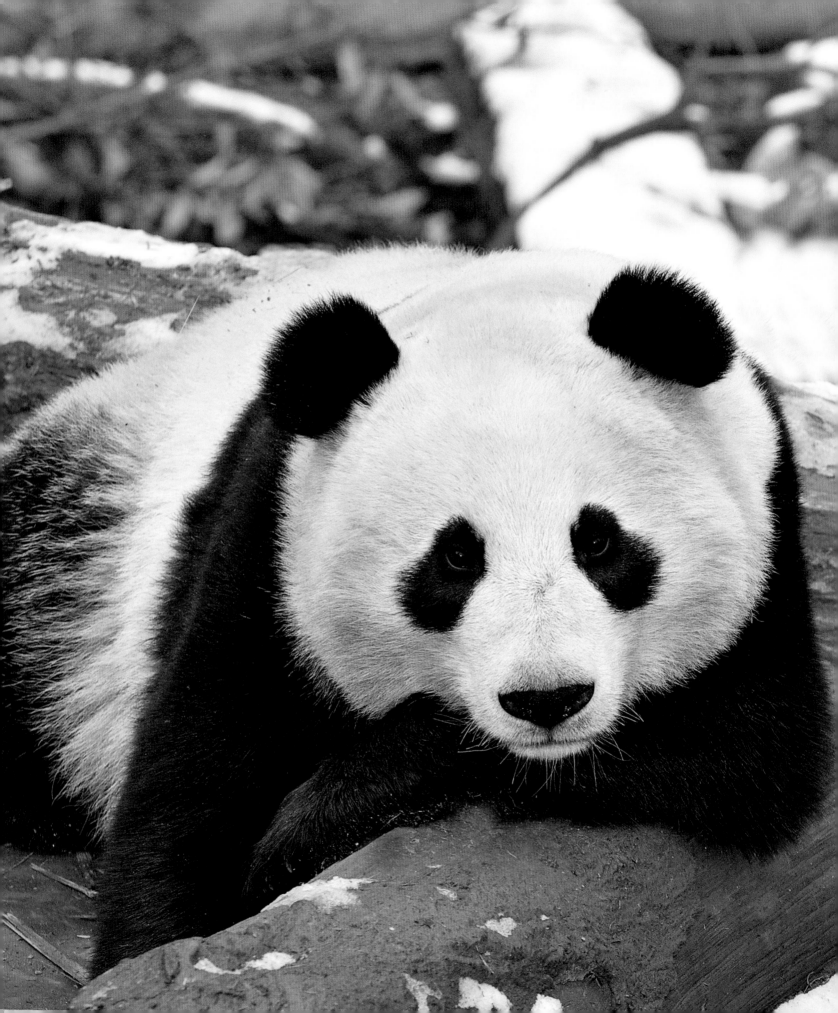

Is The Giant Panda a Panda?

The current Chinese name for giant panda, 'Da Xiong Mao' 大熊猫, was used by the media before the cultural revolution. It literally means Giant Bear Cat, which was a mistake as the animal is clearly not in the cat family. The mistake was made as journalists in those days were used to reading their newspaper headlines from left to right, whereas the interpretive in the Sichuan Museum was meant to be read from right to left, hence the original Mao Xiong 猫熊 to mean a bear with a cat-like appearance, was reported as 'Bear Cat' 熊猫, a cat with a bear-like appearance. The media reports were so powerful that the Chinese-speaking public continues to call it 'Da Xiong Mao' and the giant panda continues to carry a wrong identity in Chinese until today. However, in Taiwan, the media called it Cat Bear 猫熊 in 2008, which is a more appropriate description.

Right from the beginning it was disputed whether the giant panda was related to bears or to carnivores such as the red panda, which was also first described at Paris Natural History Museum. When Père Armand David sent his first letter to Paris regarding the panda, he had made up his mind that this creature was a 'black and white bear', but Alphonse Milne-Edwards, his zoological contact in Paris disagreed, noting that the skeletal characteristics and dental details clearly set it apart from bears, and associated it more closely with the red panda and raccoons, and as a consequence a year later the new genus was named '*Ailuropoda*', literally 'panda foot'.

Numerous 'experts' began to participate in the debate, and conclusions were often based on a few characteristics like skull and dentition, but for every study concluding that David's 'black and white bear' was indeed a bear, there was another study saying it was not.

For the next century or more there was a lively debate as scientists continued to pass judgment based on insufficient data, and 'strangely', opinions were almost exclusively divided along geographical lines with the British and French scientists concluding that the '*Ailuropoda*' was related to the red panda, whereas the rest of the continent was of the opinion that it belonged to the bear family.

Over the years many scientific methods were employed trying to determine the lineage of the '*Ailuropoda*'. For instance investigations were carried out in the 1950s to find out whether the blood proteins were more like those of bears or raccoons; the conclusion was that the similarities favoured the bear rather than the raccoon.

Later in the 1960s, scientists at King's College Hospital Medical School in London discovered that the giant panda had just 42 chromosomes, whereas most true bears have 72, which did not sound much like a close relationship.

Other scientists argued for placing the giant and the red panda in a group of their own, showing two oblong and remarkably similar shaped turds, one from the giant panda and one from the red panda.

Giant pandas are genetically carnivores. Dietary habits are influenced by the sense of taste, and as the giant panda cannot taste meat, they subsist on a bamboo diet instead. Researchers however, have discovered that giant pandas actually lack the necessary genes for complete digestion of bamboos. This may suggest that it relies on microbes in its gut to digest bamboo rather than on anything else in its genetic make-up.

But for every study concluding that David's 'black and white bear' was indeed a bear, there was another study saying it was not.

In the 1980s, some scientists came to the conclusion that the giant panda and the red panda are not closely related, and that their physical similarities are a result of the same type of food habits and lifestyle. The red panda was placed into the raccoon family (*Procyonidae*), while the giant panda into the bear family (*Ursidae*). Other scientists however, were convinced that they were relatives and belong to the same branch of the evolutionary tree. They placed the pandas either into a separate family or tucked them in with the raccoons. Each school of thought could point to specific features to reinforce its claims.

In the 1990s the science of DNA gradually became more advanced, and there is now so much DNA data available that it has even become possible to use it to distinguish different panda populations.

On the 21st of January 2010, the *Journal of Science: Nature* published a paper by Chinese scientists with the complete genome sequence of the giant panda.

Luckily for the giant panda, this paper also suggests that sufficient genetic variability may still exist in the giant panda population to offer a good hope of long-term survivability despite the species' depressingly small population numbers.

Do they look like a bear that wants to be a raccoon (or a raccoon that wants to be a bear?). Did they belong with the bears (*Ursidae*), raccoons (*Procyonidae*) or do they belong in a family of their own? Molecular studies have resolved the classification debate; giant pandas (*Ailuropoda melanoleuca*) are most closely related to bears.

However, in spite of the century long debate, and all the scientific evidence, to most ordinary people a giant panda is still a panda!

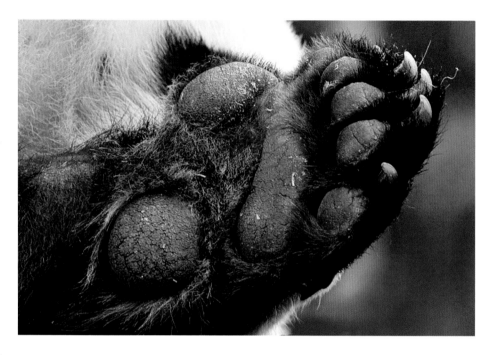

The Rule of the Thumb
A panda's forepaws are specially adapted for holding and manipulating bamboo stems, with a modified elongated wrist bone forming the pseudo thumb covered by a fleshy pad. The giant and the red pandas are the only 'carnivores' to have this 'feature'. This bone is enlarged and functions as an opposable thumb, which both species use to manipulate bamboo, and also helps them to be good tree climbers.

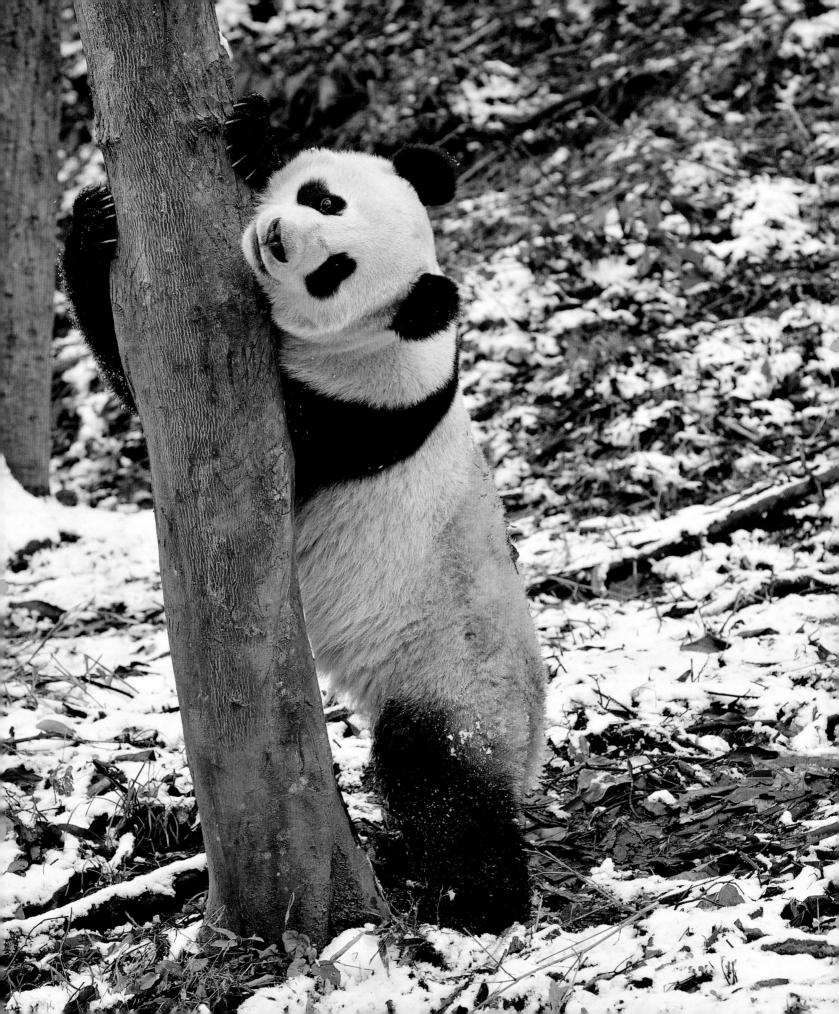

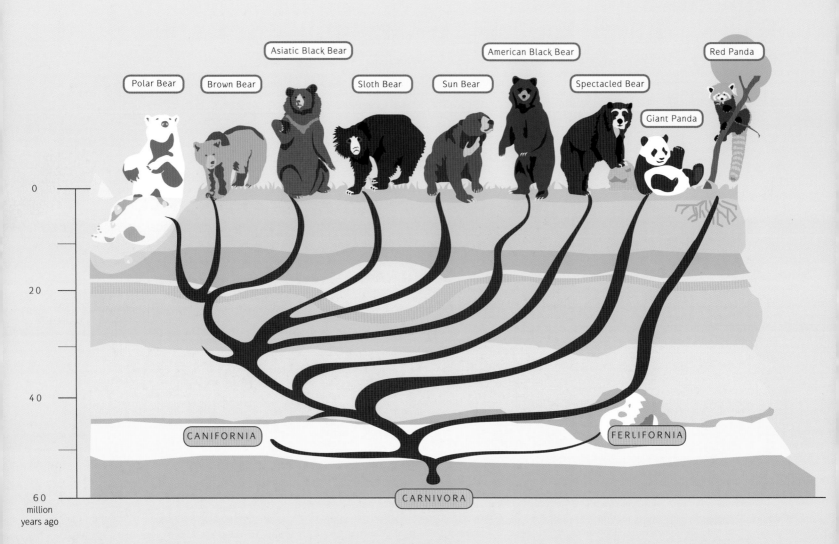

Polar Bear

Brown Bear

Asiatic Black Bear

Sloth Bear

Sun Bear

American Black Bear

Spectacled Bear

Giant Panda

Red Panda

0

20

40

60
million
years ago

CANIFORNIA

FERLIFORNIA

CARNIVORA

In the 1980's some biologists concluded that the giant panda and red panda were not closely related, that their physical similarities had evolved because of the same food habits and life-style.

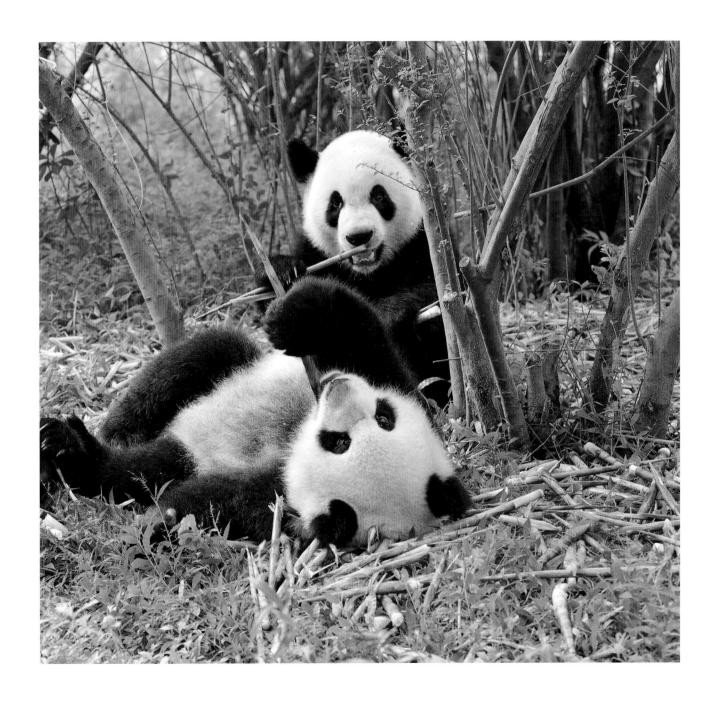

However, in spite of the century long debate, and all the scientific evidence, to most ordinary people a giant panda is still a panda!

They are also quite comfortable eating bamboo lying down.

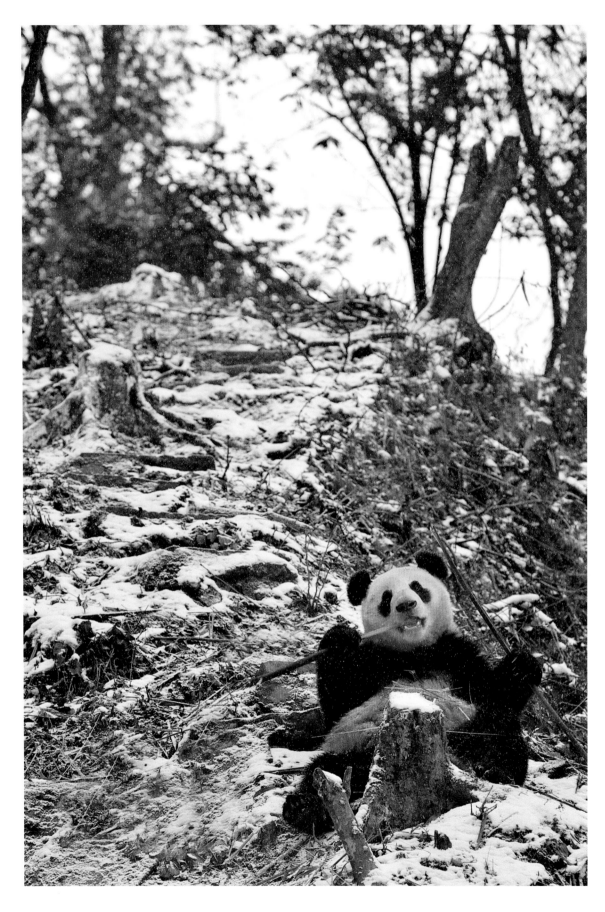

Pandas normally forage alone and come together only briefly to mate during springtime.

Qinling Mountains

Future Survival of giant pandas
in the Qinling Mountains of China

Wenshi Pan, Yu Long, Danjun Want, Hao Wang, Zhi Lu, and Xiaojian Zhu are a team of renowned researchers who carried out a comprehensive giant panda study in the Qinling Mountains from 1986 to 1999. The findings were published in Chinese in a massive 800,000 word report entitled *A Chance for Lasting Survival* (Pan *et al.* 2001). Their main findings based on the wild population in the study areas are as follows:

The giant pandas of Qinling are located on the southern slopes of the mountains at 1,300 to 3,000 metres above sea level, a habitat that is classified as mid-mountain to sub-alpine. Because the 1,350 metres elevation is the upper limit for farming, humans are precluded from year-round habitation, thus preserving the last remaining habitat in this region for the giant pandas.

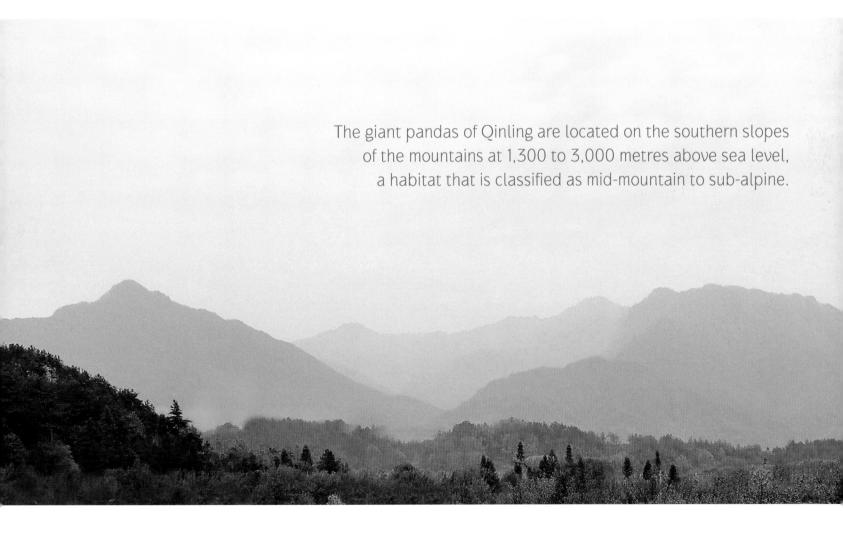

The giant pandas of Qinling are located on the southern slopes
of the mountains at 1,300 to 3,000 metres above sea level,
a habitat that is classified as mid-mountain to sub-alpine.

While logging may no longer be a principal threat; tree cutting and firewood collection for fuel and housing construction still threaten the pandas' survival.

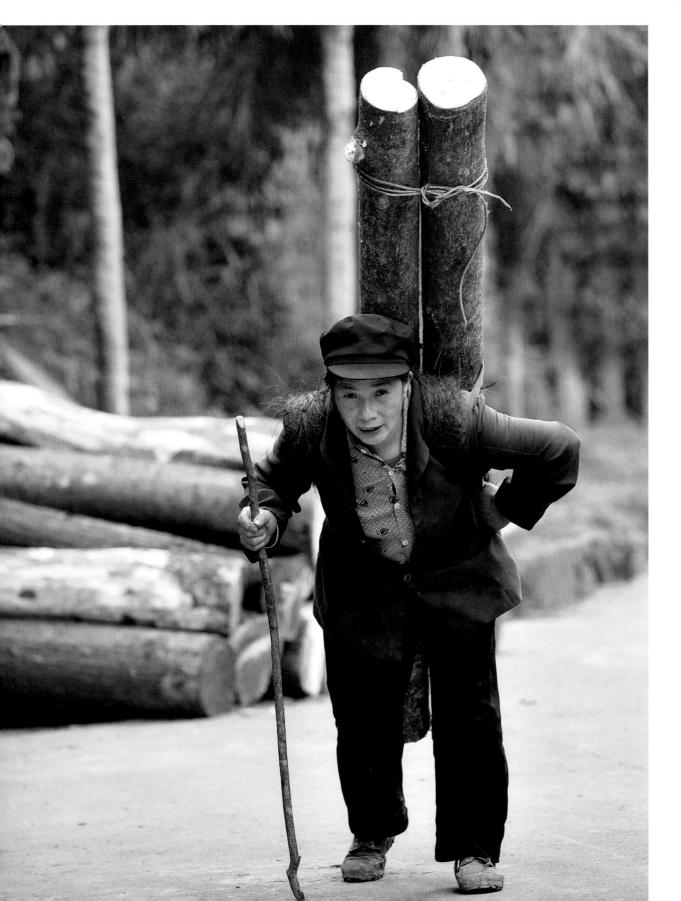

Qinling's montane-temperate and frigid-temperate climate is favourable to a thriving bamboo forest ecosystem; the dominant vegetation cover in their winter range being conifer, broadleaf and oak forest, with an undergrowth of *Bashania fargesii* bamboo.

The sex ratio of the panda population was found to be exactly 1:1, and around 50% of the pandas were of reproductive age, which for the female panda is 4.5 to 20 years, whereas the male has a shorter period from 4.5 to 17 years.

The mating season begins early March and ends mid-April. In the Qinling Mountains, both sexes have multiple mates. Pregnant females begin early migration to the low to mid-mountain zones in the autumn. Births occur between August 15 and August 25, with an average gestation period of 145 days. The average inter-birth interval is 2.17 years, in other words a female panda gives birth every second year, and a healthy female can produce up to six or seven cubs in its lifetime.

Cubs begin opening their eyes between 40 and 49 days. At around 90 days they begin to gain sight. At 75 to 88 days, the first dental eruptions occur. During the first five days after birth the mother does not leave the den. Although she begins leaving the den to defecate when her cub is 6 to 14 days old, she continues to fast during this time. The earliest departure for foraging is when the cub attains 15 days of age. The cub remains in the den for around three months, and after that the mother places the cub in dense thickets until it reaches 5 to 6 months of age. After this time the cub begins to climb trees, and stays above ground while its mother forages.

This unique comprehensive study concluded that the reproductive potential, population structure, and

> The mating season begins early March and ends mid-April.In the Qinling Mountains, both sexes have multiple mates.

genetic diversity of the species are characteristics favourable for the pandas' continued survival in the Qinling Mountains.

The greatest threat to wild populations is habitat destruction as a result of human activities. The key to preventing the extinction of giant pandas is to protect their natural habitat. If humans were to take a keener interest and show deeper concern for the conservation of wild giant pandas, then we will be able to ensure the continued existence of these lovely animals.

Adult giant pandas are normally solitary, but they do communicate
periodically through scent marks, calls and occasional meetings.

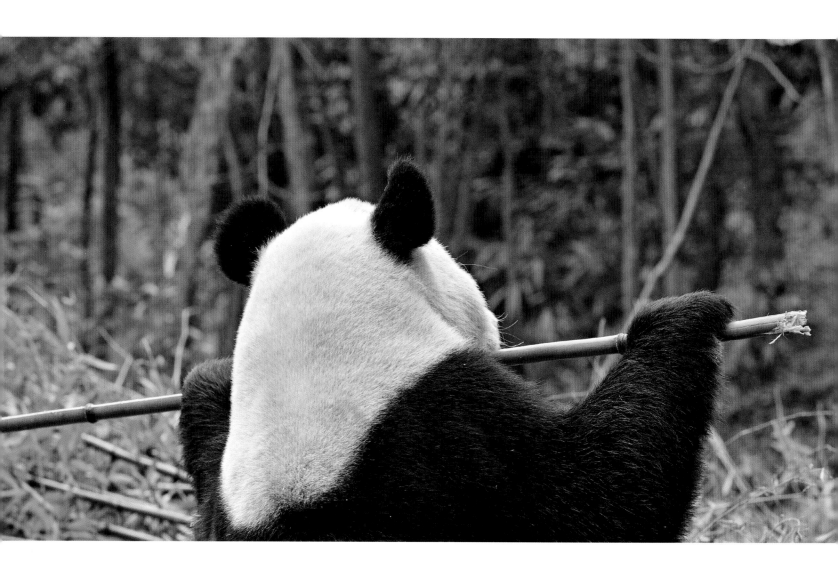

Panda Pregnancy

The giant panda is listed as an endangered animal in the International Union for Conservation of Nature (IUCN) Red List of Threatened Species. There are about 1,600 in the wild, and more than 300 living in captivity, mainly in China's zoos and research centres.

Its average life span is 20 to 30 years in the wild. As usual, those in captivity with appropriate diet and veterinary care tend to survive longer than those in the wild. The oldest panda lived for 35 years.

On average female pandas become sexually mature at 5 years of age, while for males it is normally two years later. Each panda has a home range of around 5 square kilometres; males generally have a larger home range than females.

Adult giant pandas are normally solitary, but they do communicate periodically through scent marks, calls and occasional meetings.

The mating season is from February to May, when the snow cover begins to disappear, and at this time they begin to look for a mate. Both female and male pandas leave their scent and scratch marks on trees, signalling their readiness to mate. When a female is in heat, she marks more frequently to ensure a male is attracted to her at the right time. At times they also use vocalisations to attract pandas of the opposite sex.

Female pandas can be particular about their mates. Sometimes if they attract more than one male, the female panda will be an observer as the competing males fight it out in order to win access to her.

Occasionally, curious sub-adult male pandas watch the fighting from a distance, along with young female pandas, and it is believed that such occasions allow them to learn some essential mating skills.

During the mating season, when males compete for mating rights, females often watch them fight from the safety of a tree.

When the mating order has been established, the winning male is allowed to mate her; as is the case with many other species, it is as if she knows that the strong winner has the strongest genes to give their cubs more strength and vitality to carry on their genes. In the wild, female pandas may mate with several male pandas during the breeding season.

Giant pandas are often described as poor breeders, but according to the renowned Dr. Zhang Zhihe, Director of the Chengdu Research Base of Giant Panda Breeding, "*field studies show that a wild panda pair attempted to copulate 42 times within 70 minutes, and succeeded 39 times. Also a pair in captivity was found to mate for 34 minutes*". After mating, the male takes no part in rearing its young.

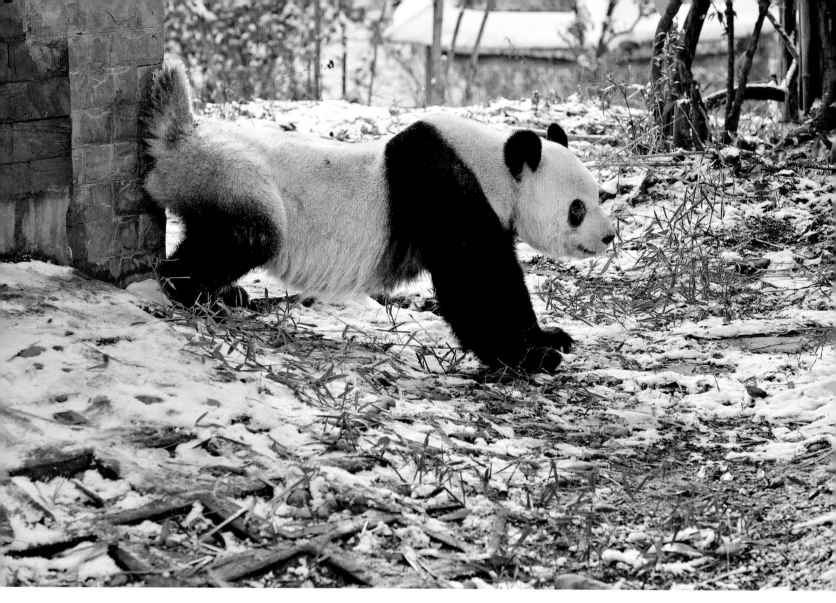

Scent marking may be the most important mode of communication among giant pandas. This is the way they keep track of and communicate with one another. Males scent mark all year round, whereas females most frequently do it during the mating season. The scents may indicate a panda's sex and age.

Hand-stand urine-marking is used mostly by males, and appears to be associated with a male's age and dominance status; the message seems to be "the higher the markings the bigger I am".

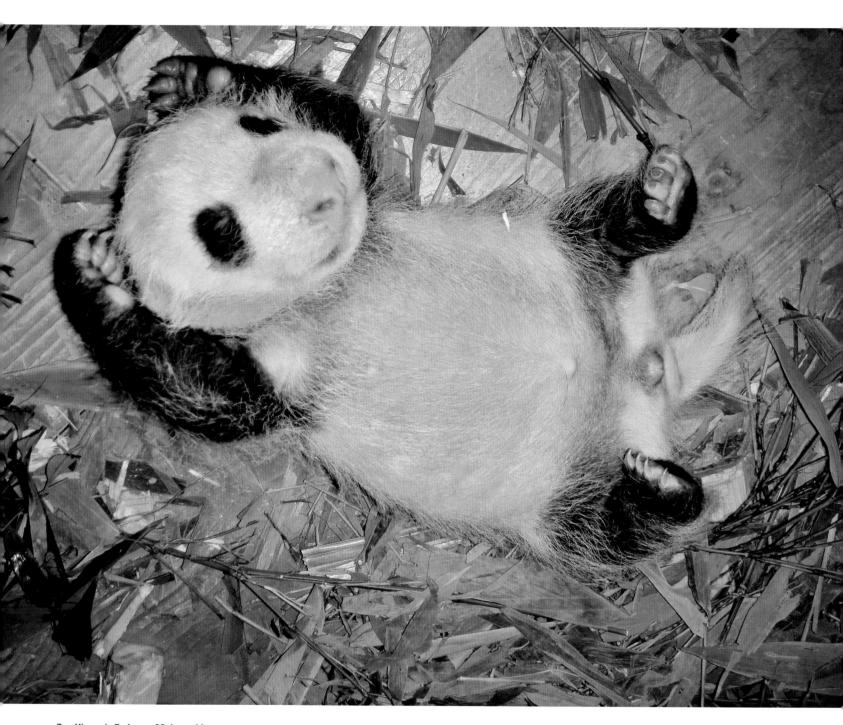

Zoo Vienna's Fu Long, 30 days old.

Growing Up

The gestation period of pandas varies from 82 to 225 days, and strangely, the size and weight of the newborn pandas are almost the same no matter how long the gestation is. The birth weight ranges from 51 to 225 grams, with an average weight of around 120 grams - less than 1/1000th of their mother's weight.

In the wild, a female panda gives birth in early autumn, often in a cave or large tree cavity, and she stays with her cub continuously for the first two weeks without eating or drinking, spending the time resting and sleeping. During this period the mother cradles the baby in her arms to keep it warm. The baby suckles between 6 to 14 times a day, according to John Seidensticker's and Susan Lumpkin's research.

The newborn pandas are very vulnerable, as many of their organs are not fully developed, and they are blind at birth. They also need their mother to stimulate their ano-genital areas for them to pass waste, as in the beginning they cannot do so on their own. For the first three months the mother ingests the cub's faeces, presumably so that predators do not smell the droppings of the young cubs.

Newborn cubs are already hungry just two hours after birth, and the mother's milk is crucial to their survival. For the first few days the mother's milk is light green and the colostrum is rich in antibodies, which aids the poorly developed immune system of the cub.

The female panda has 4 nipples, which may be hard for the tiny cub to see and find. If the cub cannot find the nipples, it will cry out loudly until the mother helps it, and once the cub touches a nipple it stops crying and starts feeding immediately.

Rare photo showing Yang Yang holding her tiny newborn baby Fu Long in her mouth in a surveillance camera shot from Zoo Vienna on 23rd August 2007. It was the first Panda born in Europe for 25 years, and the birth happened 127 days after Yang Yang mated with the male panda Long Hui. Exactly 3 years later on 23rd August 2010 Yang Yang gave birth to another male cub Fu Hu.

At birth a newborn cub is pink, but after around 15 days black patterns begin to show and its fur gradually becomes thick. After one month it starts looking like the pandas we know, however, it cannot open its eyes until one and a half months after birth, and its hearing does not develop until after two months. A female panda uses her mouth to hold, clean and move her infant.

At the age of three months the cub can see and hear, and its 'milk teeth' start to appear, and after four months it can crawl freely and will try to follow its mother to explore the surroundings. For the first time it can enjoy the fresh air and sunshine outside the den without the company of its mother.

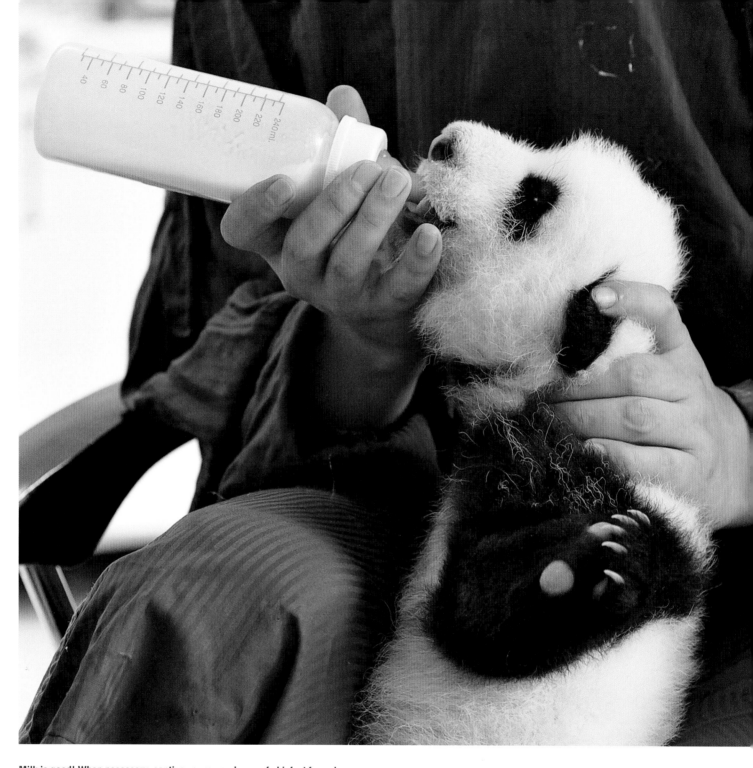

Milk is good! When necessary, captive young pandas are fed infant formula.
Mead Johnson is one of the brands used.

At four to five months the cub is quite active, moving around in the den, and sometimes venturing outside on its own. Initially the mother is very protective, but gradually she will become more tolerant and let the cub explore the nearby surroundings on its own. The cub also likes to play on its own with bamboo and other plants, probably trying to imitate its mother, and soon it will be able to climb. At this time the cub's diet gradually changes from the mother's milk to bamboo.

Still too young to walk, infants start to crawl at around two months.

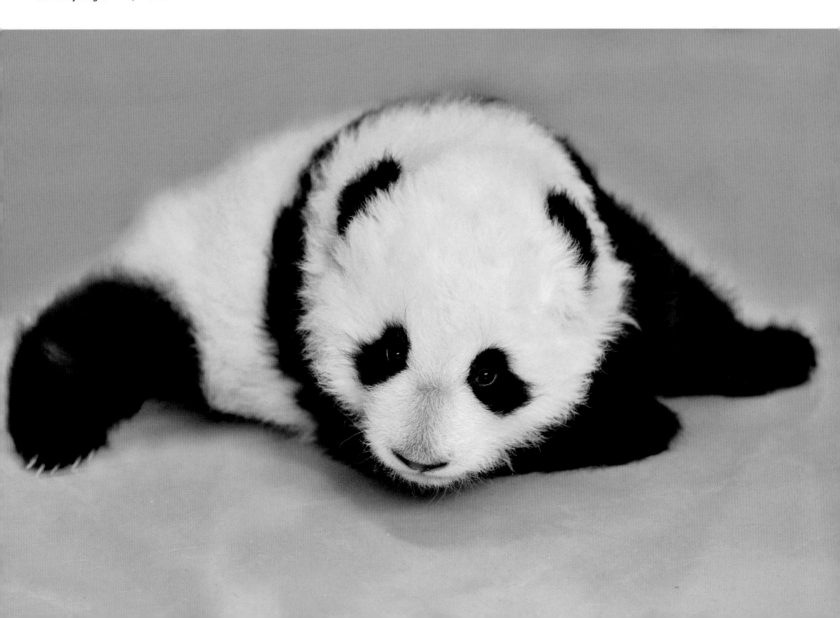

From around seven months to a year the cub will get more confident and assertive and spend an increasing amount of time in trees to avoid predators, as this is a very vulnerable time for the young panda. The cub also starts to eat bamboo consistently, and its mother gradually becomes less inclined to nurse the young, as the weaning process begins. At around 10 months, the mother and cub interact less frequently and only nurse and play a few times a day.

After 12 months the permanent teeth begin to replace the 'milk' teeth. In the wild the cub leaves its mother from 18-24 months when it is completely weaned. This is also the time that the mother may be ready to mate again.

Panda cubs cannot open their eyes until one and a half months after birth, and their hearing does not develop until after two months. It normally takes three months before a cub can see and hear normally.

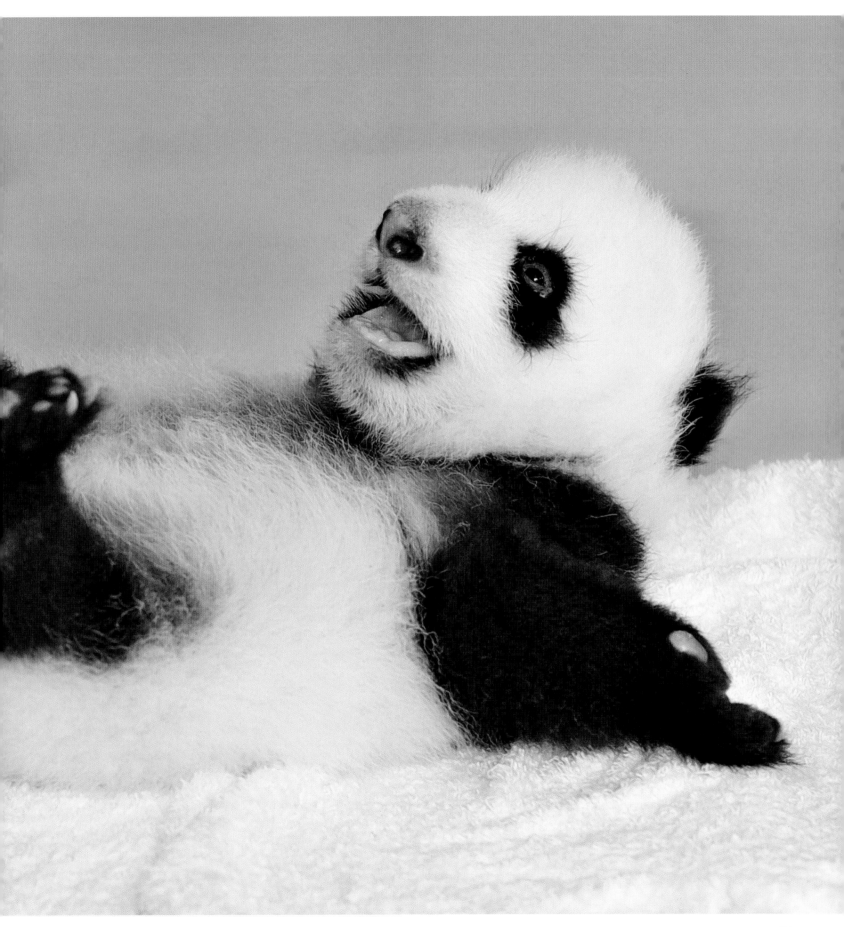

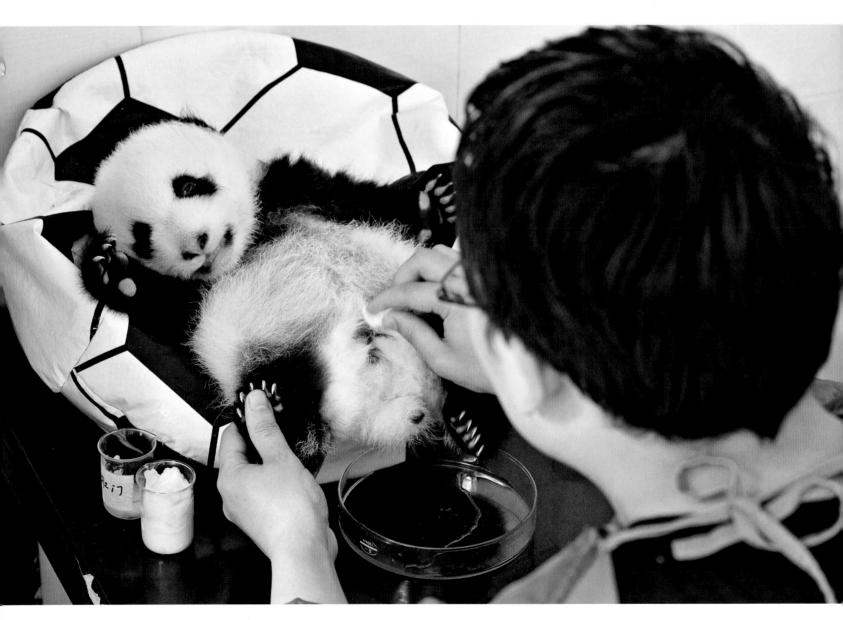

Newborn cubs cannot pass waste by themselves, but when the mother licks their ano-genital area, it stimulates them to release wastes. In captivity the same stimulation is done - if necessary by humans, as we see in this photo.

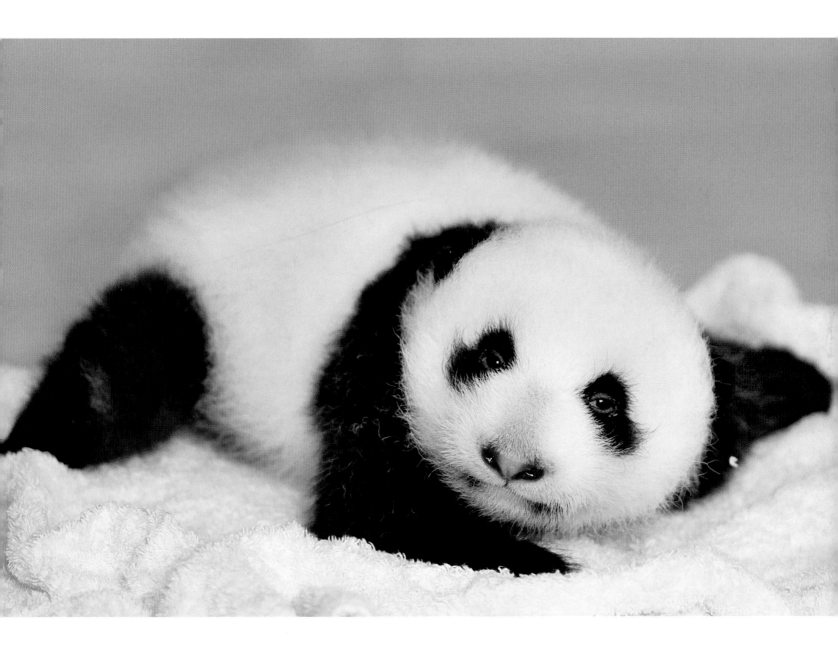

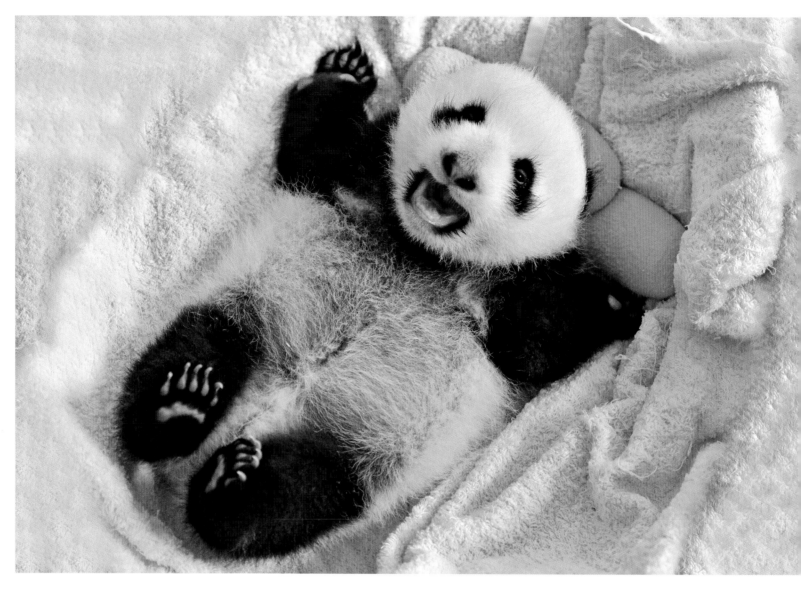

Initially the cub is highly vocal, squealing and grunting frequently to attract the mother's attention. Later on when it is left on its own when the mother is away it is usually silent, probably to reduce the risk of attracting predators.

A significant amount of research is done at the research bases in China. Here a study on "vocal communication in infant giant panda cubs" is being done by Anton Baotic, from Zoo Vienna. The cub you see at the picture was born on 13th August 2010 to 'Jini', it is just over 1 month old, and had a body weight of 1331 grams at Ya'an Bifengxia Panda Base.

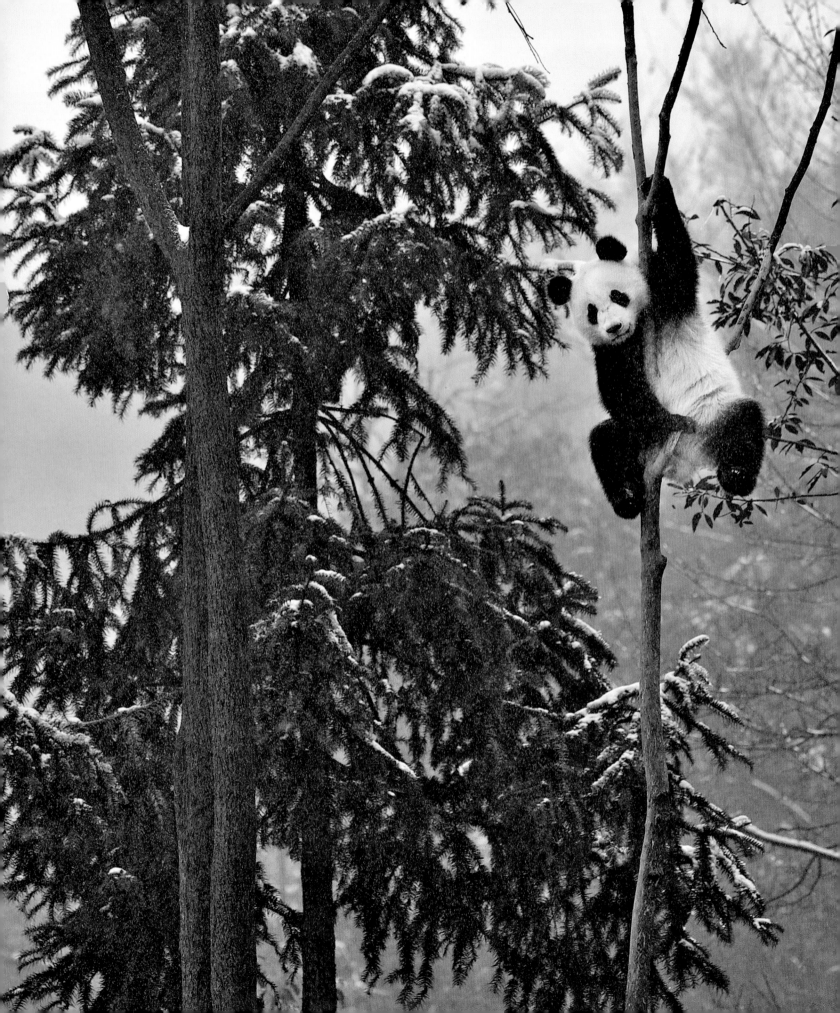

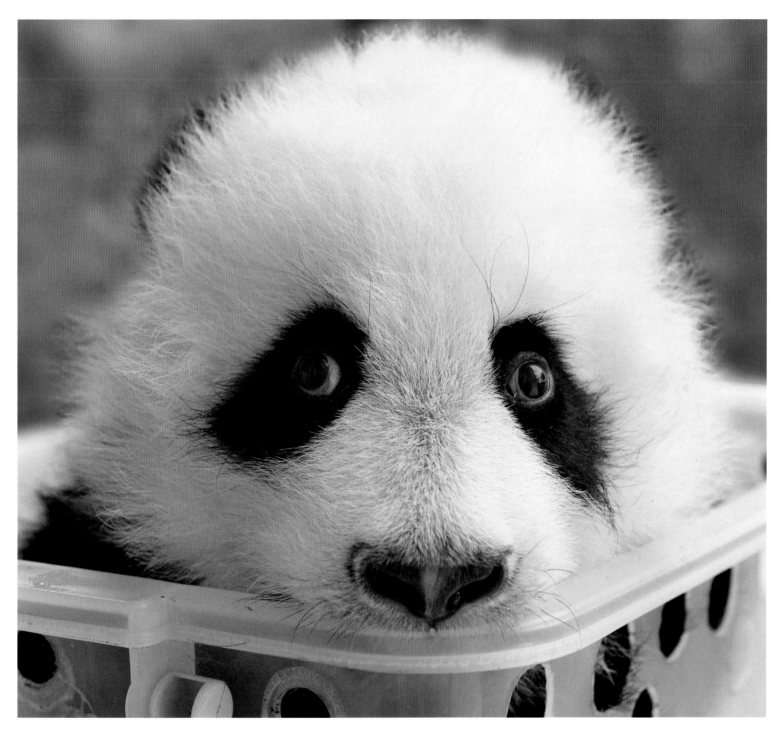

Around 50% of the time, panda cubs are born as twins, however, in the wild only one will survive. In China, scientists have perfected a method of helping a mother to raise twins in captivity by removing one of the twins from their mother at birth, to be looked after by human caregivers. Every couple of days the two cubs are swapped between the mother and human caregivers so each cub can receive enough of their mother's precious milk and attention.

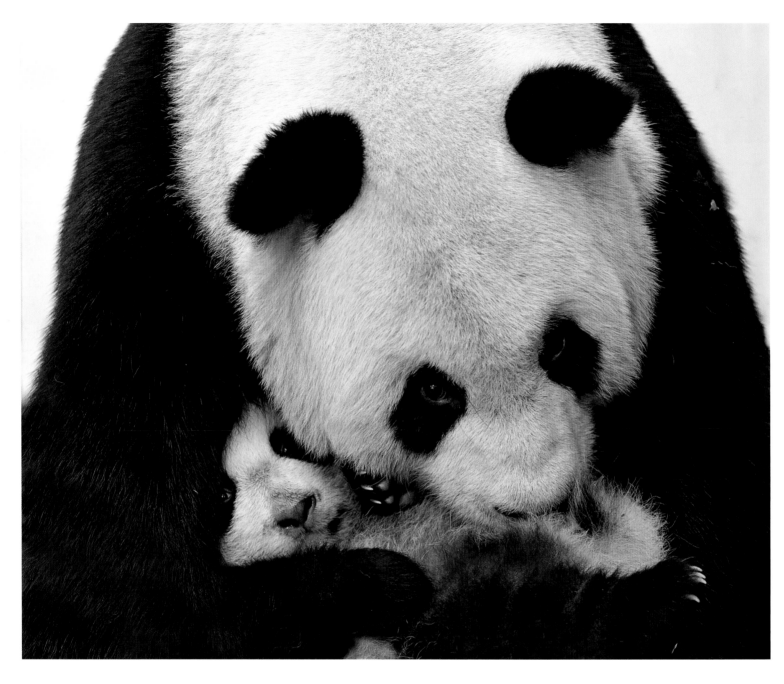

The panda mothers lick their young cubs with their warm and wet tongue, which cleans them, stimulates their blood circulation and makes them feel secure. In addition, young cubs cannot pass waste by themselves, but when the mother licks their ano-genital area, it stimulates them to do so.

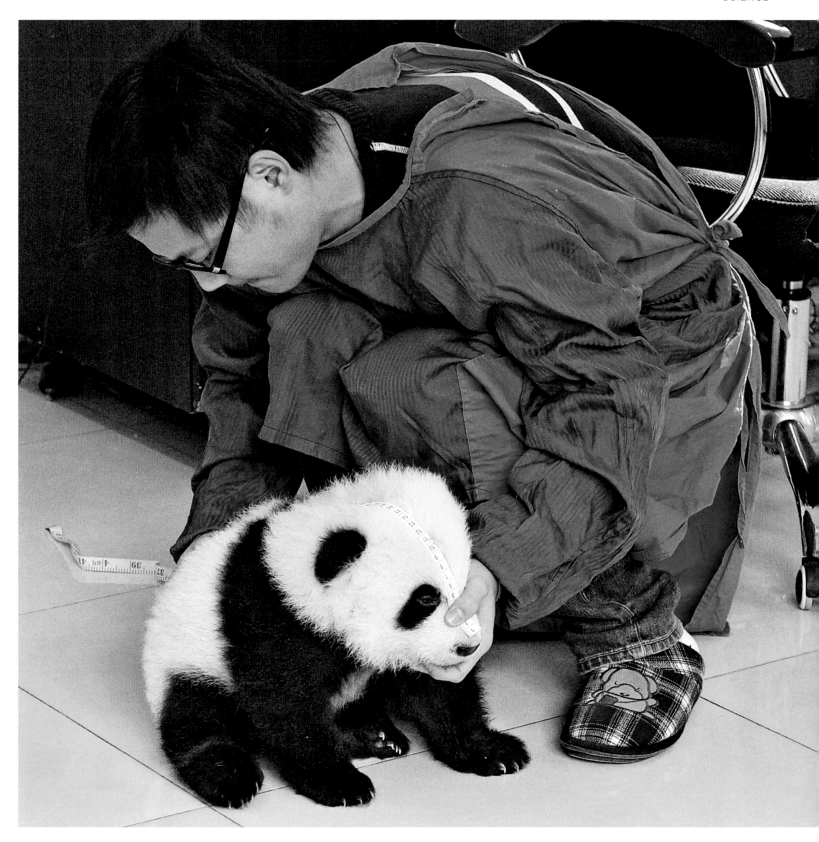

It is time for the weekly measurement. Compared to the size of the body the cub's head appears proportionately even larger than an adult panda.

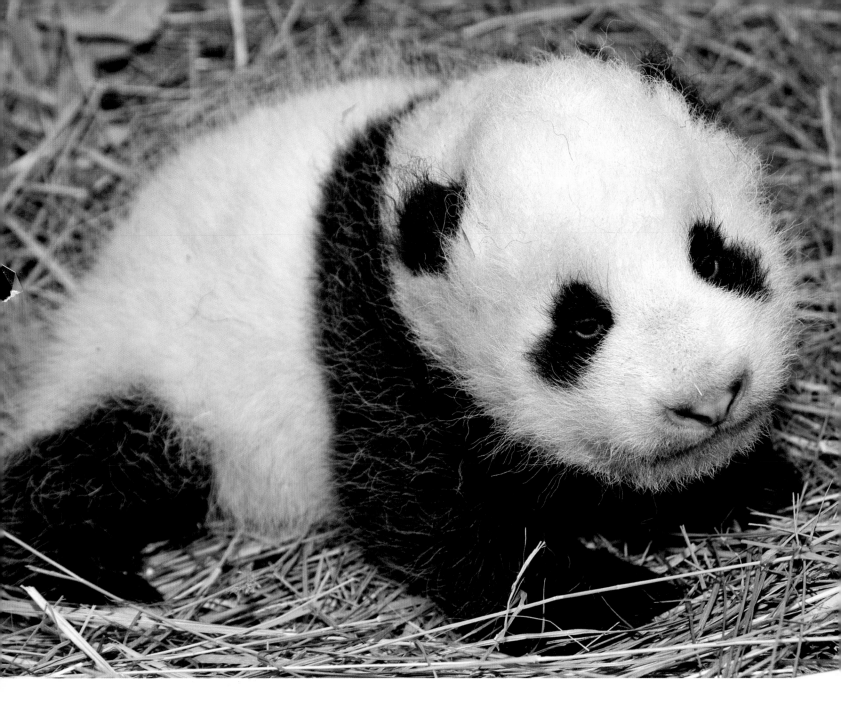

Panda cubs develop rapidly and during the first two months their body weight increases around 20 times, from approximately 120 grams to 2,500 grams. The cub above is 61 days old.

At three to four months the giant panda cub starts to crawl and walk.

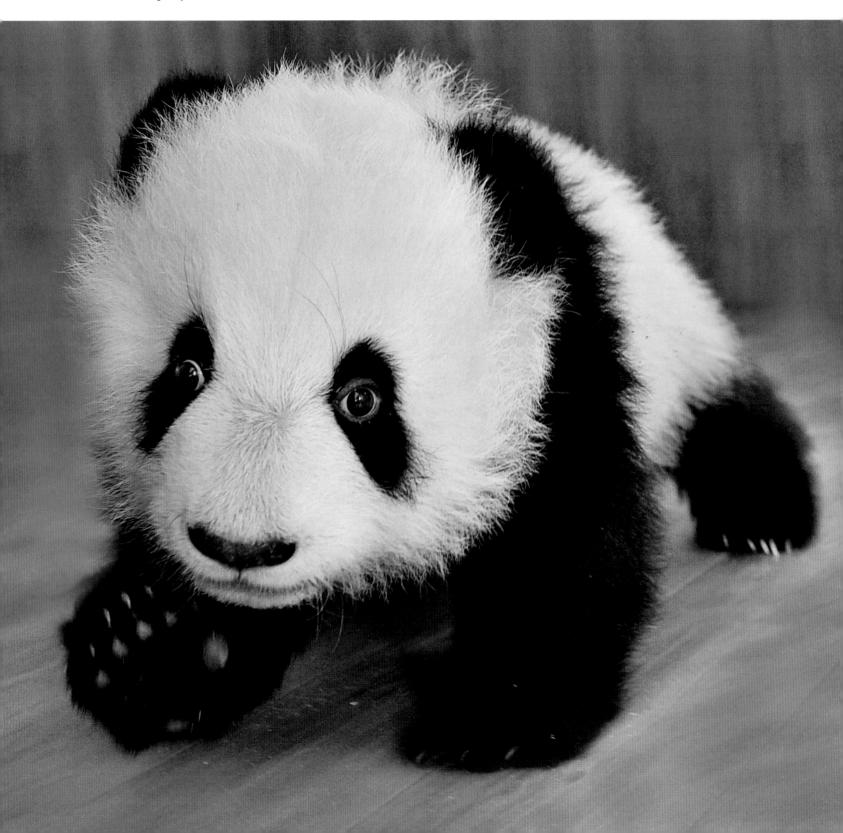

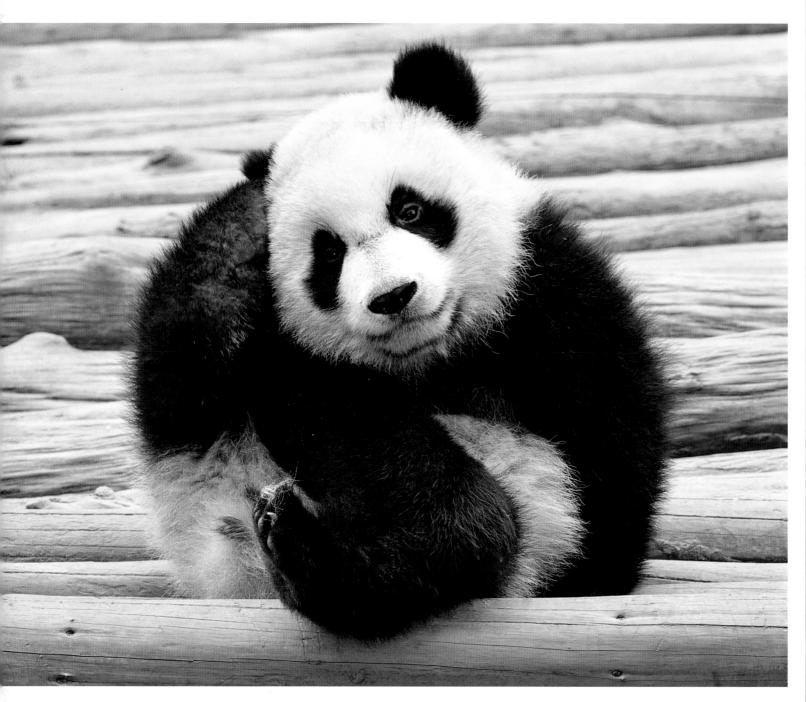

The body of a giant panda is very flexible, and it will go into strange contortions while attempting to scratch parts of its body that are difficult to reach. Here, by twisting the rear end and raising a back leg upwards the panda cub can scratch behind the ear.

At six months the panda cub is ready to explore the world.

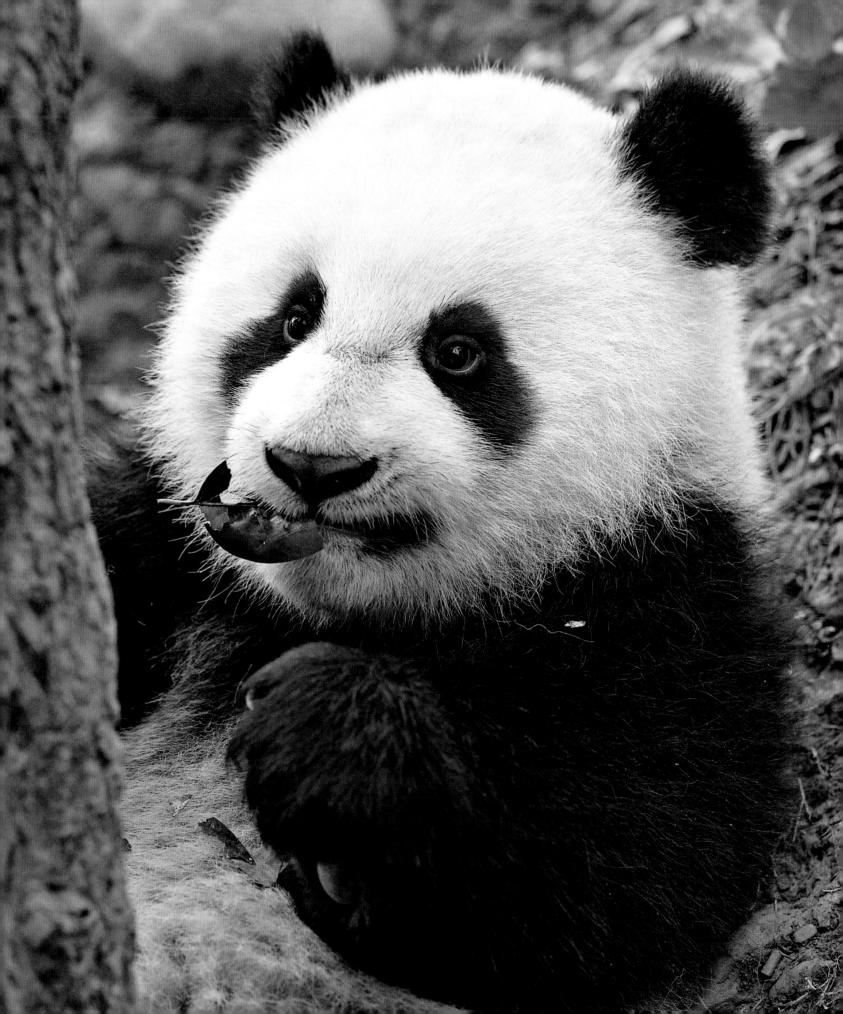

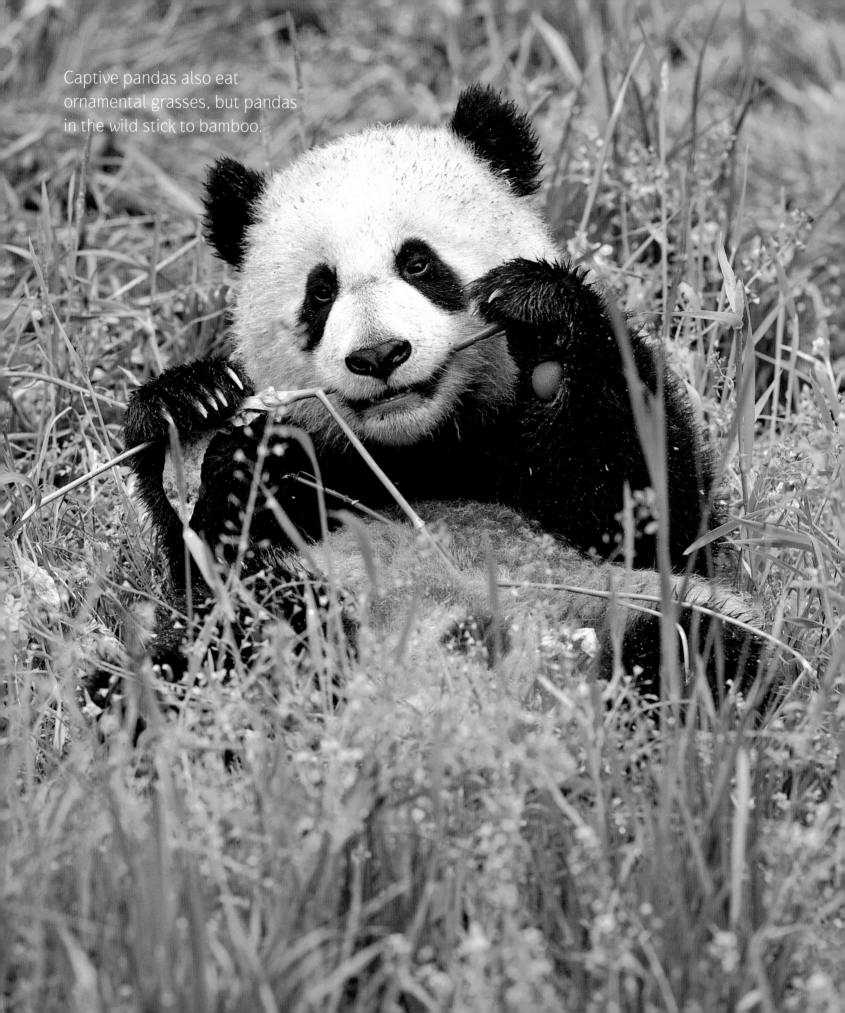

Captive pandas also eat ornamental grasses, but pandas in the wild stick to bamboo.

The world-renowned zoologists Ramona and Desmond Morris speculated that the bold black and white markings of a giant panda serve as a warning to potential predators.

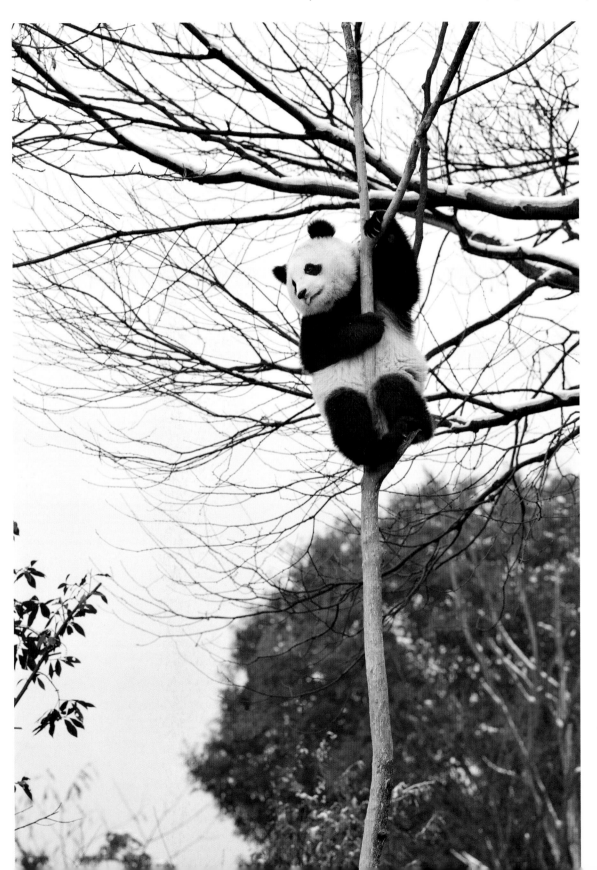

The young pandas often take refuge, and spend up to several days in trees to escape potential predators, when the mother is away foraging.

Panda cubs are born to play. As soon as they are able to move, they start to play - initially with their mother wrestling with them - and in the process the cubs grow up and gradually become strong.

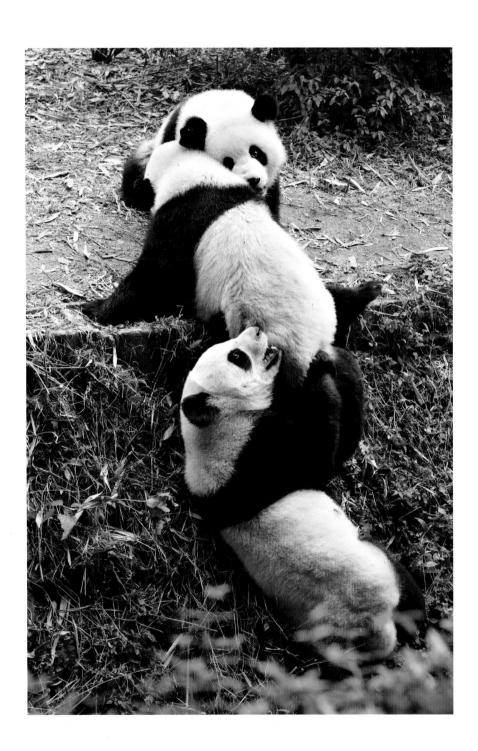

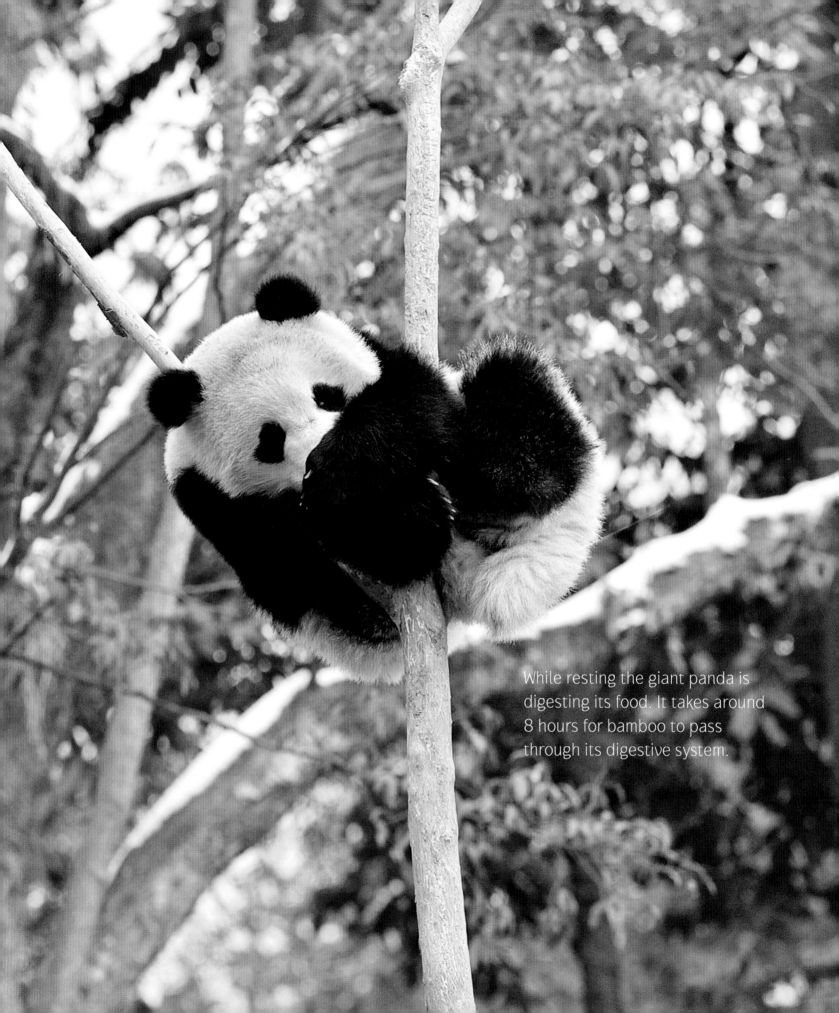

While resting the giant panda is digesting its food. It takes around 8 hours for bamboo to pass through its digestive system.

In summer if temperatures get too hot they often move higher up the mountain. If they get too hot they may enter cold streams to cool down, a behaviour also seen in captivity. In winter if temperatures get below minus 10-12 degrees Celsius, or when the bamboo starts to freeze, they often decide to go down the mountain for warmth and food.

Pandas, regardless of age, are great loungers. They need to rest whenever possible in order to conserve energy to forage and feed, since they spend so much time eating. They use anything from rocks, banks, tree trunks, branches and even snow drifts to prop themselves up when feeding or resting.

A young panda uses a hind leg to gain lift before climbing a young tree. The front limbs hug the trunk and once the panda is off the ground, the claws on all four limbs help it to gain a firm grip on the bark.

Both fore paws, which are larger than the hind paws, are used to hold and manipulate bamboo whilst feeding in a typical half sitting half lying down position.

Unlike all other bears the giant panda sits down to feed so as to conserve energy.

Like humans, giant pandas sleep up to 8-9 hours a day before continuing the task of finding and eating more bamboo.

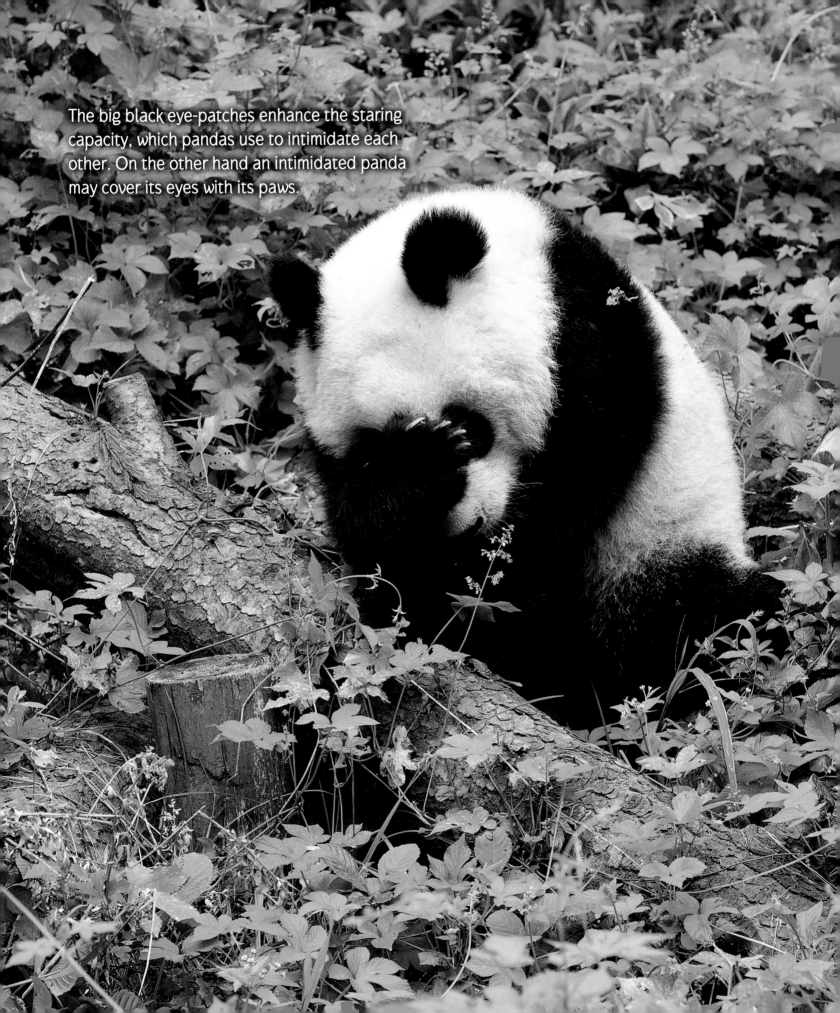

The big black eye-patches enhance the staring capacity, which pandas use to intimidate each other. On the other hand an intimidated panda may cover its eyes with its paws.

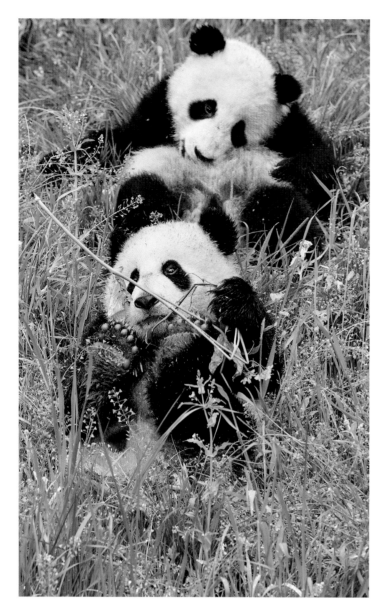
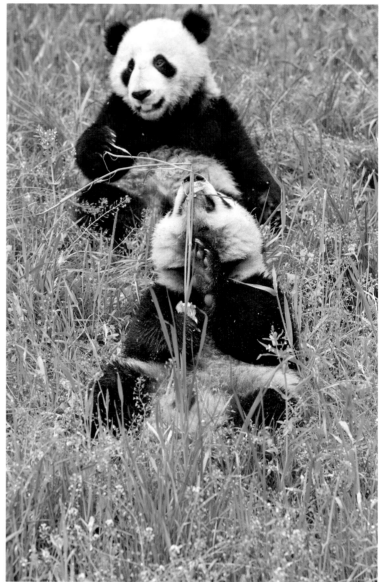

Cubs love to laze in the sun.

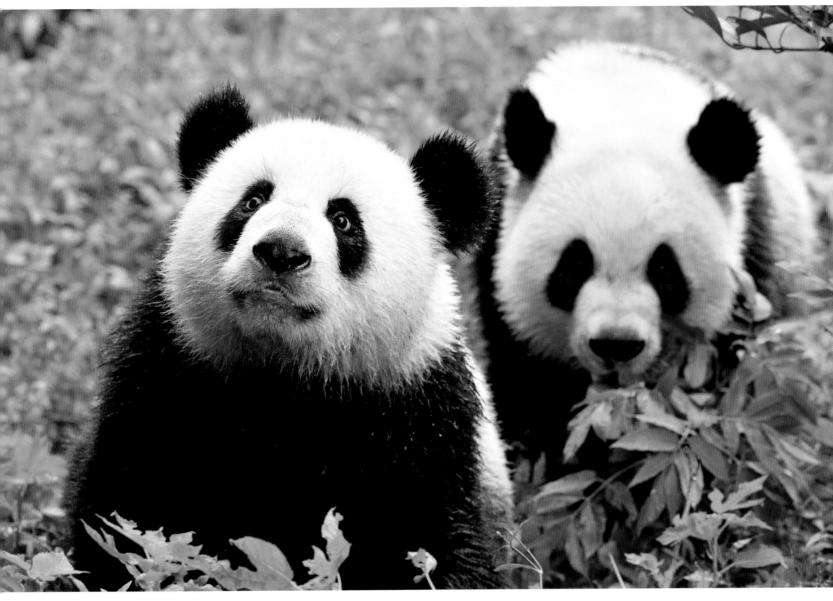

Back to Nature: Captive reproduction has improved so markedly that a
surplus of animals for reintroduction to the wild will soon be available.

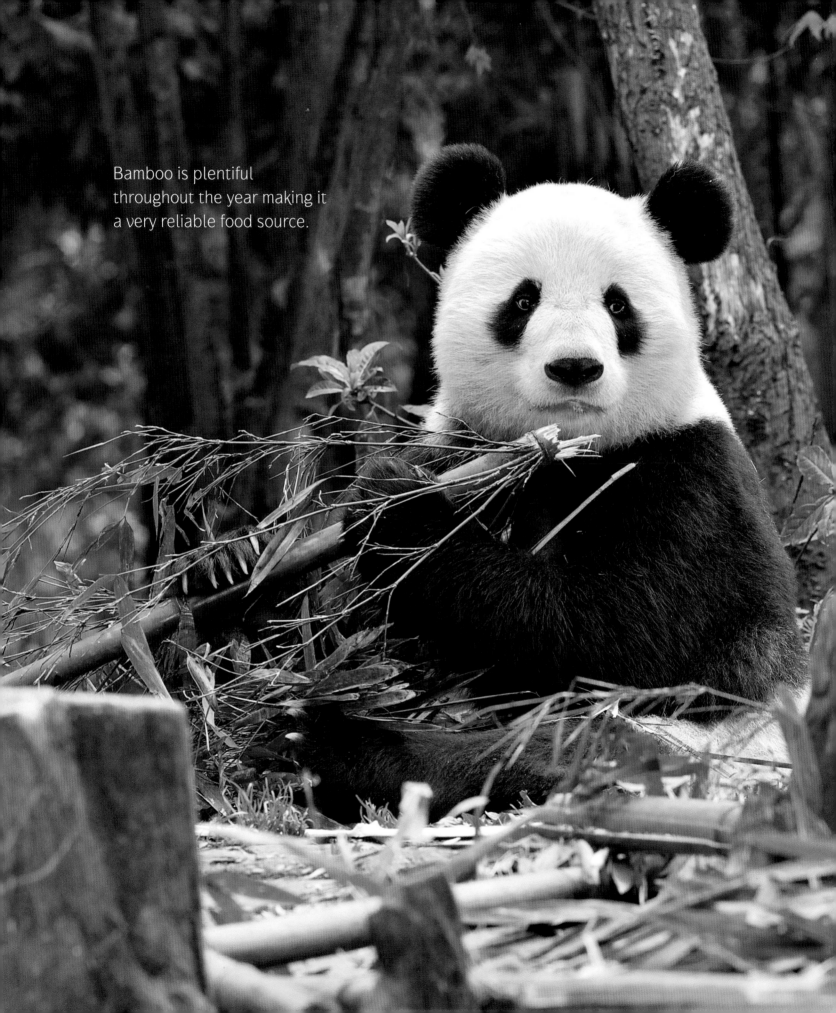

Bamboo is plentiful throughout the year making it a very reliable food source.

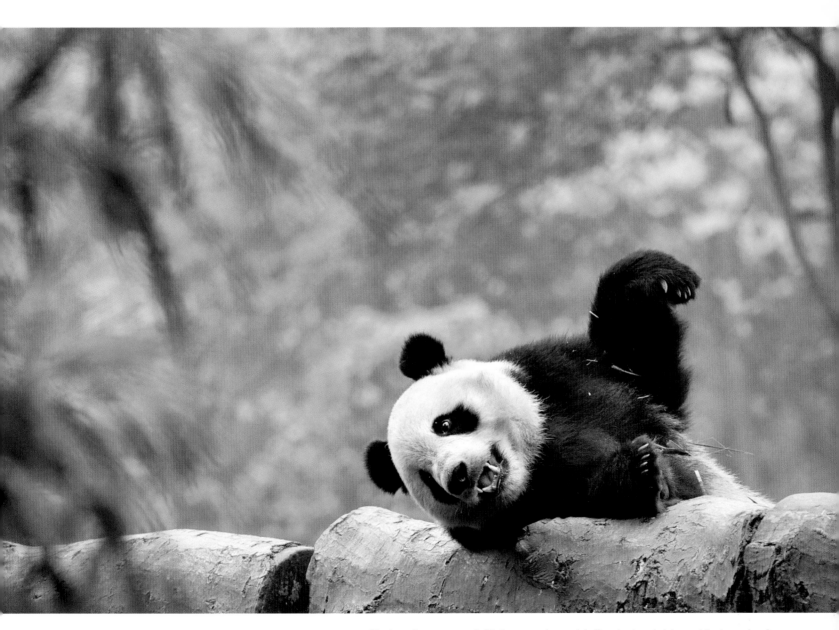

Giant pandas are suspected to have very low metabolic rates to subsist on nutrient-poor bamboo.

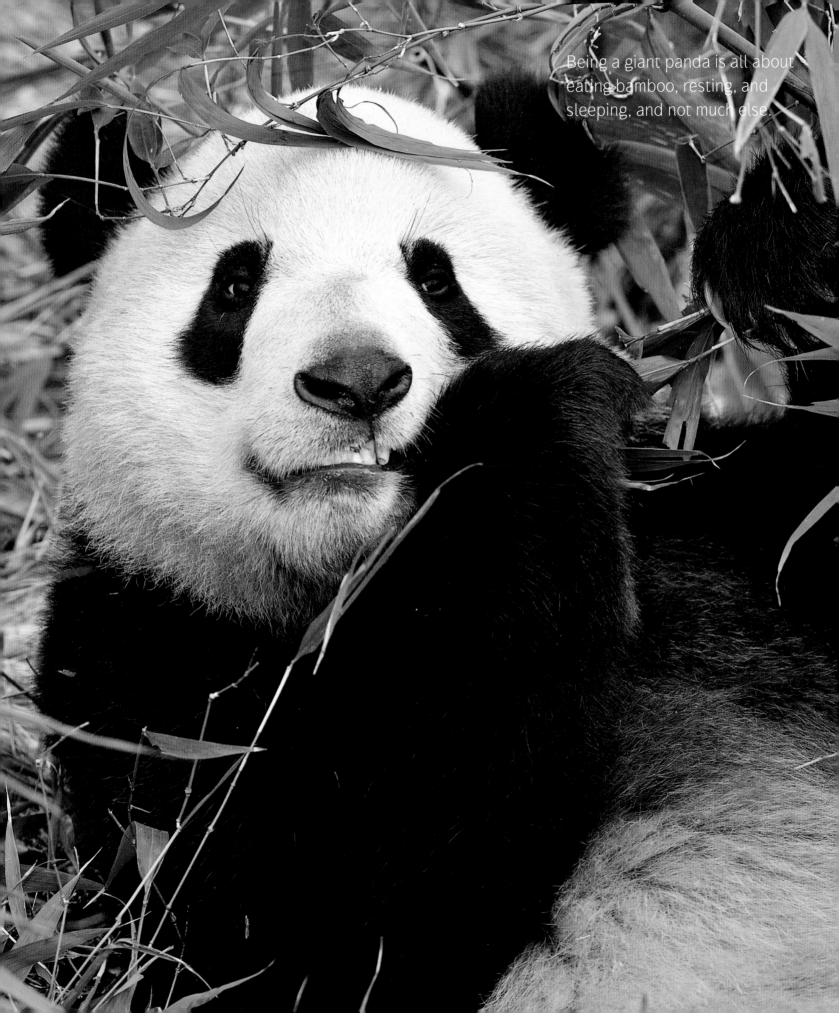

Being a giant panda is all about eating bamboo, resting, and sleeping, and not much else.

Diet: Bamboo It Is!

To consume such a large volume of bamboo means the panda has to spend 10 to 16 hours a day foraging and eating.

The giant panda's diet is primarily or exclusively bamboo. Despite its herbivorous habit, it is taxonomically classified as a carnivore, as it still has the digestive system of one. The giant panda has lived in bamboo forests for several million years, and it has evolved a highly specialized bamboo diet.

On average giant pandas eat as much as 25 kilograms of bamboo shoots a day. The diet is low in nutrients, hence a large volume of bamboo is required, and this is also the reason why pandas maintain a sedentary behaviour to conserve energy. The panda tries to avoid steep slopes, and rarely will you see it moving fast. To consume such a large volume of bamboo means the panda has to spend 10 to 16 hours a day foraging and eating.

In the wild 99 percent of the panda diet consists of bamboo. The remainder is a mixture of other grasses and occasionally small rodents or mammals. In zoos and captivity, a special diet has been concocted to supplement its low nutrition bamboo diet. It consists of sugar cane, rice gruel, high-fiber biscuits, carrots, apples, and sweet potatoes.

Bamboo generally falls into two categories - clumping and running species. The first type, which is native to South East Asia including Singapore, grows in big clumps in the open sun, and can exceed 10 meters in height and stay close to the main plant. The second type grows in the shade of other trees, and reproduces via root-like underground stems called rhizomes, which suppress the growth of other trees like conifers, growing up to 7 metres away from the main plant in a single season. This type of bamboo thrives under humid conditions and high annual rainfall.

Captive giant pandas eat specially formulated panda biscuits, apples and carrots to supplement their bamboo diet.

Moisture from the Arrow Bamboo leaves can provide much of the water that the giant pandas need, but when it is dry they need to drink at least once a day. Scientists believe regular intake of water may be needed in the digestion process of their bamboo-rich diet.

Today the giant pandas live at the northern edge of the distribution of bamboo for the region.

Depending on the species, bamboo flowers, sets seed, and then dies. This cycle occurs every half a century. The flowering occurs simultaneously over wide areas, resulting in a large-scale dying out of the panda's main food source. This is an issue in the smaller reserves where the bamboo flowering is more likely to remove an essential component of the pandas' diet. In the past the pandas would just move on to another patch with a different species of bamboo. But with humans now hemming in the reserves, many pandas may have nowhere to go.

Bamboo totally shapes the life and behaviour of the wild giant pandas, including where they live, how they forage, mate and bring up their young.

Scientists at the Wolong Reserve in Sichuan province divide the year into three seasons. From April to June, pandas eat arrow bamboo stems and umbrella bamboo shoots. From July to October they eat mostly leaves, and from November to March, the pandas consume old stems of arrow bamboo and leaves.

Bamboo is the fastest growing plant on Earth with a reported growth rate of up to 100 centimetres in 24 hours.

Bamboos contain fifty percent water, and new bamboo shoots as much as ninety percent water, but pandas still need to drink fresh water from rivers and streams. Their natural habitat in central China receives up to 1000 millimetres of rain and snow a year, and the rivers are fed by melting snowfall from the mountain peaks.

In essence, a panda is a powerful chewing machine. The large head contains a heavy skull to which strong chewing muscles are attached that power the jaws containing outsized flattened molars used for crushing the tough main bamboo stems and chewing the leaves.

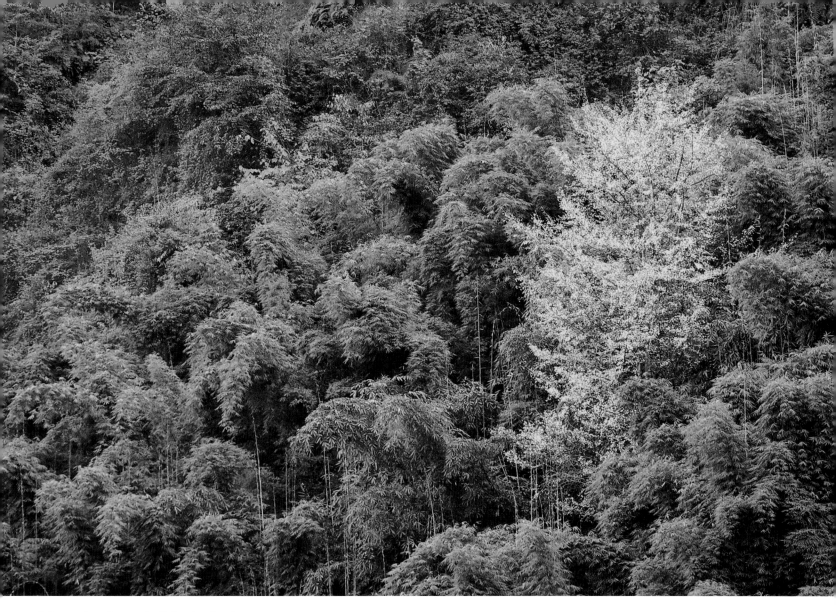

Autumn colours in an umbrella bamboo forest.

Today the giant pandas live at the northern edge of
the distribution of bamboo for the region.

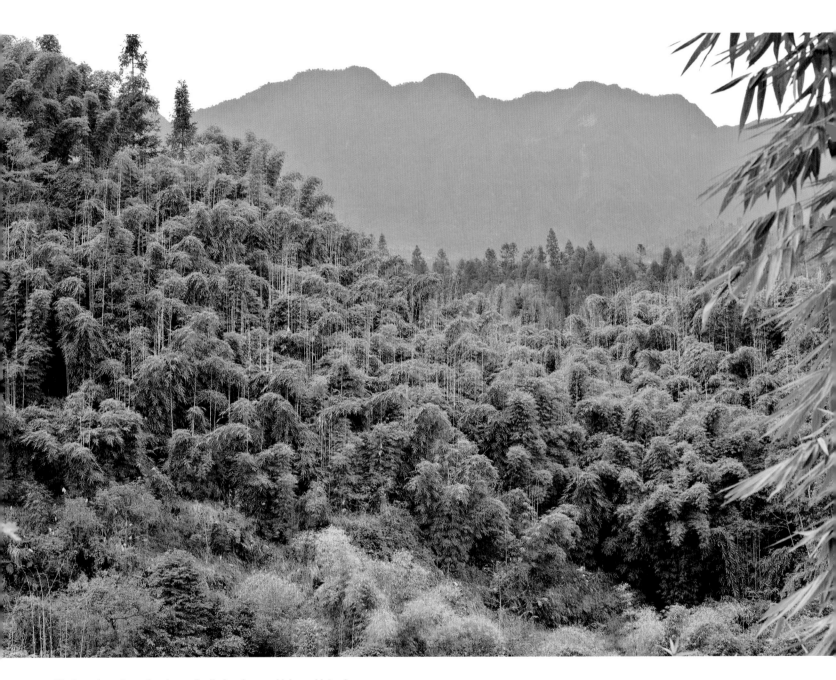

The towering, clump-forming umbrella bamboos, which need lots of sun
and usually occur at lower elevations, are not the preferred panda food.
People use this kind of bamboo mainly for construction materials.

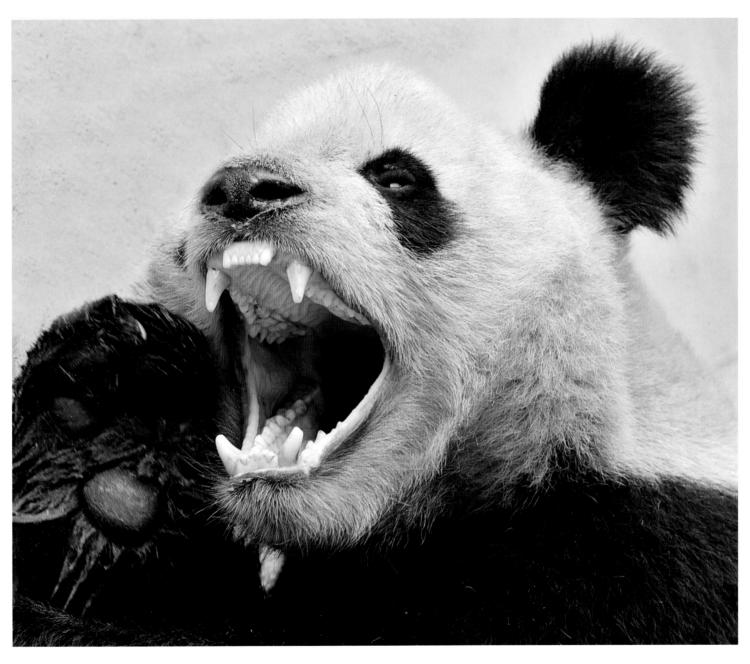

The panda has very strong jaw muscles powering the huge molar teeth that grind and chew the tough bamboos stems, culms and leaves. Like all carnivores, pandas possess strong canines.

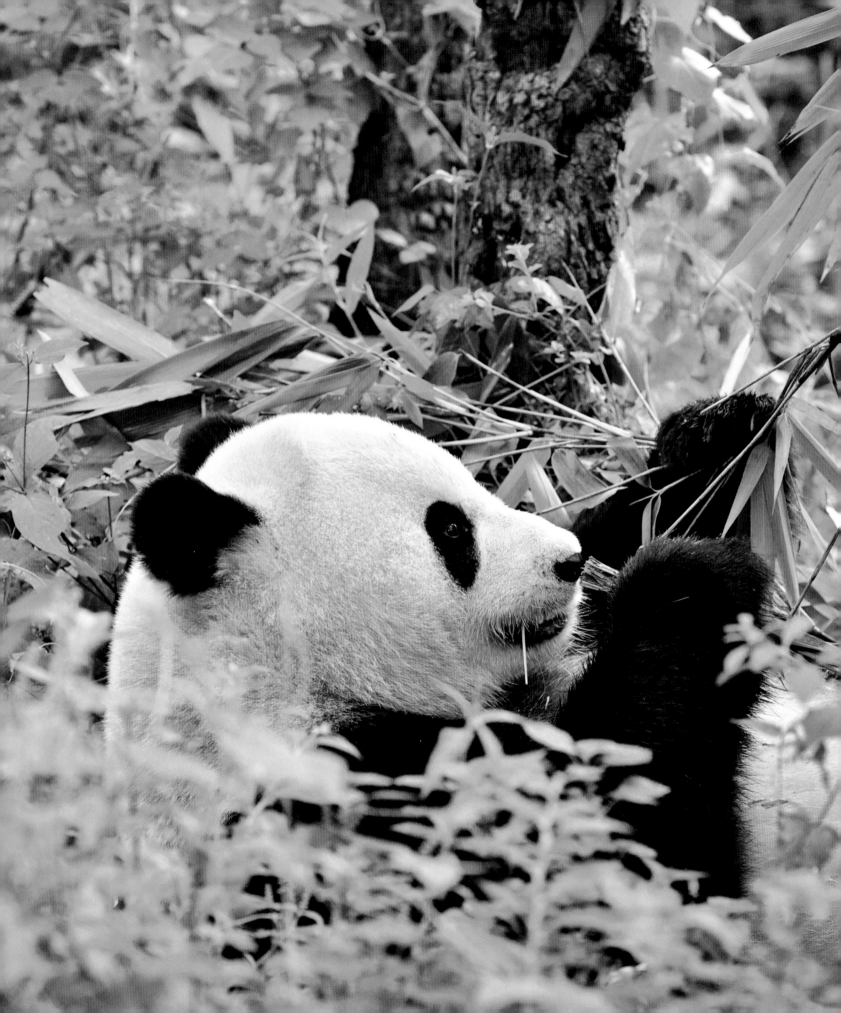

Giant pandas spend almost the whole day foraging for and eating their favourite bamboo, which constitutes 99 percent of their diet in the wild.

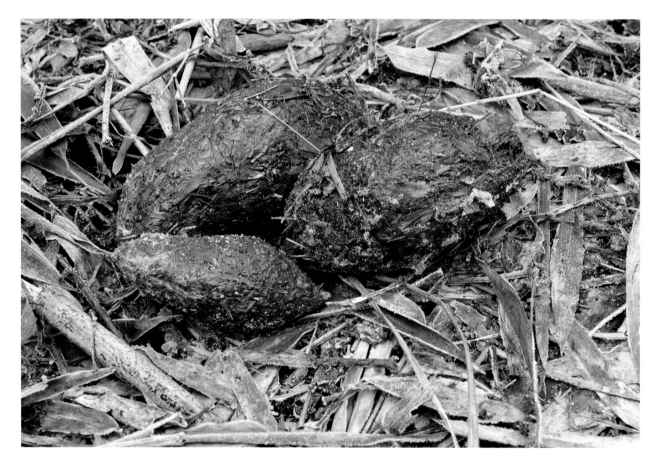

The highly fibrous panda droppings show how poorly the bamboo is digested. Bamboo is not a nutritious food, mostly comprising fiber and cellulose. As pandas cannot digest cellulose they must eat up to 25 kg of bamboo every day, and only 17% of the bamboo dry matter is digested.

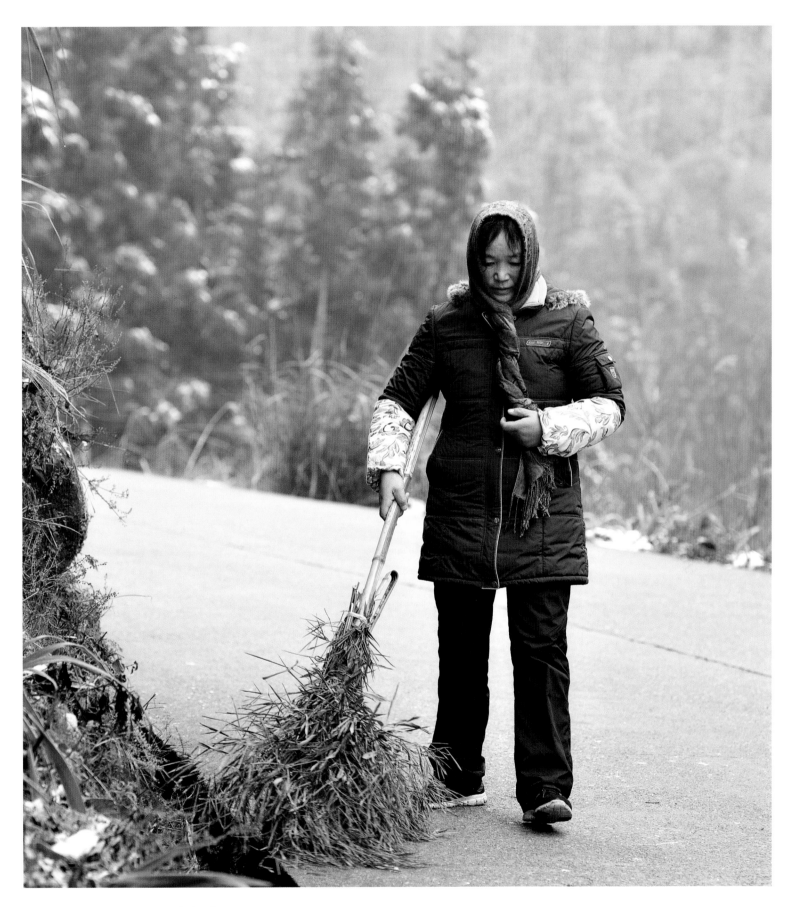

In rural areas, there are many uses for bamboo.

Giant pandas usually live at an altitude of between 2,000 and 3,000 metres above sea level, in broadleaf, coniferous and cloud forests.

A Wintry Solitude

As a panda moves through green or brown forest interiors, the black and white body completely fails to blend in with the surroundings. Come winter, it merges in remarkably well with the dark trunks and white snow. It is difficult to explain the significance of a colouration that appears to benefit an animal for only part of the year.

When the snow falls and blankets the ground for several months, pandas are well adapted for living in these conditions. At very cold conditions they will descend to lower, slightly warmer levels, and when the warmer spring days arrive, pandas will then migrate up the mountain again.

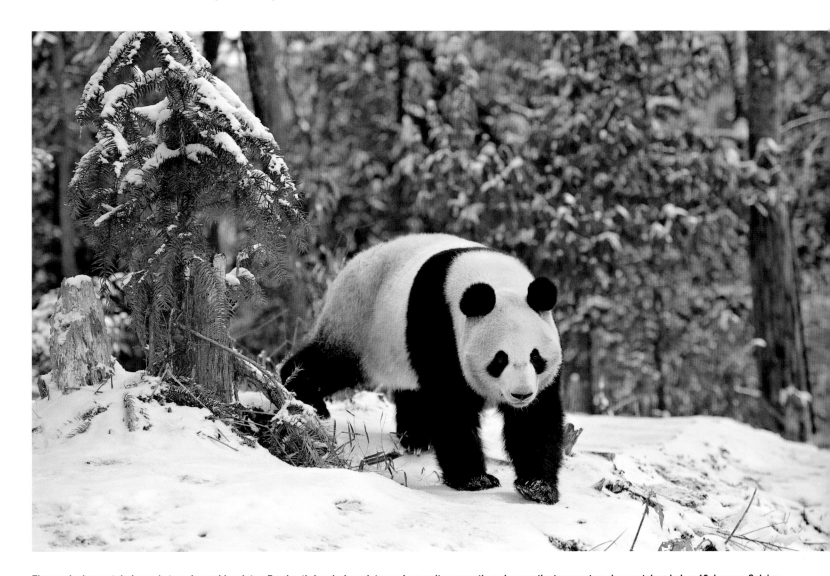

The pandas' mountain home is transformed in winter. Pandas thrive during winter and are quite energetic as long as the temperature does not drop below 10 degrees Celsius.

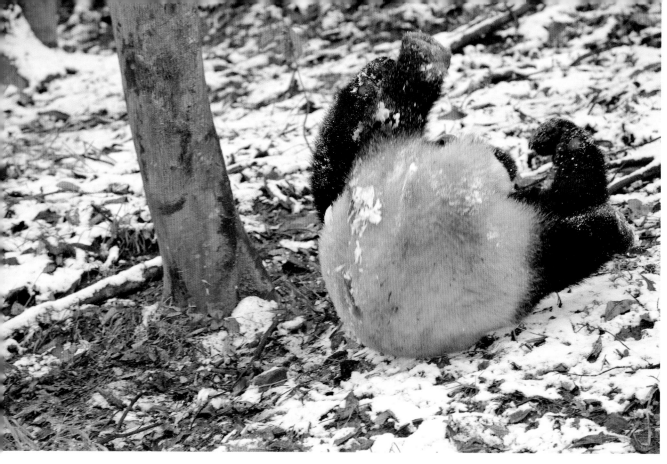

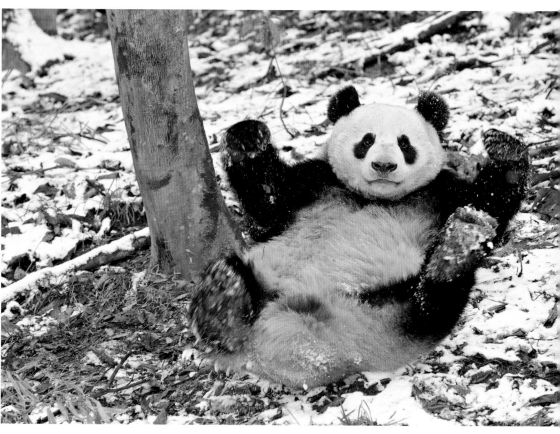

Even 'older' pandas enjoy a roll in the snow.

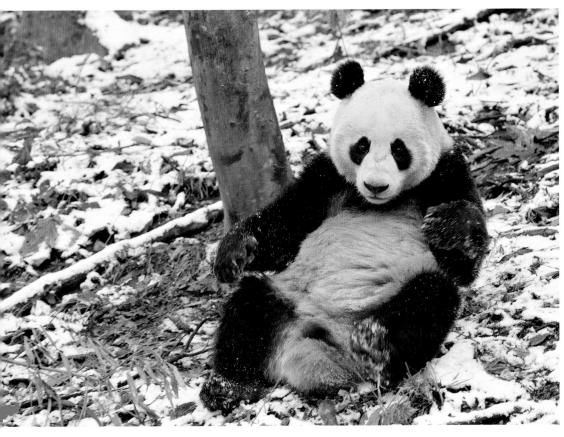

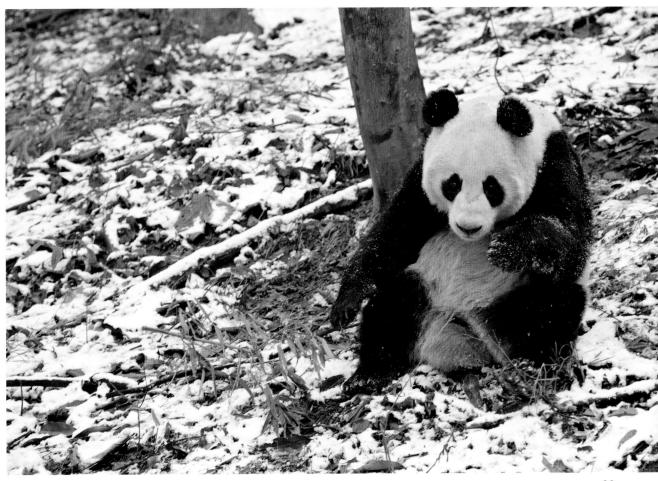

The winter can be a challenging period for humans and wildlife in Sichuan Province.

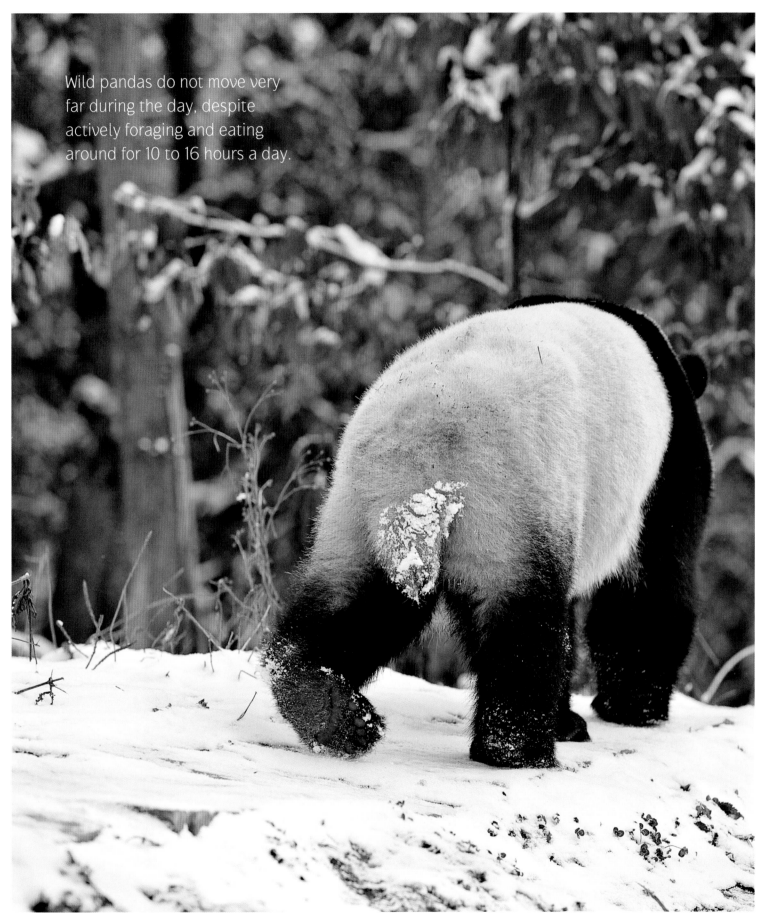

Wild pandas do not move very far during the day, despite actively foraging and eating around for 10 to 16 hours a day.

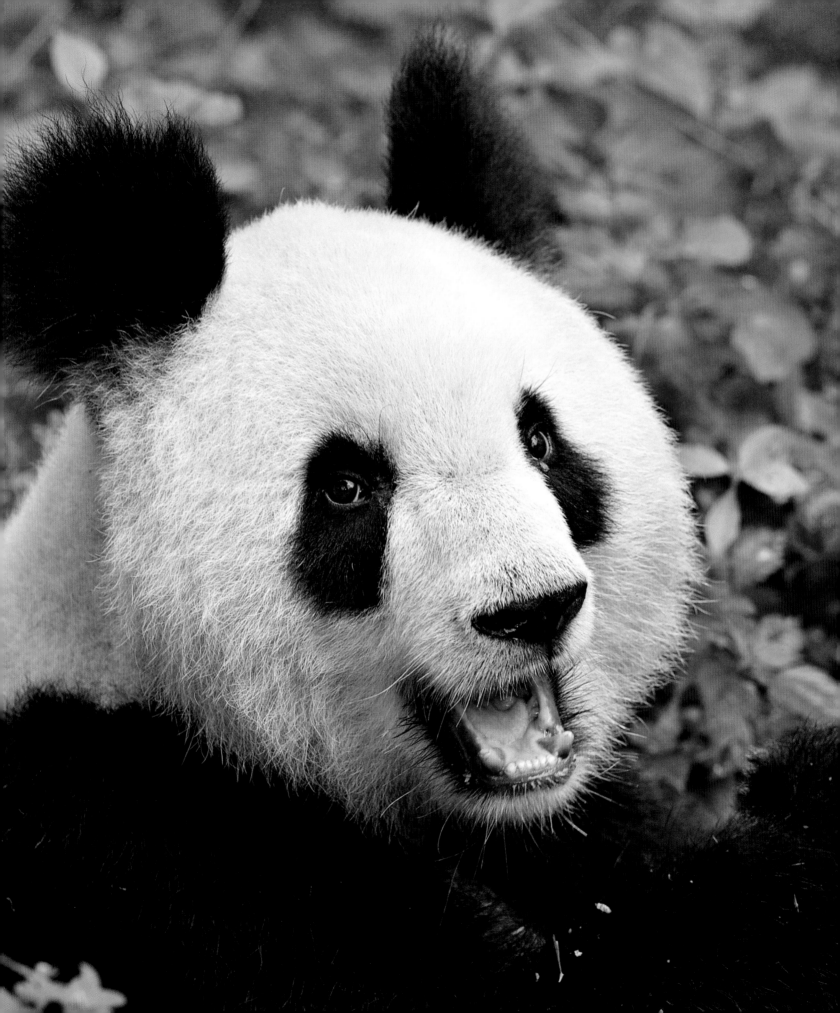

Black and White Panda Facts

Question Does the giant panda hibernate?

Answer The giant panda does not hibernate because
 it can store enough fat on a bamboo diet,
 which is available all year round.

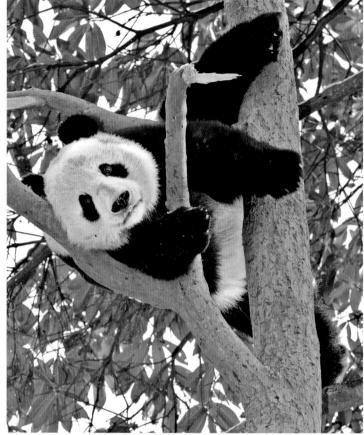

Question Can giant pandas climb trees?

Answer Giant pandas are good tree climbers. They start to climb when they are 6-7 months old.

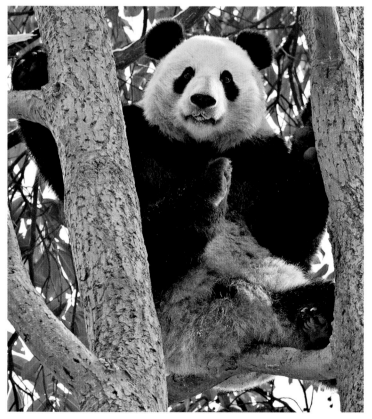

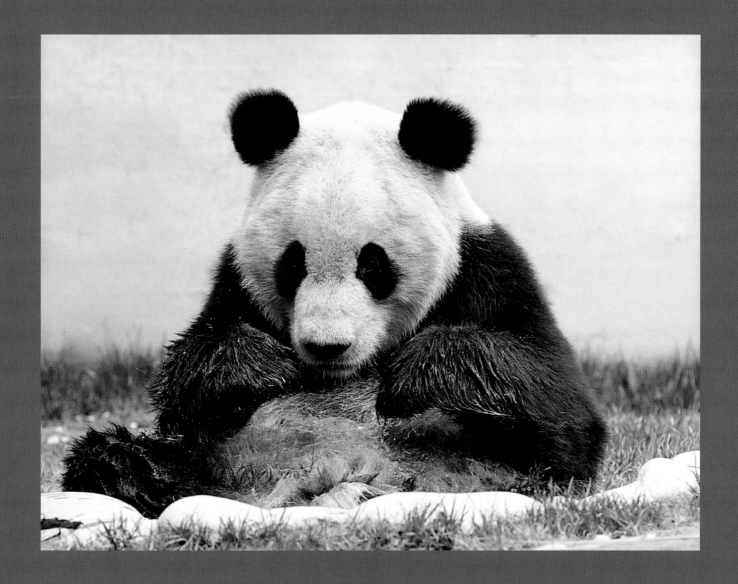

Question Can giant pandas swim?

Answer Yes, they can swim across rivers and streams,
and both old and young pandas take delight
in frolicking in water.

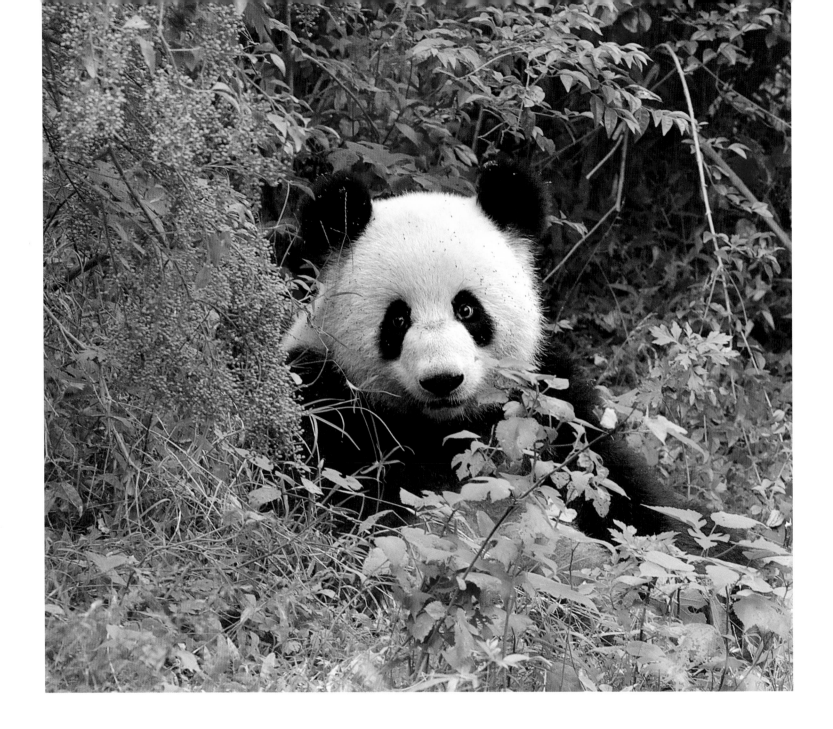

Question Do giant pandas live together?

Answer From birth till 18-24 months, the cub lives with
 its mother. After that they live a solitary life
 until the mating season in March and April
 when the male and female will only encounter
 each other for brief periods.

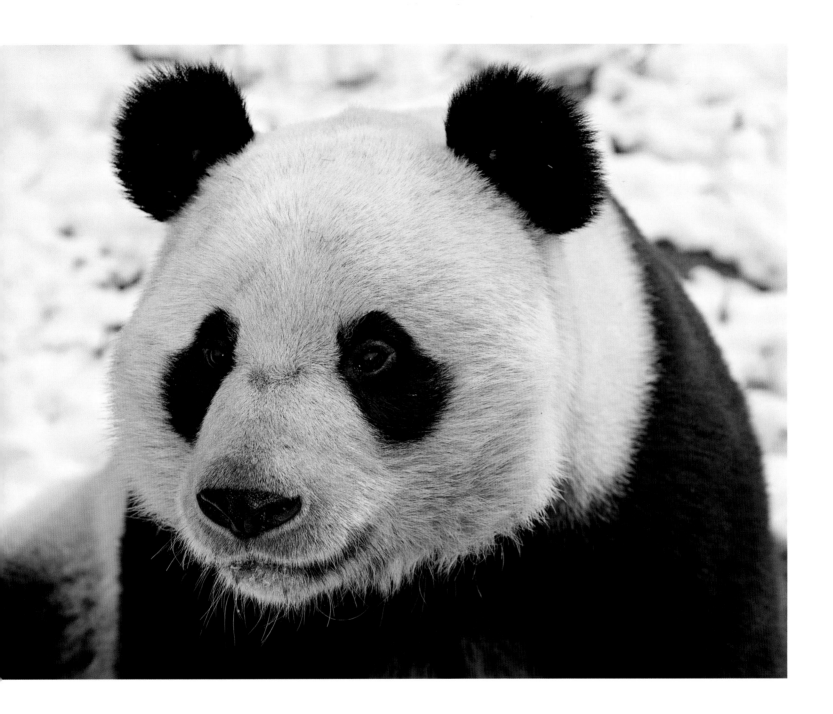

Question How do pandas survive the winter?

Answer They will move from high altitude bamboo forests to mid and low
level mountain slopes and continue to feed on bamboo.

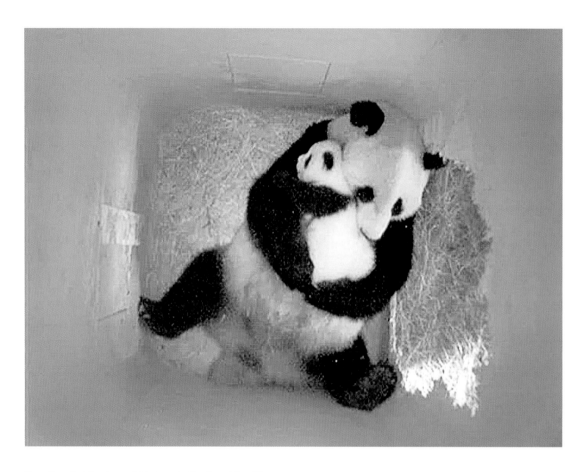

Yang Yang holding her cub Fu Long in the den at Zoo Vienna.

Question Do giant pandas make nests?

Answer Pandas do not have permanent homes. They
 sleep at the bottom of trees, under stumps
 and rock ledges. When females give birth they
 make a den in a tree cavity or stay in caves for
 three to four months.

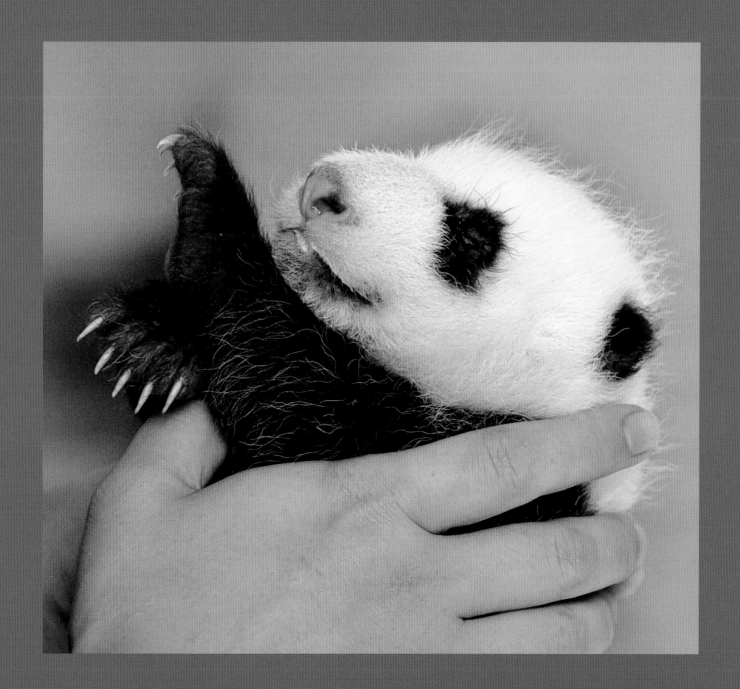

Question How many babies do giant pandas give birth to at one time?

Answer Pandas usually give birth to one or two cubs. If there are
 twins in the wild, only one cub survives. However in captivity
 both can survive if they are hand-raised.

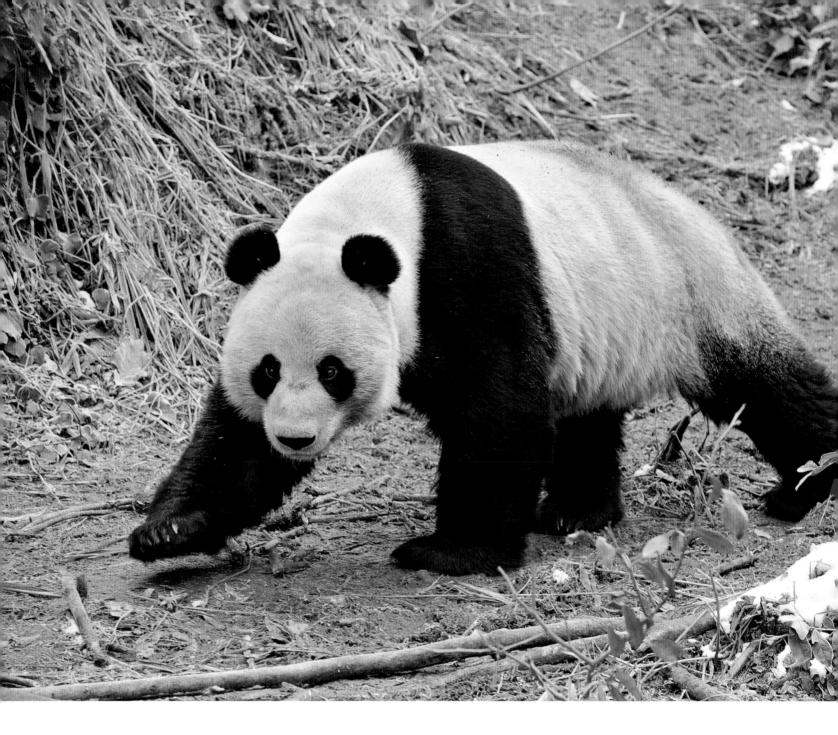

Questions How big is a giant panda?

Answer At birth it is only around 120 grams. A full
grown adult male can weigh 113 kilograms
and a female 100 kilograms. When on all
fours, its height is about 80 centimetres
with a length of 1.5 metres, including a
short tail of 20 centimetres.

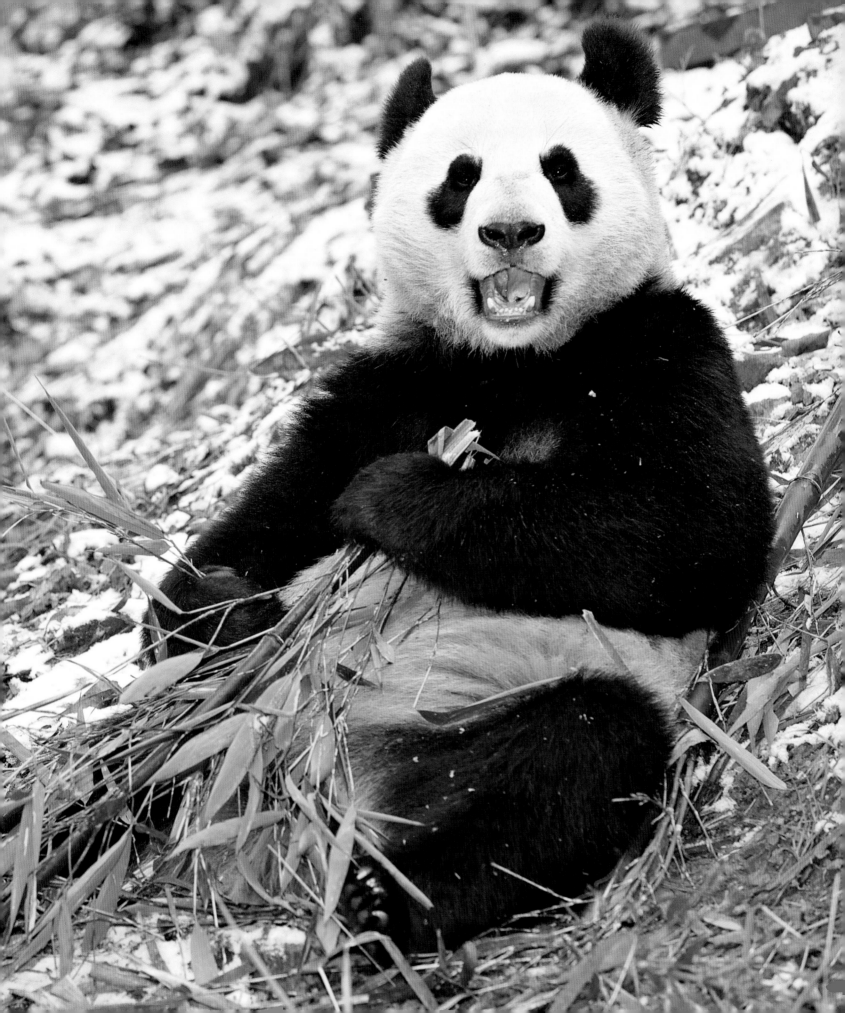

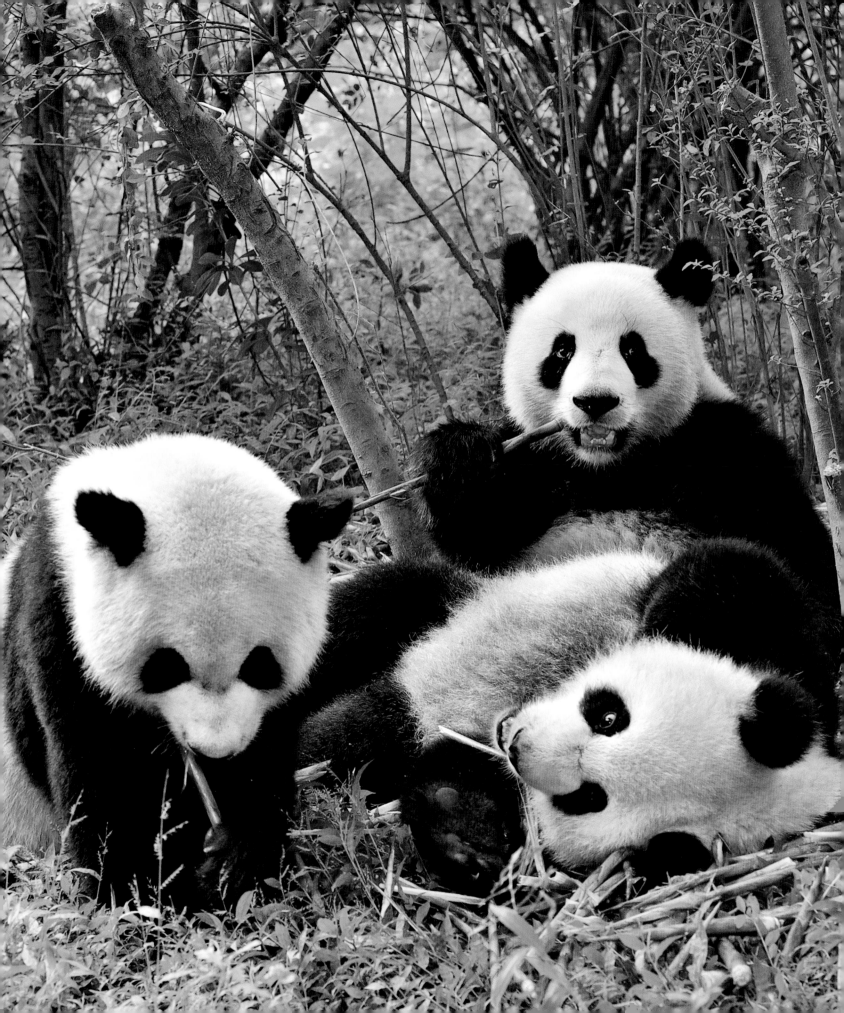

WILDLIFE IN CENTRAL CHINA

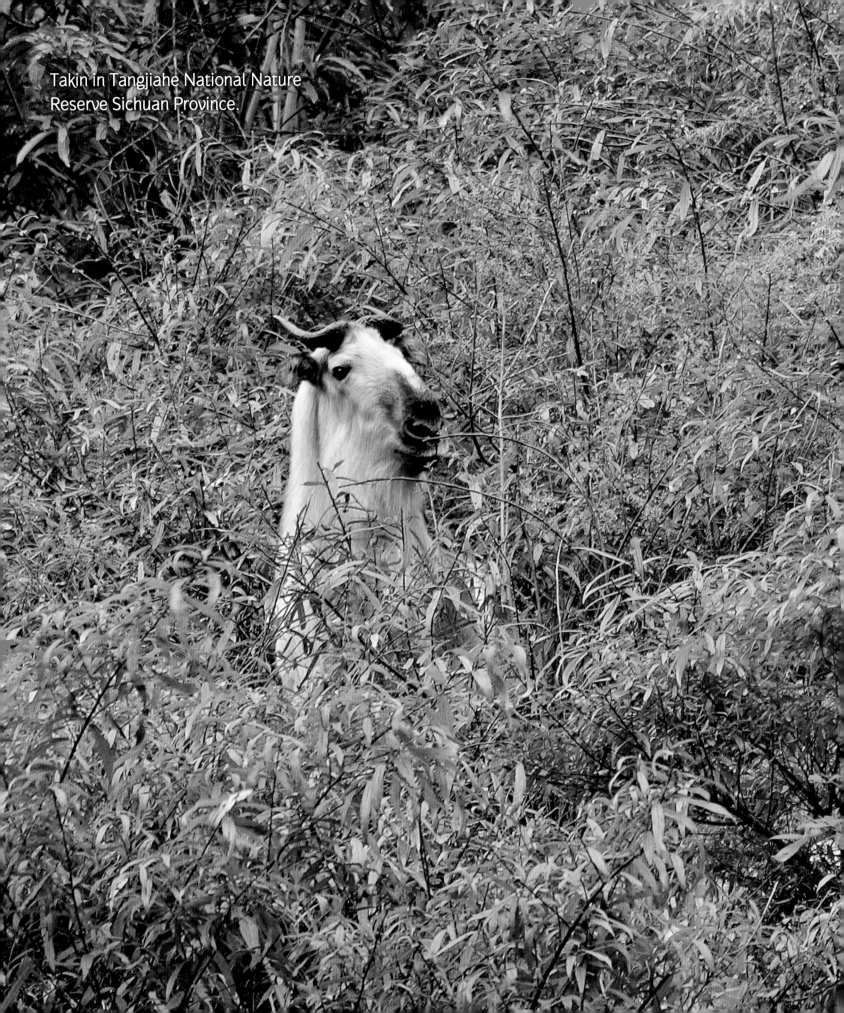

Takin in Tangjiahe National Nature Reserve Sichuan Province.

Wildlife in Central China

The remote habitat of the giant panda is home to a spectacular biodiversity of plants and animals, many of which are threatened by the same forces as the giant panda. Protecting the habitat of the giant panda will automatically help the other species that live in the same area. Most of these plants and animals, however, do not enjoy the celebrity status of the giant panda.

Along with the giant panda, the sanctuary is a refuge to other wildlife treasures like the Takin, which is a large golden-furred hoofed mammal that climbs up and down the steep slopes of the mid-level mountain ranges in the Sichuan province.

In 2006, a World Heritage Site was declared covering the Sichuan giant panda sanctuaries composed of seven Nature Reserves and nine scenic parks in the Qionglai and Jiajin Mountains. The sanctuaries are home to more than 30% of the world's endangered giant pandas, as well as the most important sites for their captive breeding. Along with the giant panda, the sanctuary is a refuge for other wildlife treasures like the Takin, which is a large golden-furred hoofed mammal that climbs up and down the steep slopes of the mid-level mountain ranges in the Sichuan province. The beautiful golden snub-nosed monkeys also add colour to the region's trees, while the glittering golden pheasants shine on the forest floor.

We should not forget other endangered species such as the red panda, the snow leopard, the clouded leopard, the musk deer and the Asiatic black bear. Apart from the tropical rainforests, this area is among the botanically richest sites of the world, and is home to between 5,000 and 6,000 species of flora, of which many are endemic.

According to IUCN (International Union for Conservation of Nature) this area is home to 542 species of vertebrates, including 109 species of mammals (more than 20 % of all Chinese mammals) and 365 birds, 300 of which breed locally, such as leaf warblers, laughing thrushes, rose finches and pheasants. China is recognized as a global centre of pheasant diversity with a total of 63 species, and the sanctuary contains 15. The butterfly fauna is rich with 731 species of *Lepidoptera*. Many animals are endemic to the region.

The wildlife and environment of the panda habitat were once quite insulated from human influence by the sheer remoteness and ruggedness of the landscape. The once continuous forests in these mountains are now reduced and broken into fragmented bamboo forests separated by patches of cleared lands and forests with a bamboo understorey confining the current populations of pandas to high ridges hemmed in by cultivated areas. Chinese authorities have established a network of panda reserves, and linkages now exist among some of these, but the panda's small population size and the small total range remains a potential threat to the viability of this species.

Takin

The takin (*Budorcas taxicolour*), or goat antelopes as they are often called, have some unusual adaptations that help them stay warm and dry during the cold of the mountain winters, when a thick, secondary coat is grown to keep out the chill. Their moose-like snout is also noteworthy, as it has big sinus cavities to warm up the air it inhales before it gets into the lungs. Without this feature takins would lose a large amount of body heat just by breathing.

They can stand up to 1.4 metres at the shoulder, weigh up to 380 kilograms and their lifespan is approximately 15 years in the wild. They forage in the early morning and late afternoon. In the summer, takins feed in alpine meadows up to 4,000 metres above sea level, and in the winter they descend into the valleys and forests, to as low as 1,000 metres. They eat a variety of grasses, bamboo shoots and leaves of shrubs and trees, and regularly visit saltlicks, which make them very vulnerable to poachers. They are threatened and increasingly rare as a result of hunting and forest and habitat loss. China has given the takin full protection under Chinese law, and two reserves have been created, also sharing the habitat with the giant pandas.

The goat antelope is sexually mature at around three and a half years of age. They mate in late summer followed by a 7-month gestation period, and the single young are born in March and April. Within three days of birth, a takin kid is able to follow its mother through most types of terrain. The takin shown here was seen in Tangjiahe National Nature Reserve, Qingchuan County.

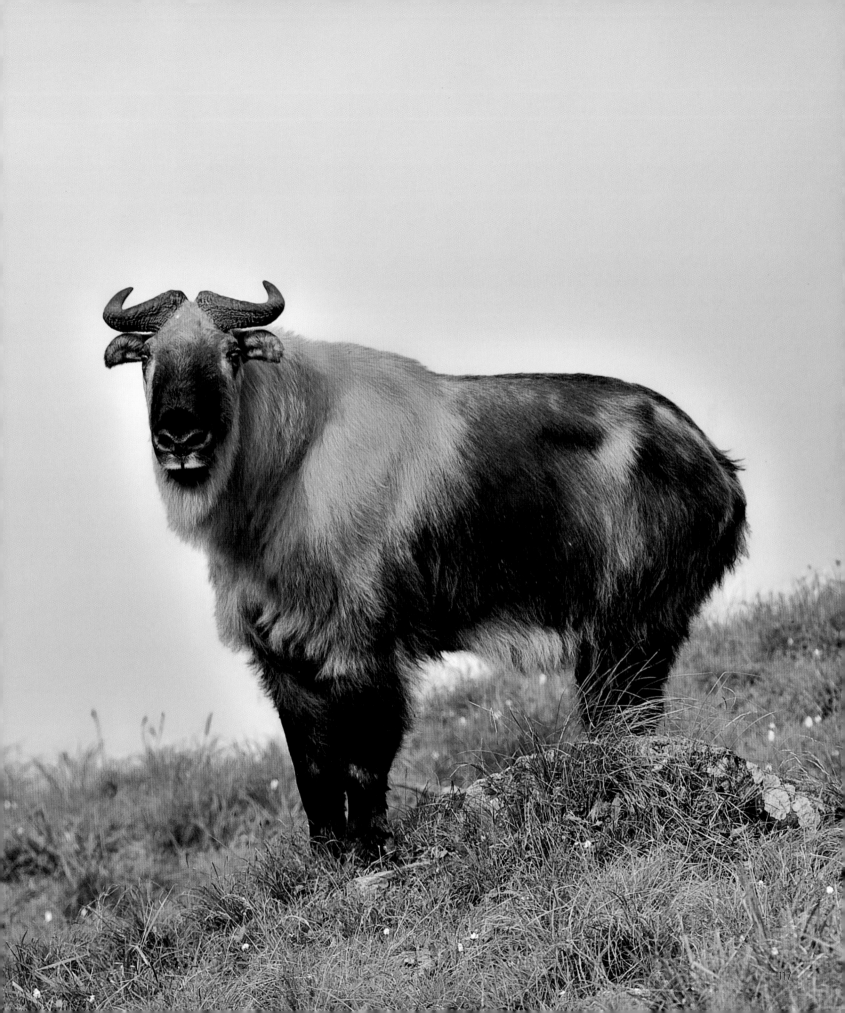

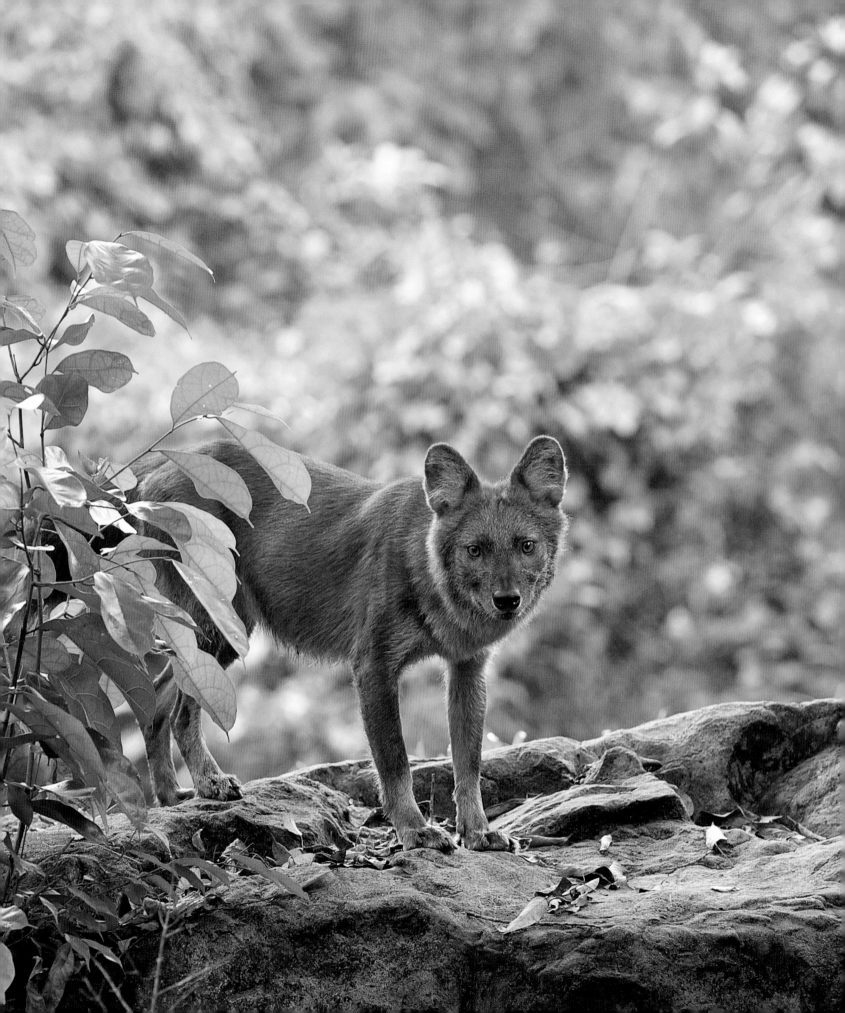

Dhole

The Dhole (*Cuon alpinus*), also called the Asian Wild Dog, is a highly social animal living in large clans. Males may reach a weight of 18 kilograms and females around 14 kilograms, with a body length of just below one metre.

The dhole is unusual in the sense that it does not fit neatly into any categories under the dog subfamilies, like wolves and foxes for example. Unlike their canine counterparts, dholes have only two instead of three molars on each side of their lower jaw and their jaws are relatively shorter. Females dholes also have more teats and can produce up to 12 pups per litter in exceptional cases.

Dholes are communal hunters and usually hunt in groups of about 10 or less. This however, is subject to the availability of prey, and hence they may also hunt

alone or in pairs for smaller preys like infant deers or hares. They prefer foraging at dawn or dusk, but may also hunt at any time of the day or night.

Dhole packs often hunt large prey including wild boar, muntjacs, sambar deer, wild sheep and goats. They can kill animals up to 10 times their own size, and according to the *Smithsonian Book of Giant Pandas*, dholes have been observed to attack giant pandas. Like African wild dogs, dholes let their young eat first at a kill.

Gestation is around 60 days, and births occur in spring with an average of four to six pups in a litter, that become sexually mature in one year. Pups suckle for about two months, and during this time the pack feeds the mother at the den site. Later one or more adults will stay with the pups at the den while the rest of the pack hunts.

When the pups begin to wean, the adult dholes will feed them by regurgitating food until they are old enough to hunt. The pups will remain in the den until around 70-80 days old, and by the time they are about 6 months old, they will accompany the adults to hunt. They start killing larger prey like the sambar deer at around the age of 8 months.

The dhole is endangered mainly as a result of loss of habitat, but also because of livestock predation, persecution of dholes still occurs with varying degrees of intensity in the region.

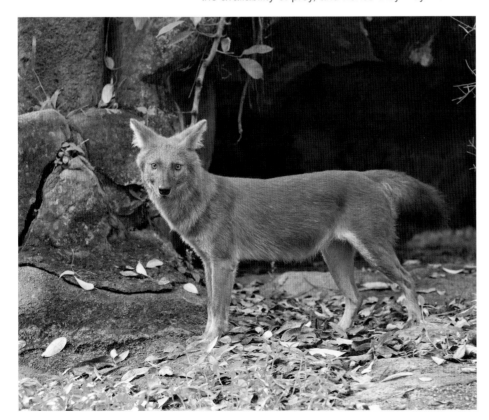

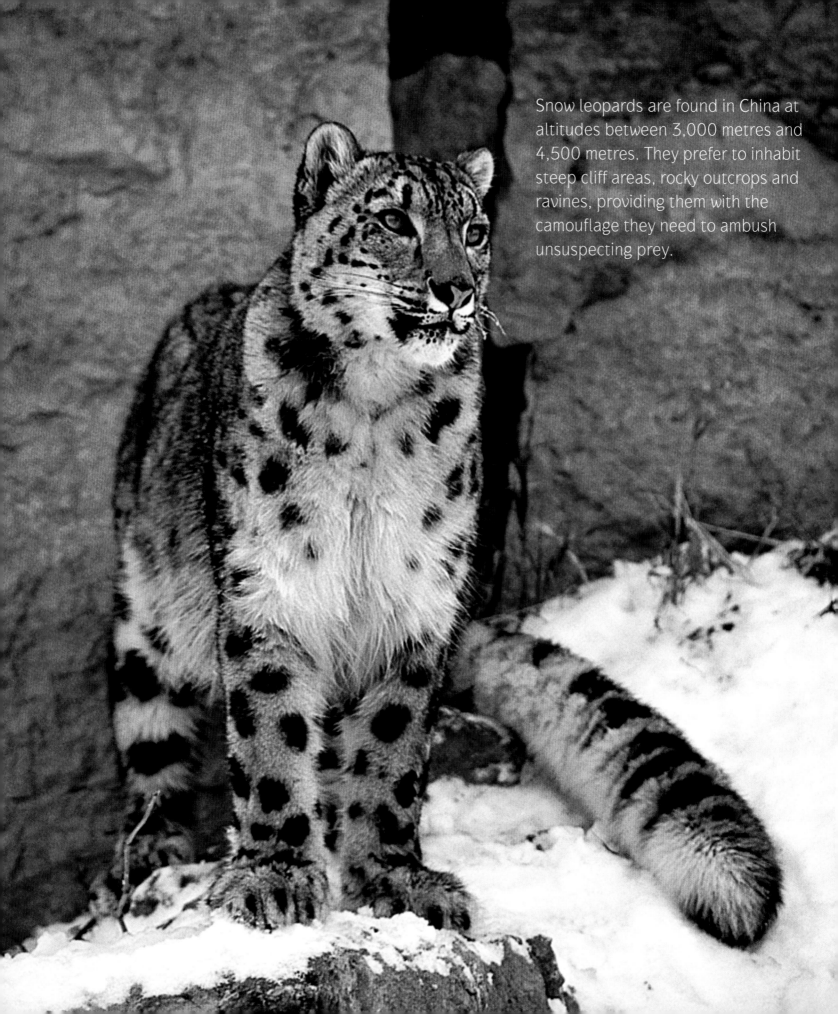

Snow leopards are found in China at altitudes between 3,000 metres and 4,500 metres. They prefer to inhabit steep cliff areas, rocky outcrops and ravines, providing them with the camouflage they need to ambush unsuspecting prey.

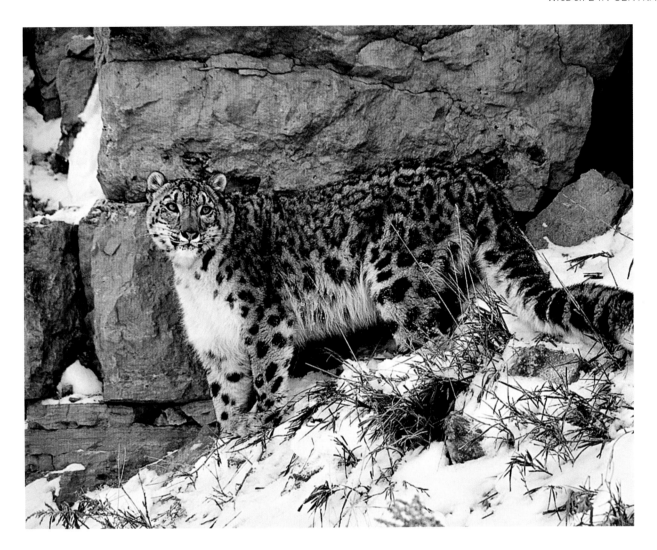

Snow Leopard

The endangered snow leopard (*Panthera uncia*) has a very long bushy tail, which is at least 75% of its total body length, and its legs seem to be disproportionately short. They have several adaptations for living in a cold mountainous environment. Their bodies are stocky, their fur is thick, and their ears are small and rounded, all of which help to minimize heat loss. Their paws are wide, which distributes their weight better for walking on snow, and have fur on their pads to increase their grip on steep and unstable surfaces, as well as to protect them from heat loss.

Snow leopards are found in China at altitudes between 3,000 metres and 4,500 metres. They prefer to inhabit steep cliff areas, rocky outcrops and ravines, providing them with the camouflage they need to ambush unsuspecting prey. Snow leopards can kill prey up to three times their own weight, which is up to around 70 kilograms. The most common prey are wild sheep, wild goats, hares, and game birds. According to *Mammals of China* there are several accounts that snow leopards appear to take advantage of snow, fog, and rain, and may hunt more intensively during those times. Often they will kill a large prey animal every two weeks, and will occasionally take livestock.

They pair during mating season in January to mid-March, and give birth between three and three and a half months later. The average litter size consists of two or three young.

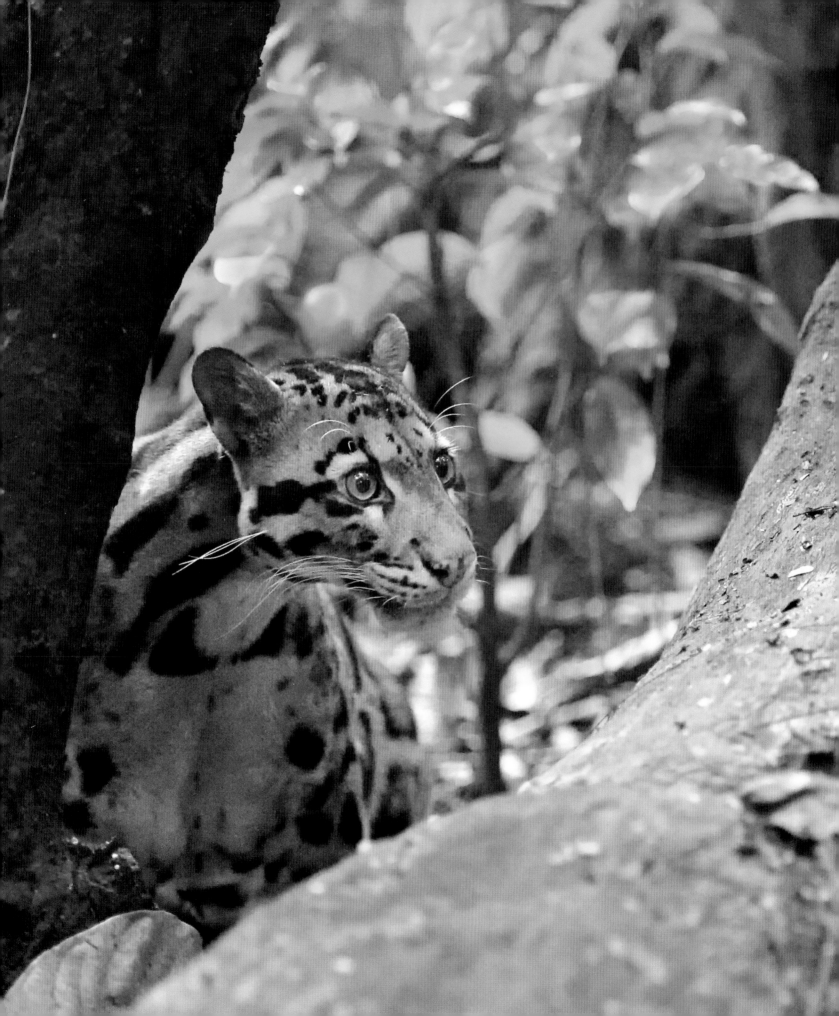

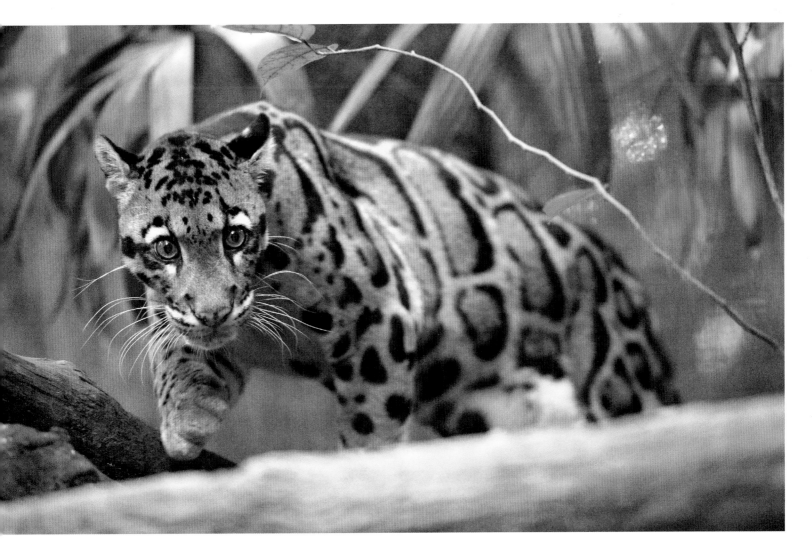

Clouded Leopard

The clouded leopard (*Neofelis nebulosa*) is found across South and Central China, and is noted for its distinctive cloud-shaped markings. The males weigh up to 30 kilograms, while the females are significantly smaller. The clouded leopard has the longest upper canine teeth for its skull size compared to other modern carnivores.

It is one of the best climbers in the cat family, and is able to climb upside down underneath tree branches and hang from branches with its hind feet. Their amazing arboreal skills stem from several physical adaptations. Their short and stout legs provide excellent leverage and a low centre of gravity. Their large paws and sharp claws also allow them to get a good grip on tree branches. Their long tail, which measures up to 90 centimetres and is about the same length as their body, also functions to help them balance.

They are thought to hunt a variety of prey including pheasants, squirrels, macaques, deer, and wild pigs. It was once thought that clouded leopards hunted while climbing. Current knowledge, however, is that most hunting is likely to take place on the ground after dark.

Clouded leopards are sexually mature at the age of two years. The gestation period is approximately three months with one to five cubs produced per litter. Cubs are independent at around 10 months of age. Females can produce a litter every year.

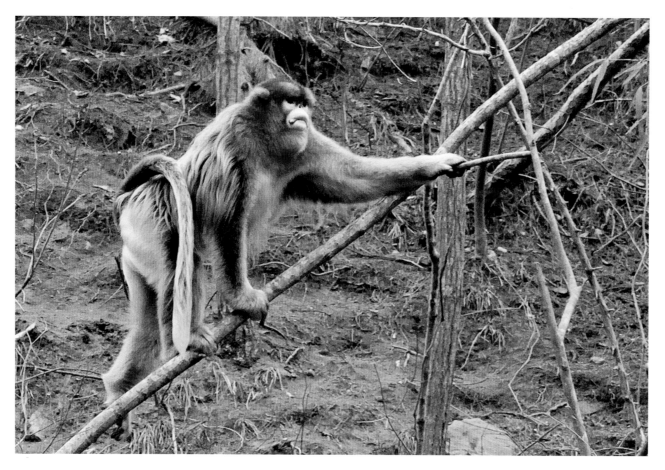

Once hunted for their beautiful fur, the golden snub-nosed monkeys are now endangered, and Chinese law protects these primates as strictly as it does pandas.

Golden Snub-nosed Monkey

The golden snub-nosed monkey (*Rhinopithecus roxellana*), also called the Sichuan snub-nosed monkey, is a beautiful, large long-tailed monkey with golden yellow guard hair on its back. The large males can weigh up to 17 kilograms, with females about half the size. The species is endemic to Central China and inhabits sub-alpine conifer forests from 2,000 metres to 3,500 metres, descending into broadleaf and mixed forests during the winter months.

It feeds on lichens found on dead trees, a wide variety of young leaves, fruits and seeds, as well as flowers. This diet can vary from season to season, showing a correlation between food availability and home range. The golden snub-nosed monkey lives in very large troops reaching a hundred or more individuals, often composed of many subgroups that may disperse and regroup in irregular patterns.

Females typically start breeding from the age of five, while males do not become sexually mature until the age of 6-7 years. The mating season takes place in the fall, with births occurring in spring.

The golden snub-nosed monkey is endangered primarily due to habitat loss.

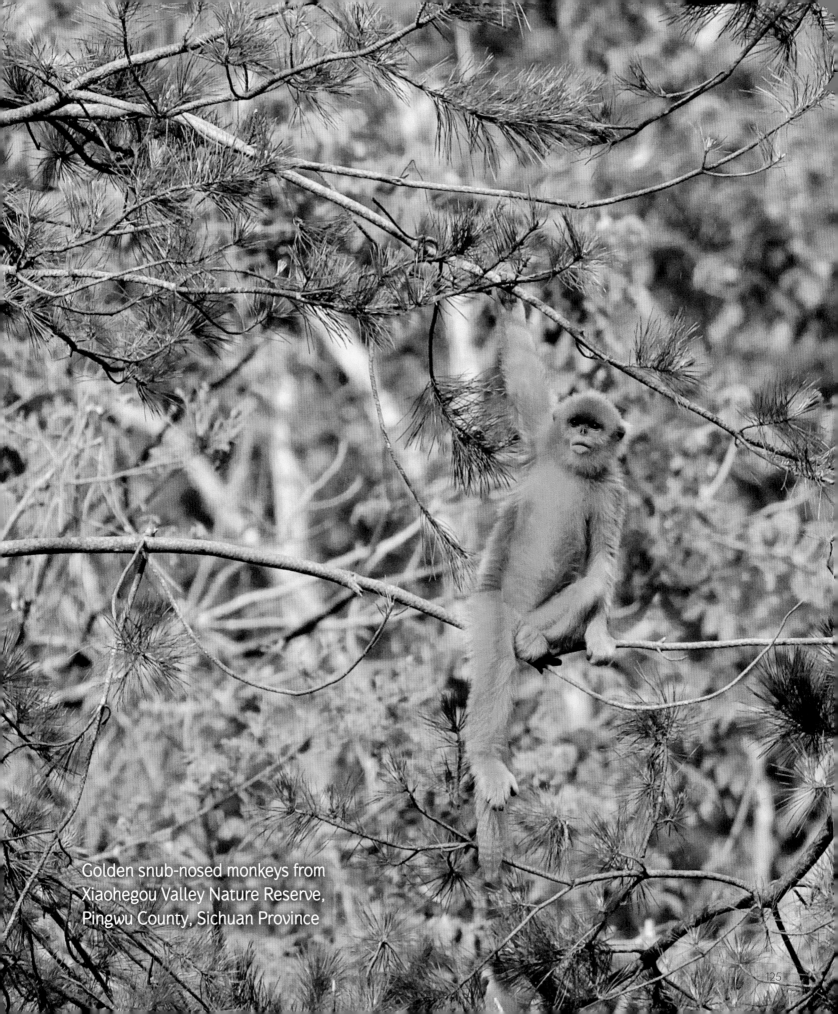

Golden snub-nosed monkeys from
Xiaohegou Valley Nature Reserve,
Pingwu County, Sichuan Province

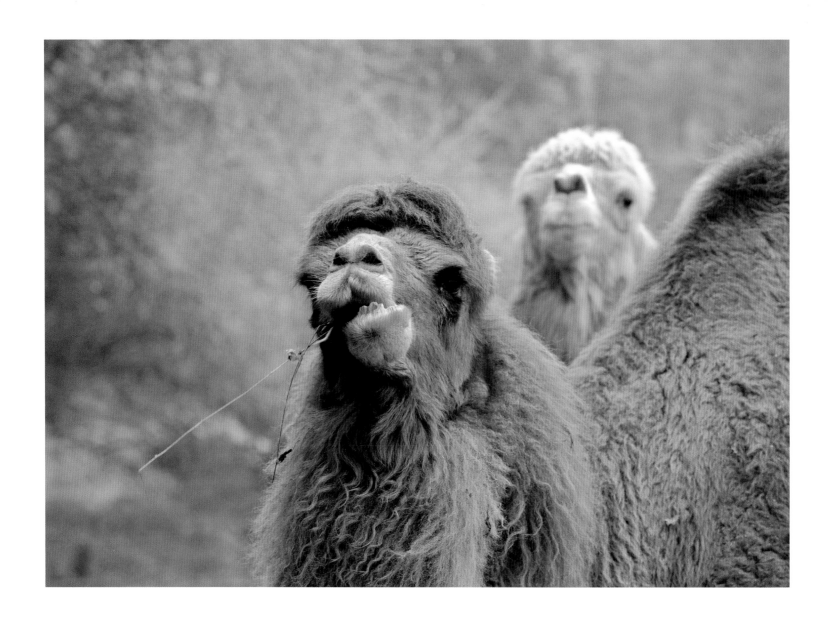

The two-hump bactrian camel (*Camelus bactriamus*) is a critically endangered species in China; however, it has been domesticated for over 4,000 years, and the domesticated form is common in many areas in China.

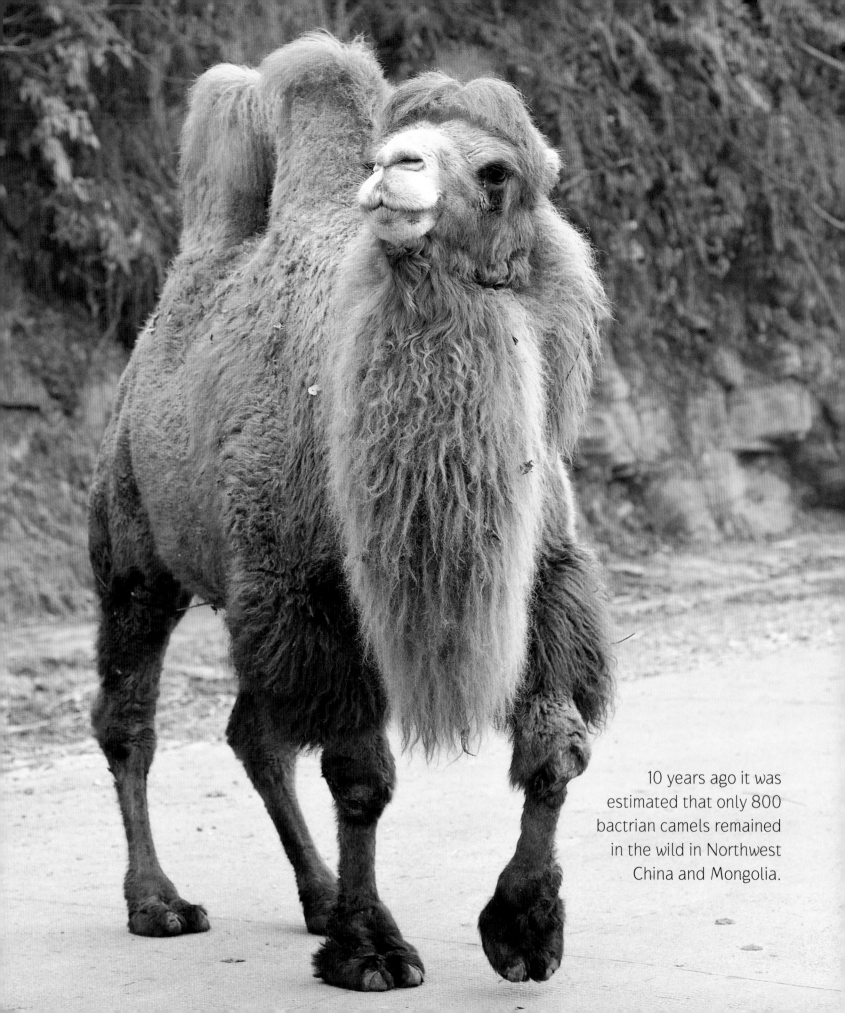

10 years ago it was estimated that only 800 bactrian camels remained in the wild in Northwest China and Mongolia.

The Other Panda

The red panda (*Ailurus fulgens*) is the original panda, named in 1825 by the French scientist Frèdèric Cuvier nearly 50 years before the giant panda was 'discovered'. Only after 'experts' erroneously concluded that the giant panda was more closely related to it than to bears, did it suffer the indignity of becoming known as the lesser panda, or red panda, which is now the preferred common name.

The red panda is endemic to the temperate forests from the foothills of western Nepal to the Qinling Mountains of the Shaanxi Province in the east.

Red pandas are enchanting animals that deserve to be better known. They typically grow to the size of a big house cat, and also have retractable claws.

Reproduction for the female red pandas begins around the age of 18 months, and they become fully mature at around two to three years old. The adults rarely come into contact in the wild, other than to mate. During the mating season which takes place from mid-January to early March, both sexes may mate with more than one partner.

Females typically give birth to one to four young. Young red pandas remain in their nests for about 90 days, during which time their mother cares for them. Males take little or no interest in their offspring.

At around five kilograms the red panda is much smaller than its black and white bamboo-eating counterpart. As mentioned, bamboo is a steady food source. However, the downside is the low nutritional value, which comes with its own constraints, making it necessary for the red panda to focus on eating the more nutritious leaves and smaller shoots. Together with a very low rate of metabolism thus making survival possible in an otherwise difficult environment. These animals spend most of their lives in trees and even sleep there. When foraging, they are most active at night as well as in the gloaming hours of dusk and dawn. They favour territories on south-facing slopes, where they can sunbathe in the treetops, as the warmth helps them conserve energy and reduces their feeding time.

A red panda's brownish and black fur serves as good camouflage as the colour matches the moss found on trees and help it to blend in while they are on top. The red panda also wraps its bushy tail around its body to keep warm during winter.

Like the giant panda, red pandas have an enlarged wrist bone that forms a sixth digit, like a thumb, on each front paw, although this is not as well developed as the giant panda's. This digit is used to grasp and pull down bamboo and other plant stems when feeding.

Red pandas have a taste for bamboo, but unlike giant pandas, they are opportunistic eaters consuming many other types of food including fruit, roots, eggs, young birds, small rodents and insects.

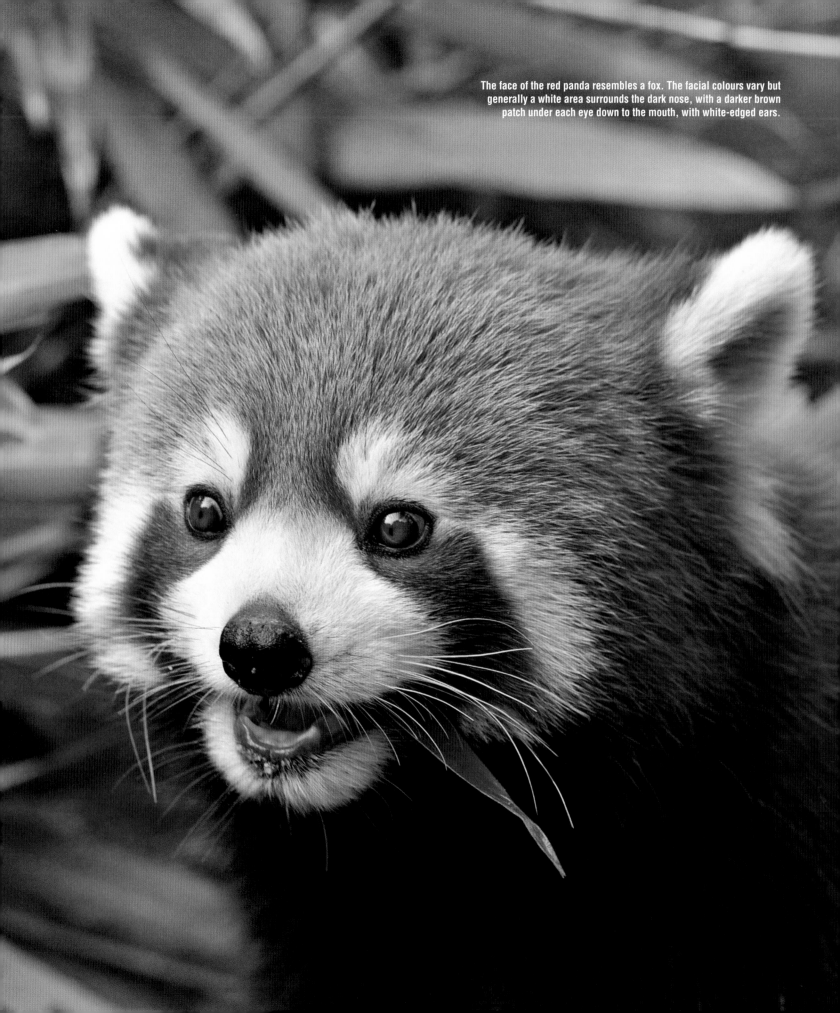

The face of the red panda resembles a fox. The facial colours vary but generally a white area surrounds the dark nose, with a darker brown patch under each eye down to the mouth, with white-edged ears.

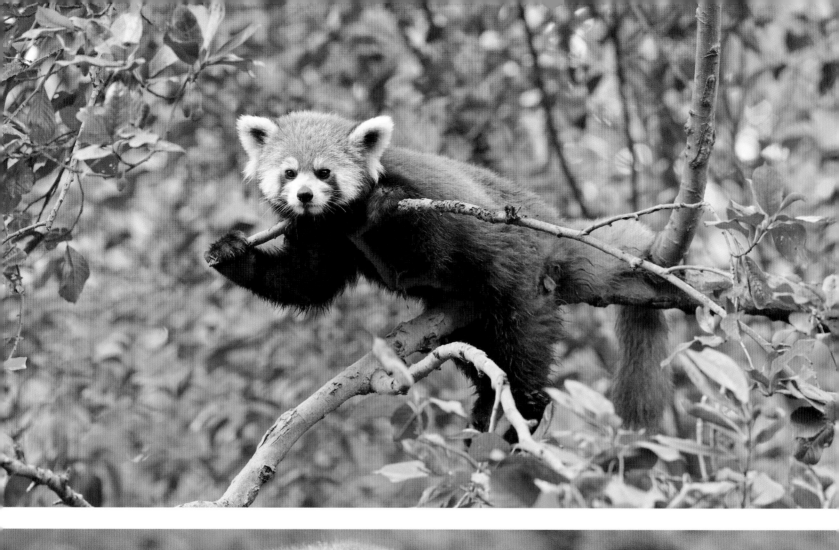

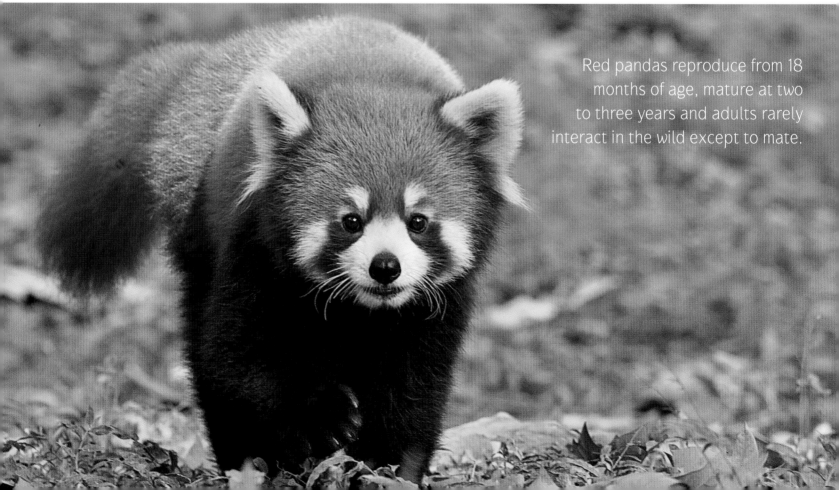

Red pandas reproduce from 18 months of age, mature at two to three years and adults rarely interact in the wild except to mate.

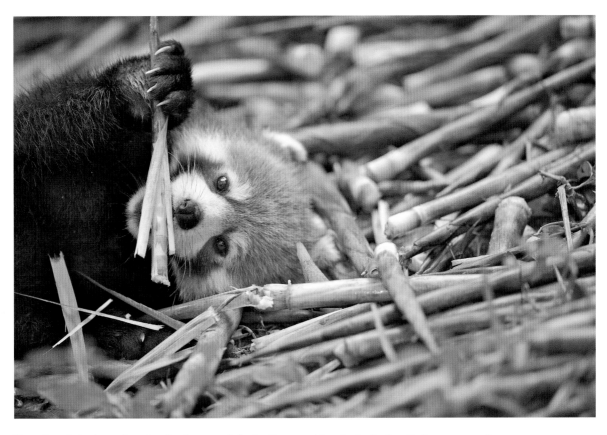

The red panda feeds mostly on bamboo leaves and shoots. They spend time to slowly chew the leaves, as can be seen in the photo. This is important to produce a more efficient food digestion process. Based on genetic evidence and new fossil finds, scientists believe that the giant pandas and the red panda independently evolved as bamboo specialists.

Red pandas have evolved several ways of meeting their energy demands to cope with the scarcity of food during winter months. They can spend up to 13 hours a day foraging and eating bamboo. Their low metabolic rate, almost comparable to sloths, can be slowed further during the colder months. Finally, the thick fur that covers their entire body, as well as the soles of their feet, also allows them to conserve body heat.

Red pandas may lose up to 15 percent of their body weight during winter when their other preferred foods, like insects, are not readily available.

The main threats to red pandas are direct harvest from the wild, deforestation, habitat degradation, loss or fragmentation. The relative importance of these factors may differ from one region to another, and requires more extensive research in order to be understood. For instance, the biggest threat in India is that of habitat loss while in China, threats stem from hunting and poaching.

Not only does the red panda share a name, it also shares its habitat with the giant panda. It too is endangered in China. The red panda has been classified as vulnerable in the IUCN Red List since 2008.

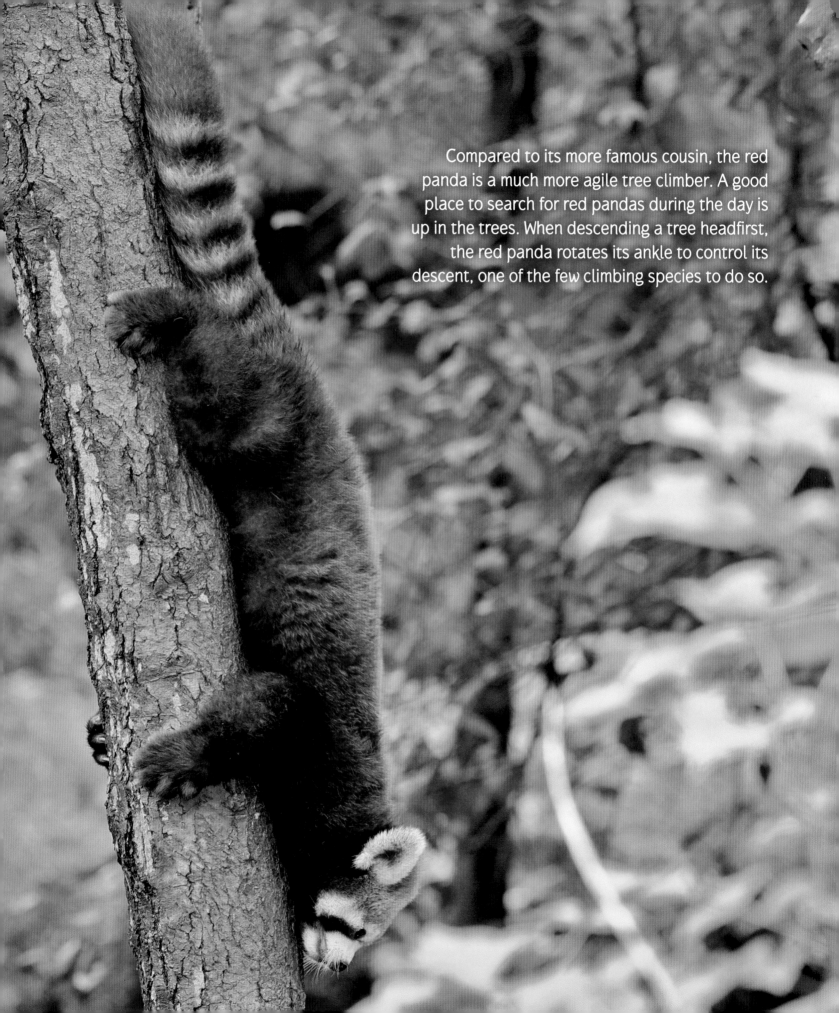

Compared to its more famous cousin, the red panda is a much more agile tree climber. A good place to search for red pandas during the day is up in the trees. When descending a tree headfirst, the red panda rotates its ankle to control its descent, one of the few climbing species to do so.

The ears of the red panda are very visible, mostly white from the front, but black with white edges if seen from behind.

These animals spend most of their lives in trees and even sleep there. When foraging, they are most active at night as well as in the gloaming hours of dusk and dawn.

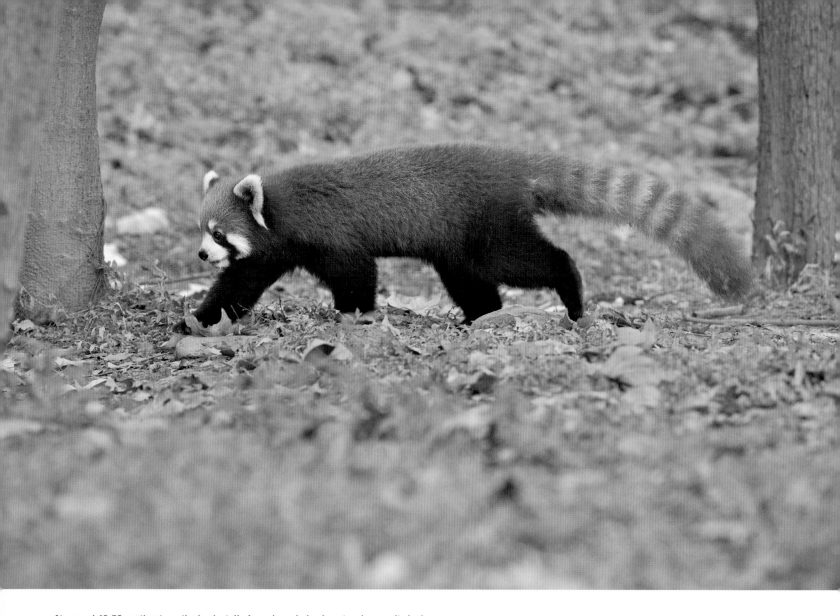

At around 40-50 centimetres, the bushy tail of a red panda is almost as long as its body

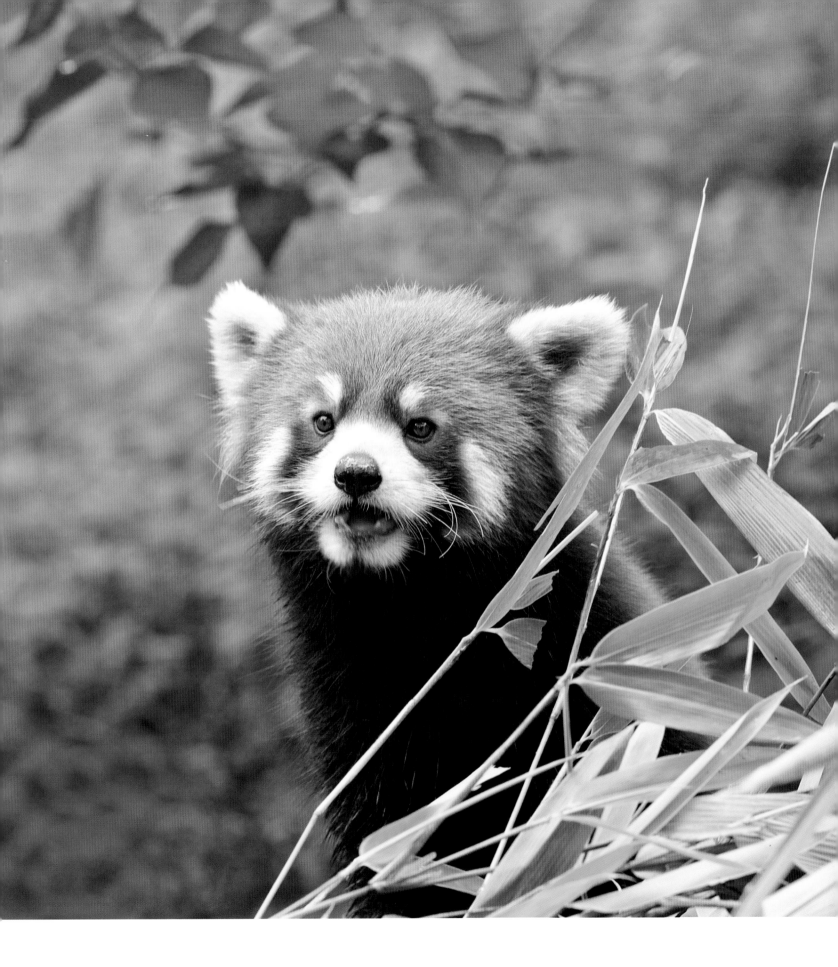

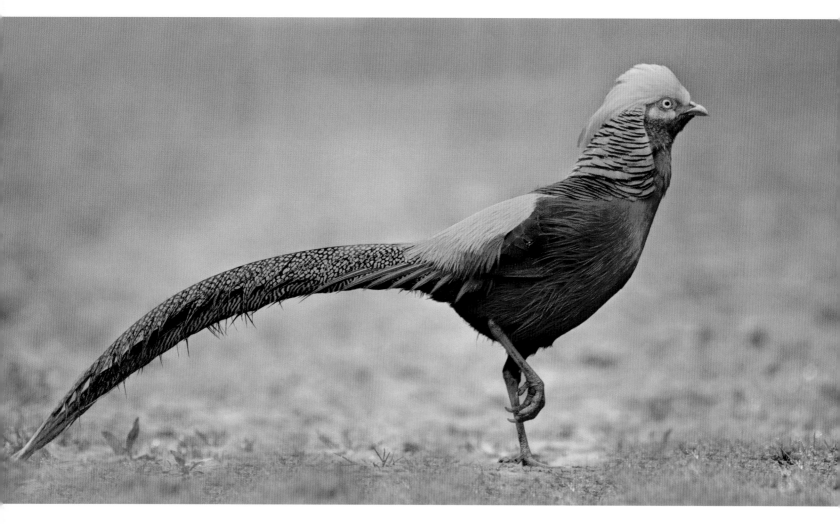

The golden pheasant (*Chrysolophus pictus*) is perhaps the most well known pheasant in China, where it is native to forests in mountainous areas in central and western provinces. Despite the male's showy appearance, these hardy birds are difficult to see in their natural habitat, which is dense and dark conifer forests. China is recognized as a global centre of pheasant diversity with a total of 63 species, and the Tangjiahe National Nature Reserve, Qingchuan county is home to 15 of them.

Birds

The Sichuan province and its Giant Panda Sanctuaries, which became a world Heritage Site in 2006, are also renowned for their variety of birdlife. According to IUCN, a total of 365 birds species can be found there, and 300 species are breeding locally.

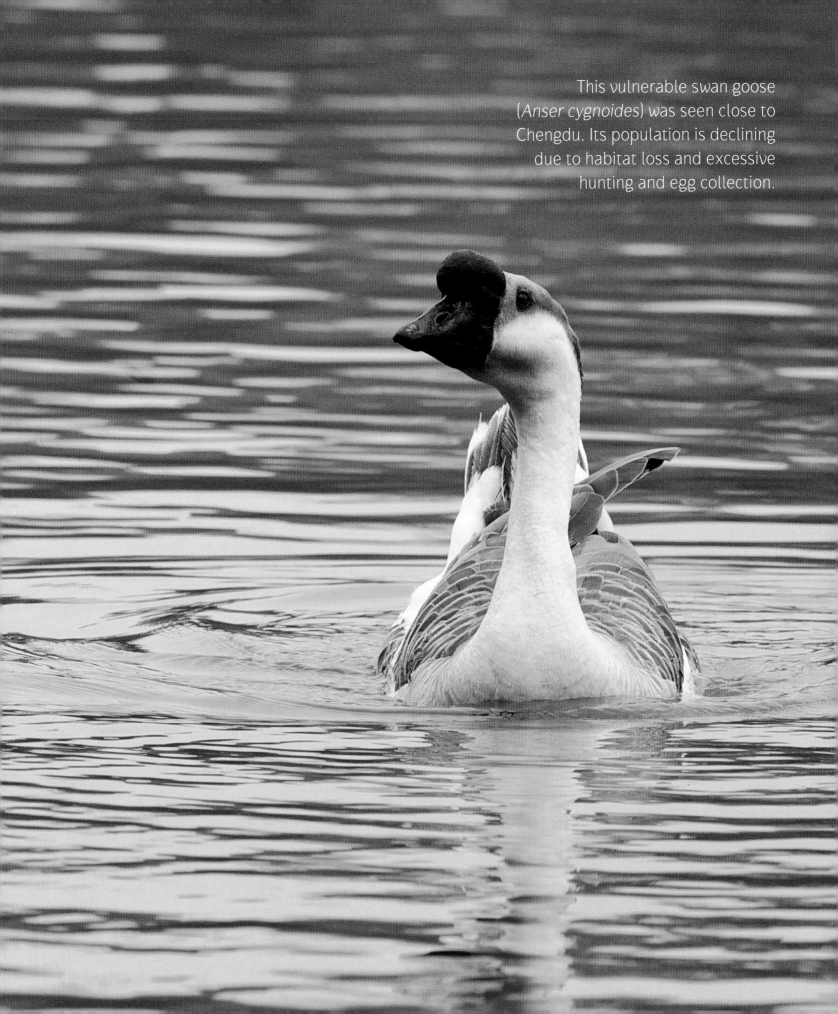

This vulnerable swan goose (*Anser cygnoides*) was seen close to Chengdu. Its population is declining due to habitat loss and excessive hunting and egg collection.

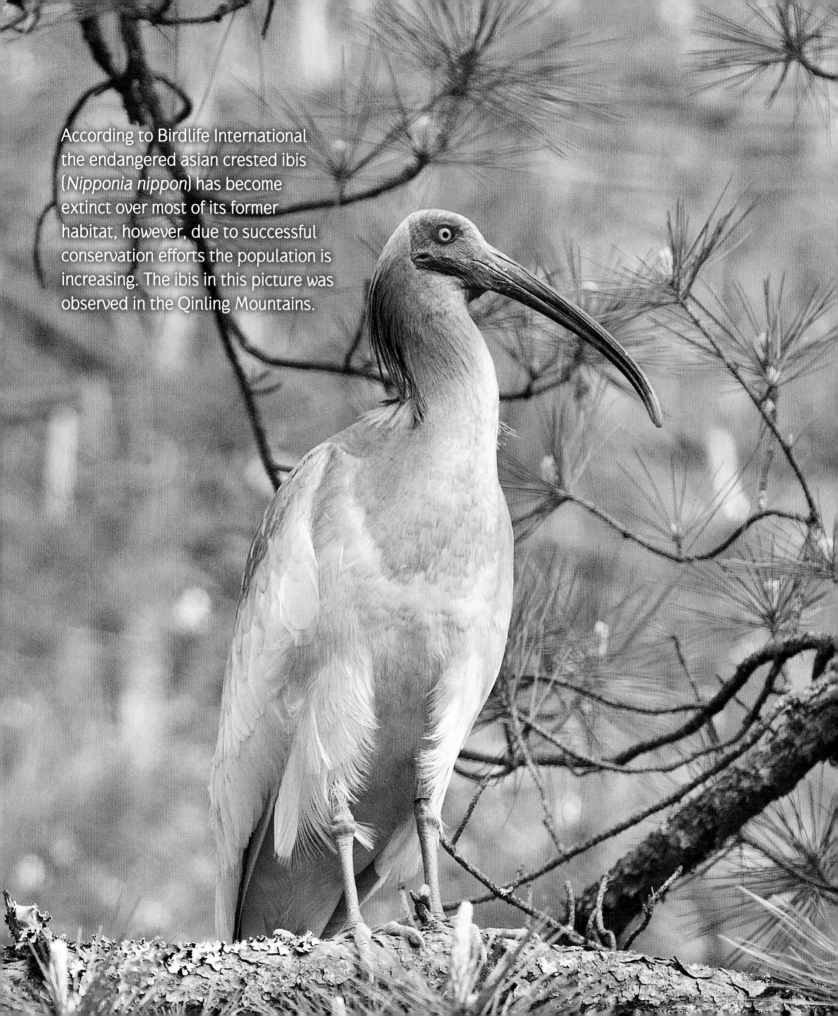

According to Birdlife International the endangered asian crested ibis (*Nipponia nippon*) has become extinct over most of its former habitat, however, due to successful conservation efforts the population is increasing. The ibis in this picture was observed in the Qinling Mountains.

Female Berezovski's blood pheasant (*Ithaginis cruentus berezowskii*) from Tangjiahe National Nature Reserve, Qingchuan county, Sichuan.

The Red-billed Leiothrix (Leiothrix lutea) is a pretty and colourful babbler with a conspicuous red bill. It lives in noisy chattering flocks in undergrowth of secondary forests. Unfortunately it is a favoured cage bird because of its active singing and beauty. Photo taken just outside Chengdu.

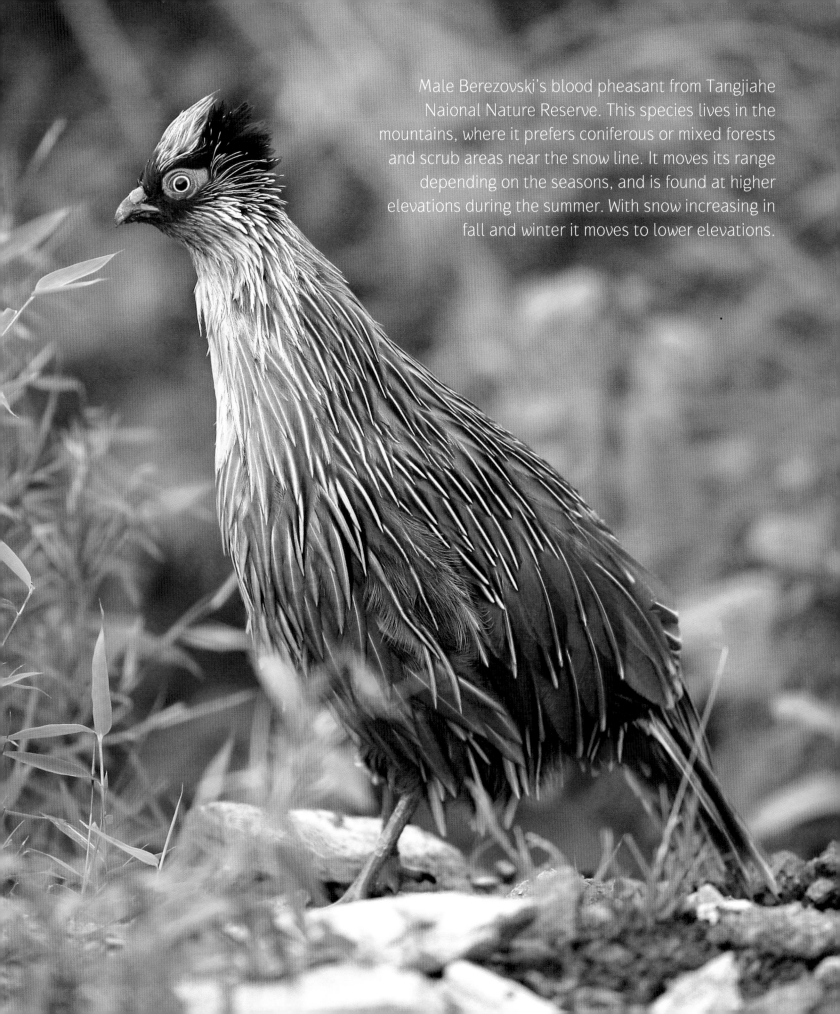

Male Berezovski's blood pheasant from Tangjiahe Naional Nature Reserve. This species lives in the mountains, where it prefers coniferous or mixed forests and scrub areas near the snow line. It moves its range depending on the seasons, and is found at higher elevations during the summer. With snow increasing in fall and winter it moves to lower elevations.

Ginkgo biloba cultivar

Iris species

Comos cultivar

Flora

IUCN notes that the Sichuan Giant Panda Sanctuaries have a total of 6 vegetation zones containing between 5,000 and 6,000 species of flora, with over 4,000 flowering plants. The reason for this diversity includes the wide range of different habitats due to the large altitudinal range and the variety of rock and soil types. The sanctuary is a significant global diversity centre for many plant groups such as roses, magnolias, bamboos, and rhododendrons. Of the latter, there are more than 100 species listed for the area. The site is a major source and gene pool for hundreds of traditional medicinal plants, many of which are now rare and endangered.

Nandina domestica

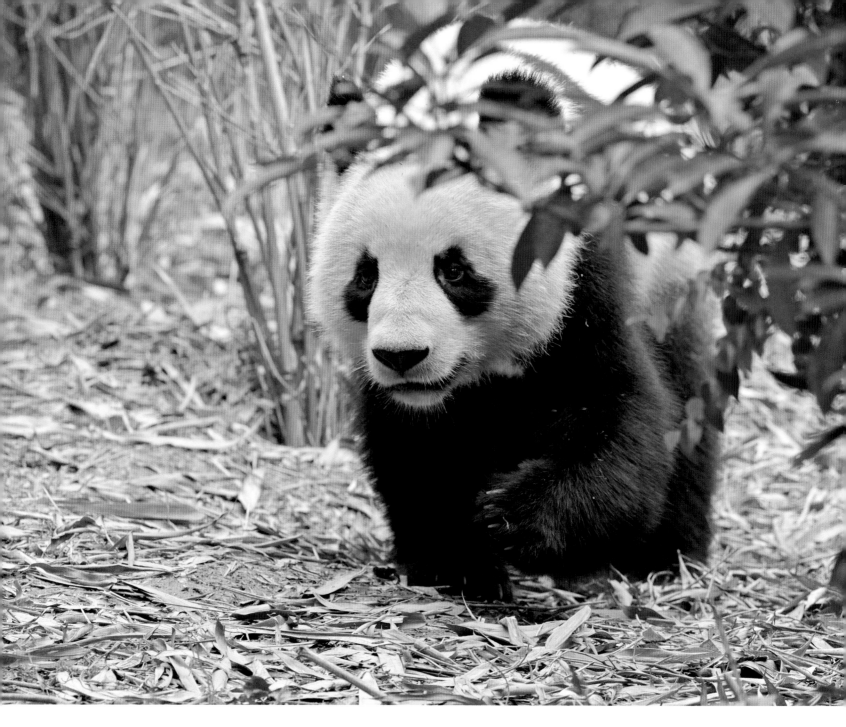

Pandas are very rarely seen in the wild, which makes it notoriously difficult to estimate the population and growth trends.

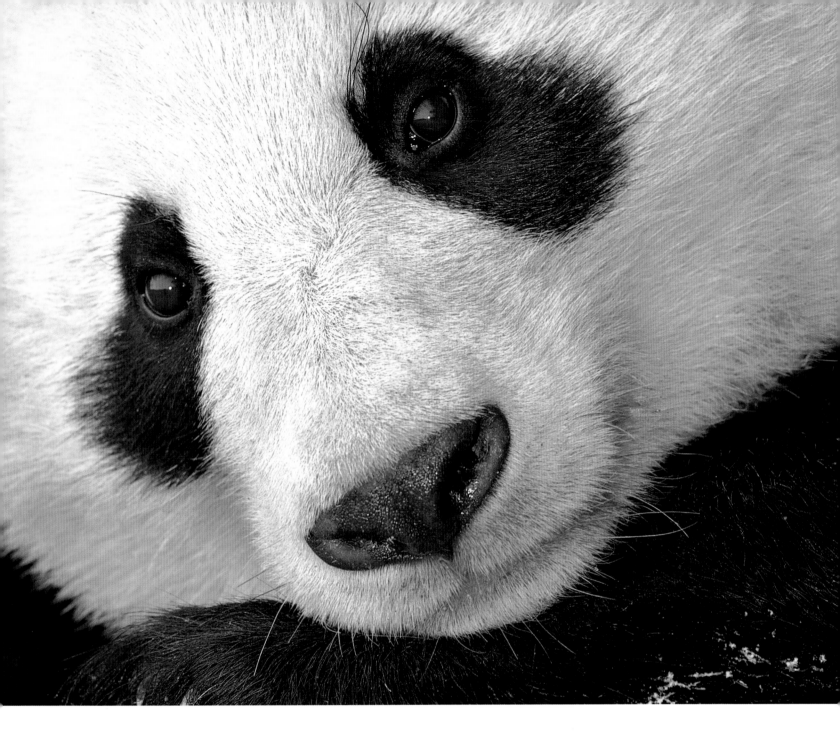

Compared to their large bodies, giant pandas have dark small eyes with pupils that have vertical slits, whereas other bears have round pupils like those of a tiger. Their vision is good, and they appear to be able to distinguish colours.

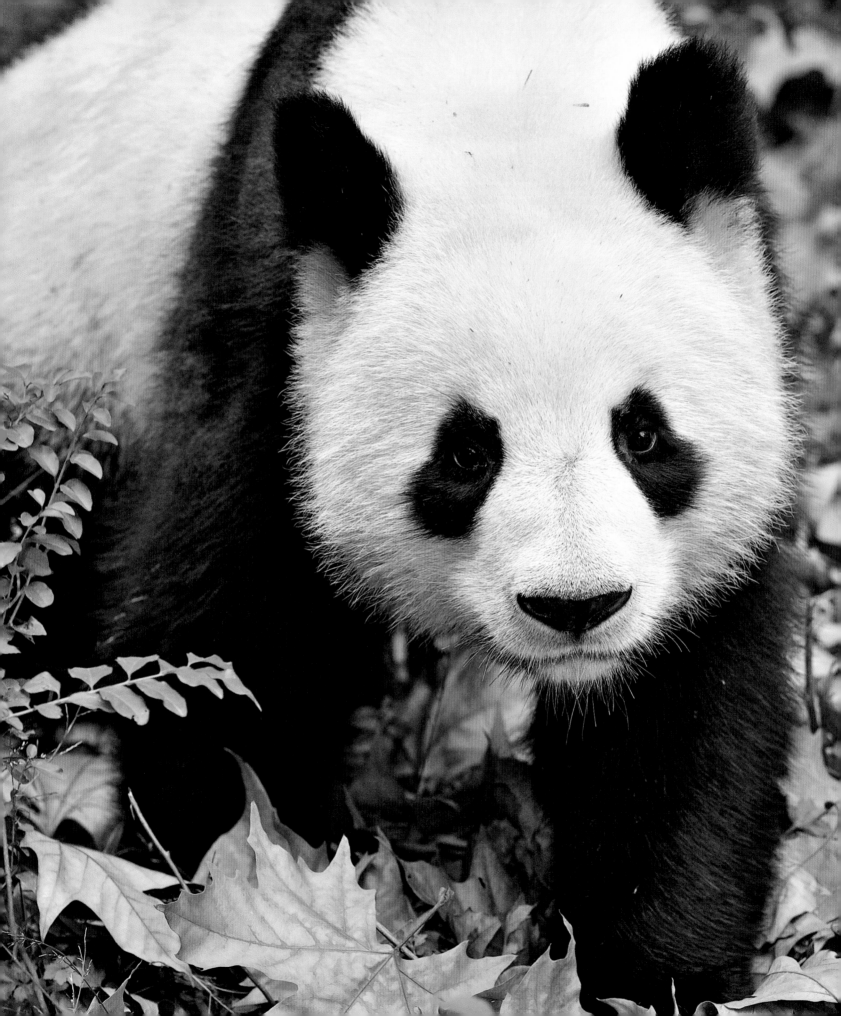

CONSERVATION MISSION

Conservation Mission

Why are wild giant pandas at risk of becoming extinct? At first, nobody knew they were, and it was only in 1990 that the IUCN changed the panda's classification to "Endangered".

According to *Saving the Giant Panda* by Terry L. Maple, a total of 36 pandas were exhibited in zoos outside China in the period of 1977 to 1983. As this was before the success of captive breeding programmes, it became clear that far too many zoos were competing for a small number of pandas, and critics of this 'rent-a-panda scheme' rightly began to suggest that the giant panda was in the process of being 'loved to extinction'.

Back in the 1980s, the picture was not bright according to pioneering wildlife biologist Dr. George Schaller, who wrote in *The Last Panda* "between 1975 and 1989 the Panda lost half of its habitat in Sichuan Province to logging and agriculture. The survivors remain in small fragmented populations, isolated in about twenty-four forest patches - a blueprint for extinction."

A decade later Dr. George Schaller was more optimistic when he wrote the foreword to *GIANT PANDAS Biology and Conservation* (2000): "In the 1980's, I was filled with creeping despair, as the panda seemed increasingly shadowed by fear of extinction. But now, in this new millennium, Giant Pandas: Biology and Conservation rightly projects hope, optimism, and opportunity."

Conservation requires a vision beyond pandas, to include the whole forest ecosystem, human land use and community development, all within a cultural context. The 1990s have seen consistent change in that direction. A national conservation plan began to be implemented in 1993.

Firewood collection in panda reserves continues to be an issue.

Today pandas enjoy full protection in China, and numerous new panda reserves have been created to protect them as well as many other rare species living in the same habitat. According to Dr. Zhang Zhihe's book *Unveiling Giant Pandas*, by 2010 a total of 86 panda reserves had been established covering 2.3 million hectares protecting more than 75% of wild pandas, the number of which has now been raised to 1,600.

The traditional way of protecting an endangered species adopted a simple formula: establish nature reserves and keep people out. Left undisturbed, the animals and habitat would survive there indefinitely. In the case of giant pandas, it is doubtful whether such

China's government has encouraged replanting of pines and other conifers to shade bamboos and rhododendron plants. It promotes panda conservation and gives hope to sustain its population.

an approach would work, as the number of pandas in many of the fragmented forest habitats is less than 50, which would indicate that the genetic pool of pandas in each area would be too limited for long-term sustainability.

Having reached a breakthrough in breeding pandas in captivity resulting in a captive population of more than 300 individuals in 2011, the time is approaching to consider re-introducing pandas into the wild.

The number and survival of captive-born young has increased greatly and in a dramatic policy shift, the government banned logging of old-growth forest and initiated a vast reforestation programme to turn steep hillsides from 'grain to green'.

There is now increasing awareness that panda conservation means more than just protecting reserves - it also entails dealing with the entire landscape. New concepts like buffer zones, linkages between forest fragments, multiple-use areas, and cooperation with natives who have a stake in the resources have become officially accepted.

The first step to solving any problem is to identify it clearly. This has largely been accomplished and panda conservation has become high on China government's agenda.

The most important conservation issues are the protection of the present nature reserves from further habitat degradation. Efforts should be made to connect the various fragmented panda reserves to facilitate movements of pandas from one area to another.

It is also vital to continue to get more accurate panda population figures, as without quality estimates it is difficult to make good decisions and plans for reintroduction programmes.

Following extensive flooding in 1998, tied directly to deforestation, the Chinese government started immediately with two important initiatives: The Natural Forest Protection Programme (NFPP), launched in 1998, and in the following year, The Sloping Land Conversion Programme (SLCP).

The objective of the NFPP was to introduce new and tougher measures for the protection of natural forests, including putting a stop to all logging in the upper levels of the Yellow and Yangtze Rivers by 2000. The SLCP is now known as the 'Grain for Green' policy aimed

at converting crop areas located on steep slopes to grass and reforesting erosion-prone hillsides - these projects started in the panda areas in 1999. The 'Grain for Green' programme covers more than 7,000 square kilometres in Sichuan province alone. The policy has forced farmers to abandon their agricultural fields on steep slopes and to convert them into forests by replanting trees. They are then given grain and cash subsidies proportional to the amount of farmland that has been converted to forest. The seedlings for replanting these natural forests are provided. These policies have the true potential to turn tree-cutters into tree-planters, and can make a meaningful difference in securing the future of the giant pandas and their habitat.

Consequently, these policies have led China to become the first in the world in terms of forest area gained per year (FAO 2006). The suitability of these newly forested areas for pandas is still not proven, however a platform for the recovery of panda habitats has been established.

To ensure the successful implementation of these programmes, the Chinese Government invested US$2.7 billion in the NFPP from 1998 to 2000, and committed an additional US$11.6 billion to take the programme up to 2010, with the majority of the funds spent on retiring, resettling, and retraining forestry workers, according to Henry Nicholls's excellent book *The Way of the Panda*.

According to *China Daily*, the 4th National Wild Panda Census began in July 2011, and trackers would collect panda droppings for DNA analyses, which would allow zoologists to track individual pandas and more accurately estimate the number of pandas living in the wild. The National Census, which is done every 10 years, was last conducted in the period 1999-2003 when a total of 1596 pandas were counted. The current census is expected to be completed in 2013. As previously mentioned, we believe that the importance of these population surveys cannot be overestimated.

In what could be a potential breakthrough in China's panda conservation programmes, *China Daily* reported on 11th January 2012 that six young pandas bred in captivity were released as a group into an enclosed forest in Sichuan province. The six pandas were selected for health, behaviour, and genes from among the 108 pandas at the Chengdu Panda Base.

The Chengdu Panda Base has released 10 captive-bred pandas back into the wild over the span of the past three decades or so. Their efforts however, were seldom successful as domestically-raised pandas have great difficulty adapting and surviving in the wild, which is also the reason why some environmentalists question this type of project, which does not, address the main problem - the loss of suitable habitat.

"The release is the first step of a project aiming to help the endangered species to adapt to the wild environment and eventually survive in the wild", according to Fei Lisong, Deputy Director of the Chengdu Giant Panda Breeding and Research Centre.

He added "they are in their sub-adult age with comparatively strong survival ability and rapid growth. They will be the first group of pandas released into the 'Panda Valley', centre, which is located in Majiagou in Yutang town in the Dujiangyan city, about 40 kilometres west of the provincial capital of Chengdu".

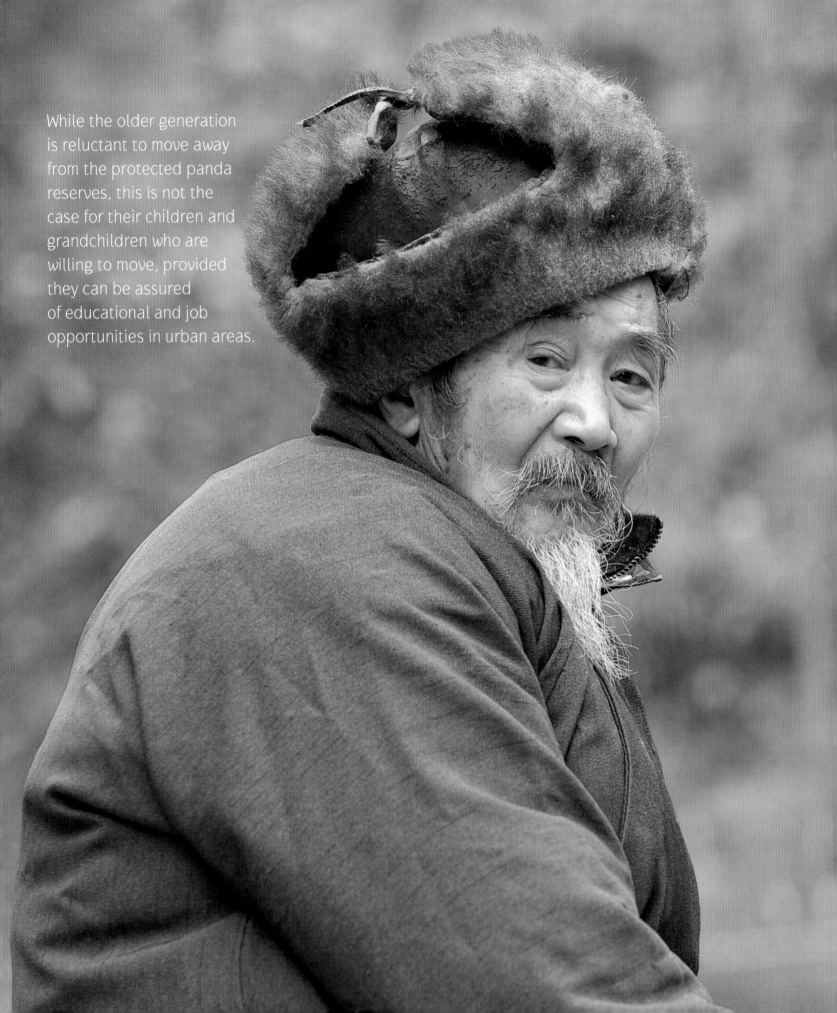

While the older generation is reluctant to move away from the protected panda reserves, this is not the case for their children and grandchildren who are willing to move, provided they can be assured of educational and job opportunities in urban areas.

Chinese researchers believe that releasing six pandas together, unlike previous attempts to release them individually, will help them to survive in the wild. "It is expected that some of these pandas will be released into a much larger semi-wild area with more abundant bamboo choices and no man-made structures", said Fei.

While we are convinced that pandas can survive long-term in captivity, the future for giant pandas in the wild will depend on conservation programmes, which must be adaptable and linked to the welfare of the people living close to them. The current fragmented panda habitats should be further connected, and all mining and logging activities should be banned and no further road building projects should be carried out in 'sensitive panda areas'.

We believe that the priority is to protect the pandas in the wild, however, breeding pandas ex-situ, or out of their habitat, and reintroducing them into the wild will improve the gene pool and avoid inbreeding in the wild.

Educating the younger generation on conservation is key to moving forward, and many zoological organizations support and run such activities. For instance, the Wildlife Conservation Society runs education programmes for schools in four provinces in China, including Sichuan. Many children worry about wildlife, and they depend on adults for the uplifting messages that give them hope for the future.

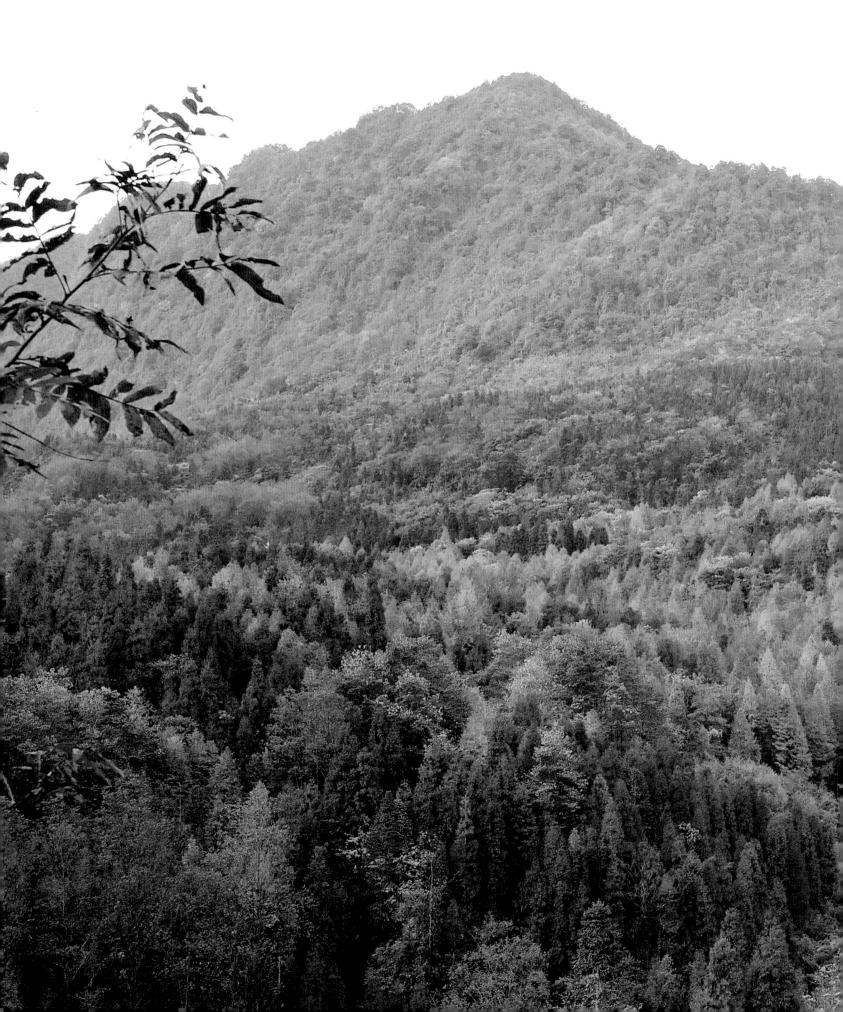

After some devastating floods in 1998, China began to reforest steep slopes throughout the panda's range. The policy forced farmers to abandon agricultural fields on steep slopes and replant these areas with trees, for which they are given grain and cash subsidies.

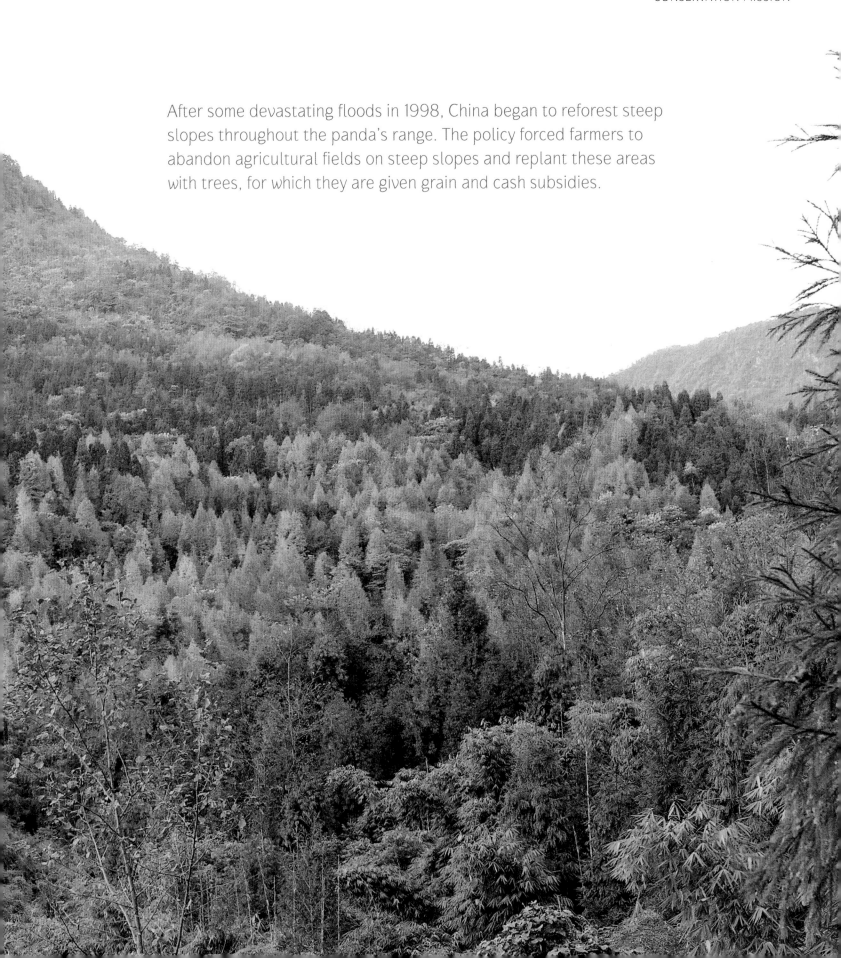

The priority is to protect pandas in the wild, however, breeding pandas ex-situ, or out of their habitat, and reintroducing them into the wild will improve the gene pool and avoid inbreeding in the wild.

There are more than 20 separate panda populations in China. Most of them have fewer than 50 pandas, which may not be enough to ensure their long-term survival. The efforts to save pandas in the wild, and to help other rare species in their range, while protecting the watersheds that support human agriculture, are therefore required urgently.

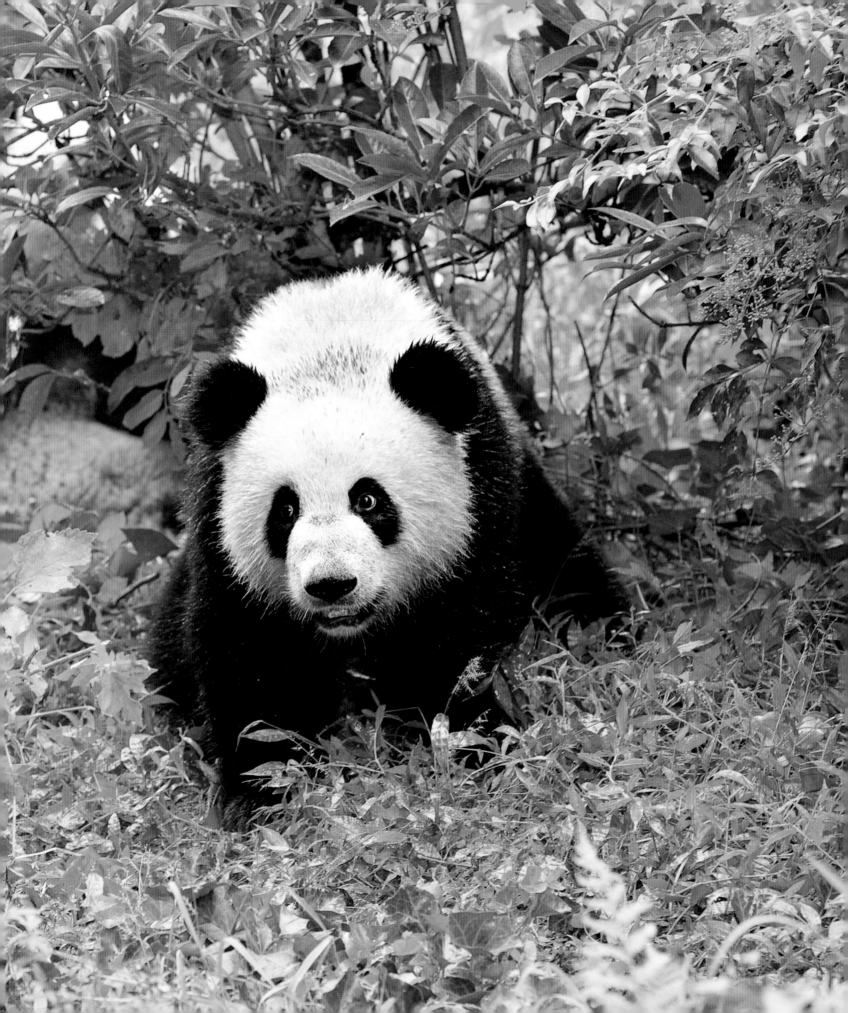

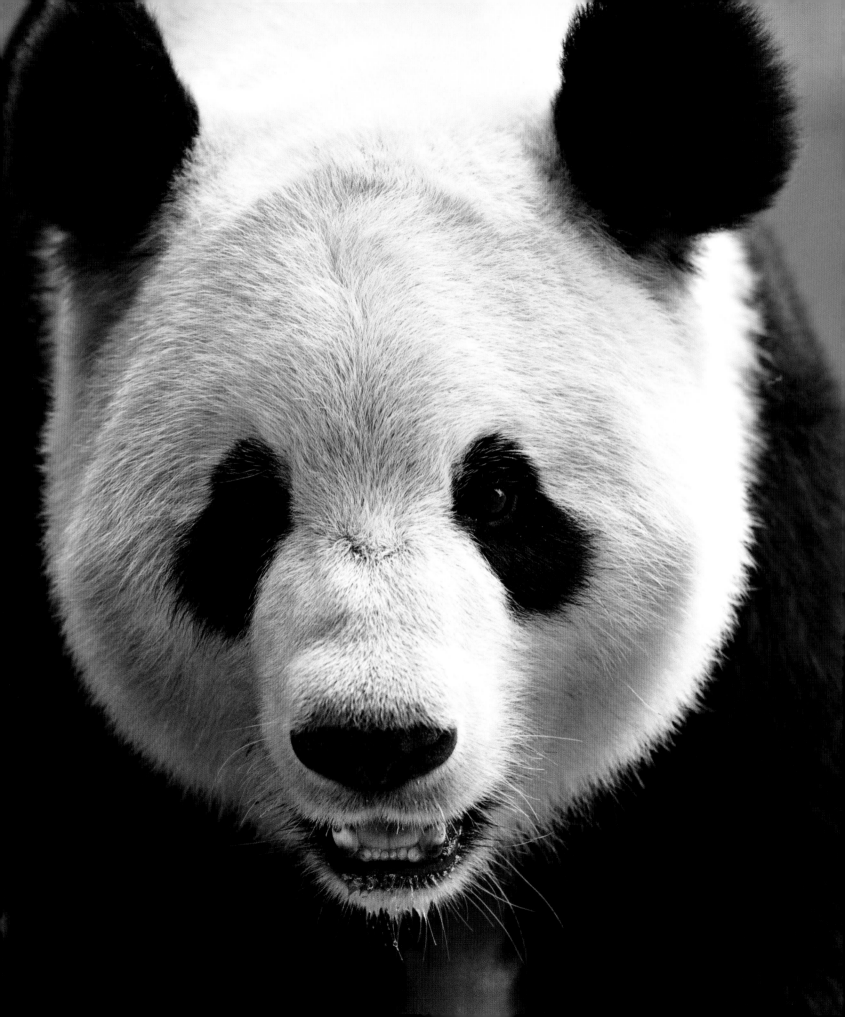

References and further reading

The Last Panda, George B. Schaller, University of Chicago Press, Chicago 60637, 1993.

Giant Pandas in the Wild, Saving an Endangered Species, Lu Zhi, Aperture Foundation, Inc, 2002.

The Way of the PANDA, The Curious History of China's Political Animal, Henry Nicholls, Profile Books Ltd 2010.

Giant Pandas, Biology and Conservation, Edited by Donald Lindbur & Karen Baragona, University of California Press, 2004.

Smithsonian Book of Giant Pandas, Susan Lumpkin & John Seidensticker, Smithsonian Institution, 2002.

Giant Pandas, John Seidensticker and Susan Lumpkin, HarperCollins Publishers, 2007.

Unveiling Giant Pandas, Zhang Zhihe, China Travel & Tourism Press, 2010.

Saving the Giant Panda, Terry L. Maple, Longstreet Press, 2000.

Mammals of China, Andrew T. Smith and Yan Xie, Princeton University Press, 2008.

Panda, An intimate portrait of one of the world's most elusive animals. Heather Angel, David & Charles Limited, 2008.

Panda, Inc. National Geographic, July 2006.

PANDA, Back from the Brink, Zhou Mengqi, Sarabank (Scotland) Ltd, 2012.

Birds of China, John MacKinnon & Karen Phillipps, Oxford University Press, 2010.

Acknowledgements

Without the assistance of many people the production of this book would not have been possible.

First of all we should like to thank our many friends in China in particular the staff of Ya'an Bifengxia Base of China Conservation and Research Centre for the Giant Panda. We are especially grateful to Dr Li Desheng, Director and Deputy Director Professor Tang Chun Xiang of the China Conservation Research Centre for the Giant Panda for their guidance and help. Also a big thank you to the drivers and guides who helped during our visits often in miserable weather conditions.

Special thanks to Mr. Jeroen Jacobs, Pambassador of Chengdu Research Base of Giant Panda Breeding, who assisted in checking the panda information, and giving helpful comments, and to Mag. Regina Pfistermuller, MSc, Curator of research and conservation, Vienna Zoo for providing background information and photos. Anton Baotic has also been helpful in more ways than one.

Our Science Advisor and friend Mr. Biswajit Guha was extremely helpful in reviewing our final draft, and making many improvements. Project Consultant Miss Zubee Ali did a great job in co-ordinating the various aspects of this publication, and also many thanks to our patient Design Consultant Miss Zinnira Bani, who contributed with her innovative design ideas during the project. Also thank you to Samantha Khoo, who did the proof-reading and fact-checking of the final draft.

Our thanks to Lim Sau Hoon, our old friend, and Frederic Snauwaert from 10AM, they were extremely helpful with their creative ideas and layout. Dr Nigel Taylor, Director, Singapore Botanical Gardens was also most helpful.

Fanny & Bjorn

All photographs in this book are by Bjorn Olesen except for the following:

Wang Fang	Page: 117, 124, 125, 139, 141
Simon Quek	Page: 49, 138
Daniel Zupanc	Page: 21, 72
Zoo Vienna	Page: 59, 108
Dong Lei	Page: 114, 136
Eveline Dungl	Page: 58

Science Consultant	Biswajit Guha
Project Consultant	Zubee Ali
Design Consultant	Zinnira Bani

Index

Index

Index

Index

Index

Index

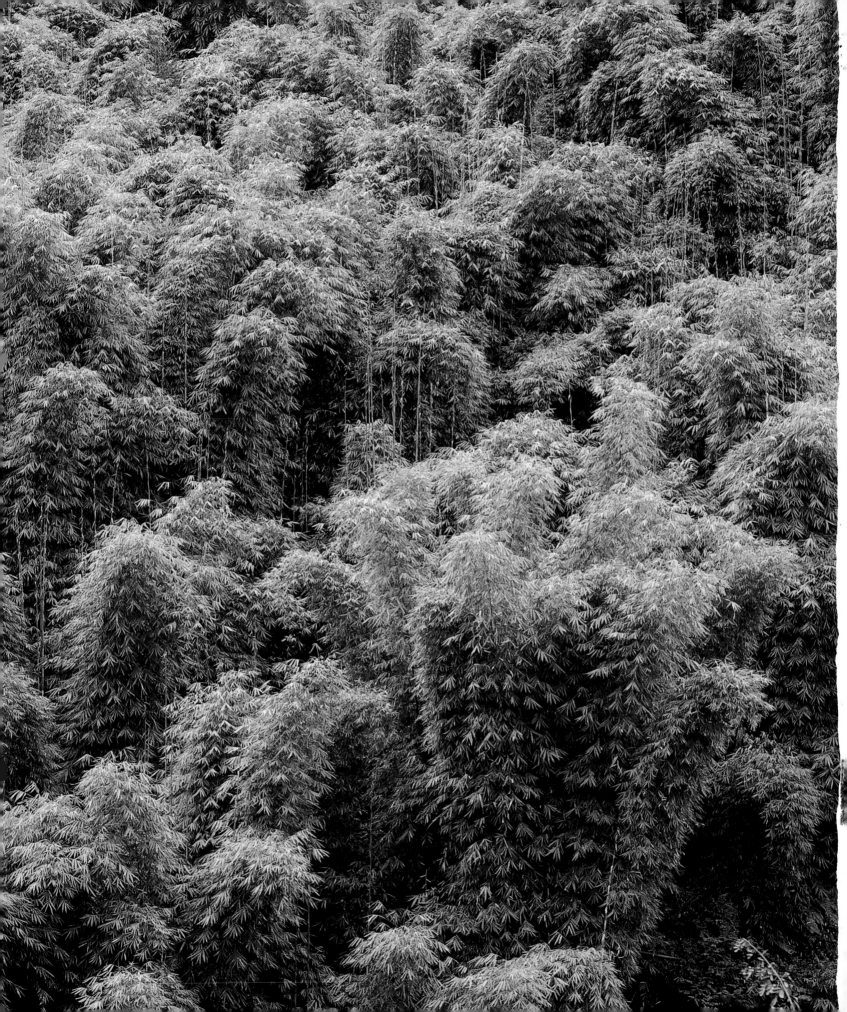